The Construction of Drawings and Movies

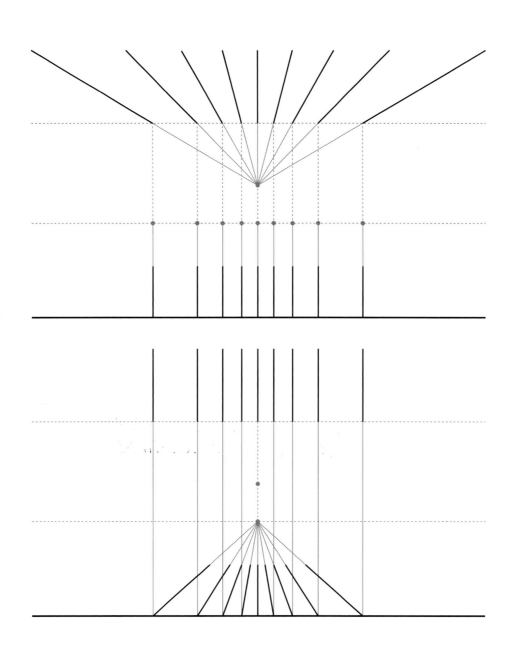

The Construction of Drawings and Movies

Models for Architectural Design and Analysis

Thomas Forget

Routledge
Taylor & Francis Group

LONDON AND NEW YORK

First published 2013
by Routledge
711 Third Avenue, New York, NY 10017

Simultaneously published in the UK
by Routledge
2 Park Square, Milton Park, Abingdon, Oxon OX14 4RN

Routledge is an imprint of the Taylor & Francis Group, an informa business

Library of Congress Cataloging in Publication Data
A catalog record for this book has been requested

ISBN: 978-0-415-89839-3 (hbk)
ISBN: 978-0-415-89840-9 (pbk)
ISBN: 978-0-203-10013-4 (ebk)

Publisher's Note
This book has been prepared from camera-ready copy provided by the author.

10 0669940 4

MIX
Paper from
responsible sources
FSC
www.fsc.org FSC® C004839

Printed and bound in Great Britain by
TJ International Ltd, Padstow, Cornwall

for my mother and father

Thus, I ask of absurd creation what I required from thought—revolt, freedom, and diversity. Later on it will manifest its utter futility. In that daily effort in which intelligence and passion mingle and delight each other, the absurd man discovers a discipline that will make up the greatest of his strengths. The required diligence, the doggedness and lucidity thus resemble the conqueror's attitude. To create is likewise to give shape to one's fate. For all these characters, their work defines them at least as much as it is defined by them. The actor taught us this: there is no frontier between being and appearing.

Albert Camus, "The Myth of Sisyphus"

For many years, I considered linear perspective and cinema to be parallel interests. The former figured prominently in my teaching, and the latter operated both as a research topic and as an amateur hobby. This book explores points of intersection between the two modes of imagery. The potential reciprocity between linear perspective and cinema first occurred to me during the production of a video analysis of San Francisco. As I shot the inclined streetscapes of that city, I realized that my compositional strategies were indebted to my understanding of architectural drawing. I sought shots that evoked plans, sections, elevations, and (especially) perspectives. In 2009, I developed a research seminar on architectural projection at the University of North Carolina at Charlotte, and my main objective was to determine the extent to which linear perspective and cinema complement each other, both practically and theoretically. I was unconvinced that the inquiry would continue for more than a semester, but it evolved into more research courses and infiltrated my studio teaching as well. Readers will likely recognize the dual influences that inform this book (research and design), as I have sought to honor the dialogue between

thinking and making that led both to its inception and to its development. This book may operate both as a studio companion and as a selective survey of important historical and theoretical concerns related to architectural imagery.

My interest in movies first emerged during my junior year abroad in Paris during the 1990–1991 academic year. The small cinemas in the Latin Quarter, which screen films from various genres and cinema cultures, seduced me into questioning my lifelong commitment to becoming an architect. Meanwhile, the *Grands Projets* of Francois Mitterand in Paris (the pyramid at the Louvre, Parc de la Villette, Opéra de Bastille, Arche de la Défense, et cetera) simply could not compete with the moving images that were flicking deep within the vernacular fabric of the city. Adding to the romance, the early 1990s was an era of intense creativity in American independent cinema, and cutting edge moviemakers such as Hal Hartley, Steven Soderberg, and the Coen Brothers seemed far more relevant to me than so-called avant-garde architects such as Zaha Hadid, Frank Gehry, and Bernard Tschumi. Instead of proceeding directly to a professional education in architecture, I entered a masters program in architectural history and theory in order to sort out my understanding of the relationship between architecture and cinema (and ultimately to decide whether to pursue a career in architecture or moviemaking). I wrote on the topic in a manner that did not adhere to (and, in fact, argued against) conventional notions of cinematic architecture, and I believed that my thesis might provide a starting point for an innovative design career. My analysis of cinema focused on structural, as opposed to phenomenological or narrative, aspects of the medium, and I understood architectural design and moviemaking as analogous ways to organize space and time. After I earned a professional degree in architecture, however, movies became a marginal influence on my work, as I resisted any use of cinema as a literal model of architectural and urban design. I had begun to make movies about cities and infrastructure, but these activities were adjacent to my work as a designer, not integral to it. The interest that had begun in Paris seemed to have run its course.

The research that I began in 2009 was a last ditch effort to integrate cinema into the trajectory of my career, and the pairing of linear perspective and cinema has revived my belief that movies are relevant to architectural discourse in ways that have not yet been explored. Once I understood the inherent abstraction of linear perspective, I was better able to understand the inherent abstraction of cinema. This book argues that both modes of imagery, despite their experiential immediacy, are untapped

resources of analytical inquiry into the nature of the built environment. I owe these recent developments to many people, only a few of whom I am able to mention here. My advisors and colleagues at Yale University between 1993 and 1995, especially Eeva-Liisa Pelkonen, Alan Plattus, and Peter Soland, were the first to encourage me to nurture a budding interest in cinema that I could have easily discarded. My advisors and colleagues at Princeton University between 1995 and 1998, especially Christine Boyer, Nasrine Seraji, and Jonathan F. Bell, further supported my attempts to question the relevance of cinema to the design process. I owe my fascination with linear perspective to my first teaching position at Roger Williams University, where my colleagues selflessly taught me how to teach design and selfishly allowed me to take control of the instruction of linear perspective. I cannot overstate my gratitude to them, especially Maurico Barretto and Julia Bernert. Two former colleagues from New Jersey Institute of Technology, Silva Ajemian and Jorge Prado, have become regular partners in crime, and their critical and passionate minds infiltrate all aspects of my work in ways that are impossible to quantify. Kate Shepherd, a close friend and artist in New York City, has helped me to appreciate the power of lines and the rigor of drawing. Charles Silver, curator at the Department of Film at the Museum of Modern Art, and the programmers at Anthology Film Archives have exposed me to movies that have revolutionized how I understand the medium of cinema. Others who have helped me in less obvious ways include Kristi Dykema Cheramie, Nick Senske, Mark Thorsby, Malcolm Harris, and Rebeca Plank.

My colleagues and students at the University of North Carolina at Charlotte have provided me with a stimulating and encouraging environment in which to grow as a teacher and a researcher. Few schools would have provided me with the support necessary to develop this book so quickly. I owe a special debt of gratitude to the students with whom I developed the processes and ideas that led to this book. Their curiosity and challenging questions inspired me to continue my inquiry.

One of my former colleagues, Kerrick Johnson, deserves special note. He helped me to develop my initial interest in linear perspective, and he has informed my inquiries into drawing and cinema in profound ways. He has taught me not only facts, but also methods and habits, and he has been, by far, my most consequential academic advisor. We have discussed nearly every idea in this book, and our agreements and disagreements have been memorable and invaluable.

Introduction

Analytical and Pictorial Imagery

The difference between the drawings of a painter and those of an architect are this: the former takes pains to emphasize the relief of objects in painting with shading and diminishing lines and angles; the architect rejects shading, but takes his projections from the ground plane and, without altering the lines and by maintaining true angles, reveals the extent and shape of each elevation and side—he is one who desires his work to be judged not by deceptive appearances but according to certain·calculated standards.

Leon Battista Alberti, *On the Art of Building in Ten Books*

In his treatise on architecture, Leon Battista Alberti argues that the architectural design process is an analytical, as opposed to a pictorial, inquiry. The author understands architecture as a complex discipline of aesthetic and technical concerns that escape the limits of visual immediacy, and he therefore urges architects to construct orthographic drawings and "plain and simple" models of their architectural proposals.[1] According to Alberti's argument, pictorial embellishments of architectural graphics hinder their ability to examine an assembly of parts in terms of proportion, tectonics, and cost, and an analytical approach defends both the architect and the client against the loss of wealth and reputation that results from poorly conceived and executed buildings. Alberti values sight as "the keenest of all senses"[2] in the judgment of architectural integrity, but his notion of vision is nuanced and implies a distinction between appearance and reality. Whereas immediate appearances of a building may signal a deficiency, more measured practices of perception are required in order to avoid the realization of such deficiencies in the first place. The specific impression of a work of architecture is pleasing only when that work upholds underlying principles that cannot be perceived through pictorial means. Appearances are the concern of the painter. In *On Painting* (1435), Alberti promotes visual immediacy as the ultimate objective of painting, and he codifies the so-called *costruzione legittima* (legitimate construction) of linear perspective as the means through which to achieve this goal.[3] Painting *is* good when it *looks* good. Architecture, inversely, *looks* good when it *is* good. The virtue of a work of architecture is knowable only through an analytical lens, and the pictorial lens of linear perspective is incompatible with the architectural design process.

This book considers Alberti's understanding of the design process as a provocation and questions the extent to which architecture is a visual art. In one sense, the matter is simple. Most people *see* architecture, despite whatever multisensory phenomena also occur during that visual reception. In a theoretical context, the matter is somewhat more complex. Images of space do not capture the experience of occupying a space. Architecture appears to its occupants, but it also transcends its appearance. To celebrate this conundrum, as this book intends to do, is to embrace one of the many frustrations of the architectural design process. Between reality and representation, there is always a gap, and it is a potentially productive one. Alberti's orthodox position against pictorial imagery prevents a full realization of that potential, so it needs to be moderated. Pictorialization is an inevitable and valid mode of inquiry that allows designers to consider their projects, both literally and figuratively,

through a different perspective. Alberti was able to reject the use of pictorial imagery as a design tool because of his absolute faith in the power of classical proportion to render architecture beautiful. Most contemporary designers are not blessed with such clarity and confidence. Lacking the authority of a golden rule to regulate their decisions, it is unsurprising that, during the design process, architects inquire as to what their projects *look like*.

Because architecture is not (exactly) a visual art, the proper role of pictorialization in the design process is an open and difficult question. An obvious danger arises when architects calibrate specific visual impressions from specific locations, as they are limited in their ability to control how occupants move through and look at their work. Every building contains an infinite number of possible visual impressions, depending not only on the exact position of an occupant's eyes, but also on transitory and uncontrollable factors. The goal of this book is to consider pictorialization not as an act of scenography, but rather as a process of interrogation. What follows is an investigation into the potential of pictorialization to become an analytic tool that addresses a wide range of architectural qualities, none of which meet the criteria of a purely visual effect, but all of which recognize that vision matters.

The Digital Divide (or lack thereof)

The use of pictures to analyze architectural proposals is an increasingly prevalent phenomenon. In the digital age, vision may no longer be "the keenest of all senses," but it is certainly the dominant one. Both the venue of the screen and the perspectival biases of digital modeling programs have nurtured a culture of *looking at* architecture during the design process. Digital tools of pictorialization reduce (or even eliminate) a productive form of resistance that once characterized analog tools of pictorialization. Instead of constructing images through arduous procedures, designers typically consume images that were created for them instantaneously by a computer. Immediacy by no means precludes analysis, but they are rarely complementary. Likewise, resistance by no means mandates analysis, but a construction process at least requires a more deliberate cognitive operation than clicking "render." Digital design tools have the capacity to generate analytical imagery and to engage their users in productive processes of image construction, but *the will to construct* is a necessary precondition for that capacity to flourish. This book aims to instill that will in its readers, regardless of their specific design processes.

Preliminary (and, admittedly, anecdotal) evidence suggests that the will to construct is far weaker than the will to consume. As an educator, I regularly witness how students (both beginning and advanced) behave on the computer. The following scenario, while not universal, is common enough that most readers should recognize it as a prevalent phenomenon of contemporary education and practice. The tool of choice is typically a digital modeling program, and the view of choice is typically a perspectival view of the design project. More advanced programs allow for multiple views on the same screen, and more advanced (or talented) designers take advantage of this potential, but the perspectival view is almost always paramount, for all of the obvious reasons. The rhythm of the design process in this scenario is remarkably consistent among beginning and advanced designers of varying talent, which suggests that it is somehow innate. After making an adjustment to a model, a designer typically spins the camera so as to view the project from a series of indefinite (and usually random) positions: zoom in, zoom out, spin, zoom in, zoom in, spin, zoom out. A new adjustment is made, and the cycle repeats. The quality of the resulting projects varies according to the talent of the designer, meaning that this scenario does not preclude or promote good design. In the hands of a skilled designer, skill emerges. In the hands of a weak designer, weakness prevails. In all cases, however, an opportunity is lost, as evaluation displaces analysis, and as passive observation overrides active dissection. Although decision-making occurs and projects progress, the design process becomes an unregulated spectacle of almost infinite possibilities, which distinguish themselves only by their phenomenal effects.

Student presentation strategies typically demonstrate a similar problem. Again, the following is a general scenario, but most readers should recognize the tendencies described. An untrained student who uses a digital modeling program as a design tool typically generates graphics for presentations through a point-and-shoot operation. This operation entails steering a camera through a model, capturing a series of views, rendering those views, and finally sending them to printer. Inevitably, some of the views are strategic, and others are not. Many are likely redundant and exist simply because of the ease with which they are able to exist. Bird's-eye views are especially popular, and analytical views are rare. The lack of resistance in the image generation process promotes (but does not mandate) a lack discipline and judgment. Rendering choices, likewise, are typically neglected or poorly managed. Surface renderings, which give a pictorial effect, are popular, as are views that appear to be line drawings. The latter are especially troubling because the printed lines give

the false impression that the designers are thinking orthographically. In fact, they have not drawn a single line and may not even understand how lines communicate spatial information. The lines in such renderings are merely the edges of solids in the model, and they may not communicate information about the project strategically (or even correctly). Certain lines may detract from the usefulness of the view, and potentially strategic lines may be missing. Students who print such views seem to understand that line drawings matter, but they mistakenly believe that images of lines are sufficient. I consider renderings of this sort to be *pictures*, as opposed to *drawings*, which is a distinction that will be explored in depth throughout this book.

One could argue that the freewheeling spirit of the working methods just described is an asset, not a detriment, to creative thinking. Diagramming, for example, is an invaluable component of any design process, and it is best performed recklessly and without regard to rules or expectations. The design process, however, requires a variety of modes of inquiry, including a careful and controlled analysis of variables. Looking at architecture is valuable, but it is not enough. When a digital model is the primary (or only) vehicle of the design process, as it often is, the designer must operate it in different ways. One mode of operation that allows designers to examine design modifications through a controlled lens is a strategic limitation of the viewing parameters on the screen. Even the most basic programs allow users to define specific points of view, and the analytical potential of devising a specific series of views is significant. A thoughtful designer, for example, may establish a collection of views and a sequence of viewing them that complements a particular design objective. Suddenly, the performative advantages of digital media complement, instead of undermine, the analytical power of traditional drawing.

Digital strategies, of course, must be taught, just like traditional drawing skills. The ease with which beginning students learn how to use digital modeling programs does not excuse educators from regulating how students operate these programs during the design process. Left to their own devices, some (and I would argue most) students will guide the viewing camera through and around their project, as if flying a helicopter in a video game. Without discouraging that mode of exploration altogether, educators must also provide specific strategies for analytical modes of inquiry. The ability to use a program is independent of the consciousness of its full potential. Most of the problems related to digital image generation result from intuitive, instead of strategic and analytical, uses of modeling programs, and they are easily avoidable

with proper training. Readers who consider themselves above the extreme scenarios described here should be wary of less obvious digital abuses that they too may perpetrate. Like false-friends in a foreign language (i.e., words that sound familiar but do not mean what one expects them to mean), the interfaces of digital processes can mislead even a skilled and talented designer. It is important to scrutinize every click and drag.

An underlying assumption of this book is that the digital revolution is changing everything and nothing. While the look and feel of design processes are changing, and while architectural form is evolving in unprecedented ways, architecture will never be reducible to phenomenal effects. The fact that pictorialization is emerging as a paradigm of architectural imagery is therefore a pressing issue. Most digital design platforms generate perspectival views that are variations of Alberti's *costruzione legittima*, and time-based architectural imagery is becoming increasingly more sophisticated and cinematic than conventional fly-through sequences, which first appeared in the 1990s but never became widely used in either education or practice. What follows is an appeal to uphold Alberti's general understanding of the critical role of analytical imagery in the design process and to adapt it to contemporary practices of image-making. In other words, the goal is to integrate the analytical logic of orthographic drawing into the pictorial dispositions of linear perspective and cinema. This is not a manifesto that seeks to define precise working methods or to promote a "right kind" of architecture, but rather a call to acknowledge the importance of analytical processes in whatever methods may be used now or in the future.

My appeal to an Albertian notion of analysis is not a denial of the potential of digital practices to redefine the nature of the design process. Digital practices should not be expected simply to facilitate and to accelerate the execution of inherently analog methods. The potential of the computer is surely greater than that. Still, it is unlikely that even a pure form of digital practice will overturn the relevance of a critical discourse on architectural imagery. Consider, for example, the emerging practice of digital scripting, which is an analytical design process that occurs in a non-graphic environment and therefore in a manner that is not directly analogous to any analog practice. Even scripting, however, leads to the production of architectural imagery that is used to evaluate (or ideally analyze) a design proposal, and an ability to interpret and to manage that imagery is essential. Otherwise, analytical

and pictorial processes may evolve into two distinct poles of the design process. Whereas analysis may be relegated to non-graphic modes of operation, such as scripting, pictorialization may be taken for granted as nothing more than a tool to generate vignettes of an already completed design process that occurs in a non-graphic medium. This polarization of analytical and pictorial processes would be the ultimate realization of the Albertian ideal of a strict dichotomy between architectural and painterly imagery. The challenge is to collapse the analytical into the pictorial, not to separate them. The potential divide between analytical processes and pictorial imagery is avoidable if designers understand the analytical potential of their imagery.

This book reveals ways in which architectural imagery, whether analog or digital, may operate analytically, despite the biases of default settings or a user's preconceptions. Its lessons are applicable to a wide range of contexts and objectives, including the frontier of the digital future. The vignettes that result from digital processes have enormous analytical potential, and a thorough understanding of linear perspective is necessary in order to realize it. Likewise, time-based architectural imagery has the potential to overcome the pictorial nature of the fly-through sequence, and a thorough understanding of the construction processes of cinema allows for the realization of this potential. Linear perspective and cinema may seem like anachronistic and/or obsolete modes of imagery given the current pace of technological development, but they underlie new modes of imagery and cannot be disregarded. Periods of transition such as the early digital age require a critical, as opposed to a nostalgic or reactionary, lens onto history. It is essential to discern historical practices that may be sacrificed from those that may be applicable (or even fundamental) to seemingly new types of imagery. This book asks reader not only to consider seemingly traditional modes of process, but also to execute them through new methods that elucidate their still latent potential. An immersion in these processes will lead to different reactions and conclusions, and this is precisely the point—to initiate a dialogue on the nature of architectural imagery and inquiry.

The Productive Gap

Analytical imagery results from strategic acts of construction. This book examines issues related to the construction of two specific modes of imagery: linear perspective and cinema. They share several commonalities. Each was interpreted as the apotheosis of visual immediacy in a given era. Each entails complex (if not

tedious) acts of construction that belie its alleged immediacy. Each engages the built environment in a critical discourse on architecture and urbanism. Although both are allegedly dying (or already dead) epistemological models of perception, they continue to inform the making and reception of architectural imagery, and it would be perilous for any contemporary architect to disregard them. Linear perspective and cinema are the bookends of Modernity—the beginning and end of a distinct lineage of image-making. Whereas linear perspective captivated practitioners and theorists of architecture in the Renaissance, cinema did so throughout the twentieth century. This book examines the relevance of that lineage to contemporary education and practice.

The first step is to challenge the assumptions of realism associated with linear perspective and cinema. The main point should be obvious: neither linear perspective nor cinema replicates human vision, and this gap should not be considered a deficiency. Drawings and movies are culturally specific conventions that provide both philosophers and art historians with endless fodder for debate on matters such as the nature of visual truth and the role of imagery in the formulation of social, political, religious, and even economic ideals. The more modest focus of this book is a limited set of practical and theoretical issues relating to the architectural design process. What matters here is the manipulation of the systematic conventions behind these modes of imagery in order to reveal underlying qualities of proposed or existing architectural projects. Once released from the burden of a literal correspondence to a phenomenological encounter with the built environment, linear perspective and cinema may communicate the type of spatial knowledge that Alberti attributes to orthographic drawings and physical models in his architectural treatise. The goal is not to erase the experiential dimension of these images through complete abstraction, but rather to temper their illusionistic expectations and to add something that escapes normative vision. What designers know about architecture is not the same as what they see when they look at it. Even pictorial graphics must go beyond visual impressions.

The dissociation between linear perspective and human perception was understood not long after Alberti published his treatise on painting, and some painters considered the dissociation as a flaw of the drawing system. Leonardo da Vinci, for example, wrote extensively on the ways in which linear perspective distorted natural vision. One example is his conclusion that a linear perspective image appears natural only

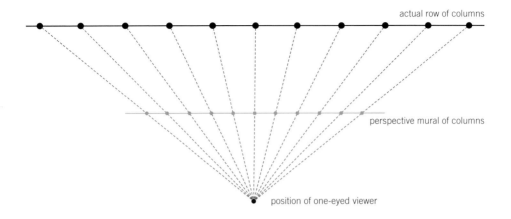

Figure 0.1: Author's interpretation of Leonardo's "point of view" theory

The above diagram depicts, in plan, the relationship between a row of columns (in black) and the position of a one-eyed viewer. A linear perspective mural of the same row of columns (in gray) may be placed in front of the actual row of columns and simulate its appearance for the same viewer if the viewing point of the linear perspective corresponds to position of the viewer in both plan and elevation. From every other location, the linear perspective mural will appear distorted and unlike the actual columns.

if it is viewed, with one eye, from a precise location that corresponds to the viewing point of the linear perspective (see Figure 0.1). The viewer, in a sense, needs to occupy one of the geometric parameters of the drawing in order for it to appear natural. Two paintings by Leonardo may be interpreted as attempts to override the limitations of this geometric condition. A preliminary drawing for his depiction of *The Adoration of the Magi* (1482) adheres to the checkerboard rigidity that is typically the result of the *costruzione legittima*, but the final painting obscures the grid with natural forms and allows the eye to wander through the depicted space of the painting in a fluid manner, not unlike an eye in front of an Impressionist painting.[4] The handling of the figures in the painting defies two conventions that were common in strict examples of linear perspective painting from earlier in the fifteenth century; the figures appear neither as static chess pieces on a grid (see *The Flagellation of Christ*, 1445, by Piero della Francesca) nor as a row of characters that frame the edge of a perspectival space (see *The Marriage of The Virgin*, 1450, by Perugino)[5]. Instead, they occupy a spatial environment that, despite an underlying

grid, is ambiguously described. Leonardo's depiction of *The Last Supper* (1498) creates a similar spatial enigma. Analytical drawings by Martin Kemp demonstrate that the space depicted in the painting does not adhere to a correct use of linear perspective.[6] The geometric manipulations in the painting are subtle, but they (along with Leonardo's painterly style) have significant consequences, as a comparison to Andrea del Castango's 1447 depiction of the same subject makes clear. Castango strictly adheres to the rules of linear perspective, and the result is a rigid and abstract work. It is a classic example of the "machine aesthetic" of true linear perspective. Leonardo follows a less orthodox (and technically incorrect) method. He softens the rigidity of the perspectival space and creates a more phenomenological scene, one that has palpable depth and perceptual ambiguities, not unlike human vision. He clearly aims to bridge the gap between linear perspective and human vision.

This book, conversely, explores how to occupy and to take advantage of that gap. The potential for productive abstraction in linear perspective lies in its geometric relationship to orthographic drawing. As Chapters 1 and 3 will illustrate, linear perspective and orthographic drawing are two sides of the same coin. Each is embedded within the other, and each may be extracted from the other if the reciprocal processes are understood. Differences between the two types of drawings are important to recognize, but it will be demonstrated that Alberti's attempt to cast painterly and architectural drawing as opposites is dubious. Throughout this book, the reciprocity between orthographic drawing and linear perspective is scrutinized and exploited as a vehicle of analysis. Once illusionistic assumptions of pictorialization are suppressed, this reciprocity allows for the application of analytical properties of orthographic drawing, such as line weight, onto linear perspective.

The productive gap in cinema is both relevant to and distinct from the one in linear perspective. The cultural impact of the arrival of cinema at the end of the nineteenth century cannot be compared to that of the arrival of linear perspective in the beginning of the fifteenth century, especially in terms of its relationship to human perception. The debates over the dissociation between linear perspective and human perception in the fifteenth century were understood as having profound theological, scientific, and cultural consequences. Cinema did not exude such gravitas when it first appeared as a scientific invention that evolved into a form of mass entertainment. Later in its history, philosophers and art historians retroactively recognized that its profound impact on culture warranted serious research into the psychological

dimension of the medium. Film theory provides linguistic, psychoanalytic, and feminist lenses (to name just a few) through which to read the impact of the medium on human perception and consciousness. While no film theorist would claim that cinema replicates how people see, many claim that cinematic experiences are no less significant than real experiences because viewers "lose themselves" in the illusionistic space of the screen through a willing suspension of disbelief.[7] That condition, however, is not inherent to the medium, but rather the result of both a certain approach to movie making and a certain approach to movie exhibition. This book explores other approaches to cinema, ones that emphasize the raw formal qualities of the medium over its potential to induce psychological immersion. The matters significant to this book lie entirely within the realm of architectural imagery.

Early cinema reveals much of what is important about the medium for the purposes of this book. Screening venues at the turn of twentieth century were full of distractions, and no viewer lost consciousness of the artifice of the medium or considered it to be an immersive psychological journey. Reports of viewers' fleeing from the image of an oncoming train are likely apocryphal. Early movies are straightforward constructions: some are records of actual locations and events, such as Thomas Edison's films of Luna Park (1903); others are depictions of staged locations and events, such as the Auguste and Louis Lumière's *Workers Leaving The Factory* (1896); still others are pure invention, such Georges Méliès' *A Trip to the Moon* (1902) and Edwin Porter's *The Great Train Robbery* (1903). All of these approaches, despite varying degrees of creative license, share an understanding of cinema as a pictorial (or non-analytical) medium, and these unassuming motion vignettes may be interpreted as examples of the type of immediacy that Alberti seeks through the use of linear perspective in painting. They may also, however, be interpreted as the raw material of an analytical approach to cinema. Behind the pictorial impulse of early cinema are two straightforward methods that hold the key to the construction of analytical imagery: the capturing of shots and the editing of shots into a sequence. Early cinema provides especially pure examples of the power of shooting and editing, before the emergence of special effects and complex narrative structures. The objective is to release the shot and the edit from their normative functions of storytelling and to incorporate them into an architectural discourse. Once recognized as vehicles of analysis, the shot and the edit may be exploited in order to transform motion vignettes into analytical inquiries.

A short film by experimental filmmaker Bill Morrison, *Outerborough* (2005), illustrates the potential of a raw shot to become analytical through an editing strategy. Morrison constructs his film through the use and reuse of a single-shot archival movie, *Across the Brooklyn Bridge* (Bioscope, 1899). The shot is taken from the front window of a subway train as it traverses the Brooklyn Bridge; the train travels from a depot on one side of the bridge to a depot on the other side. The orientation of the camera is parallel to the direction of the train, so the shot provides a frontal, as opposed to a lateral, view from the train, which makes it a somewhat unusual view. Morrison uses two copies of the shot in his movie and arranges them side-by-side, in the manner of a stereoscope or a diptych. The two images play in a continuous loop side-by-side throughout the duration of the movie, which runs for nine minutes. One of the images is flipped along a vertical axis, so that it becomes a mirror copy of the other, instead of an exact copy. When the movie begins, the mirrored copy runs in reverse, so it is not obvious that the two images are copies of each other. The initial loop of the two images runs at regular speed and last for about ninety seconds. Astute viewers will recognize by the end of the first loop that the two images are copies of each other. Subsequent loops of the images run at increasingly faster speeds, always at the same rate as each other. After a few loops, Morrison also superimposes additional copies of the original shot over both images. Some of these additional copies vary in speed and direction. Eventually, overlapping loops run at dizzying speeds and in multiple combinations that make it difficult to read the integrity of the original shot.

Morrison's methods reveal a variety of spatial and temporal conditions of the bridge that are unapparent in the original shot. In one instance, the images run so quickly that the bridge towers appear as an orthographic elevation. This elevation is overlaid with various rhythms and densities of linear components, which are tracks and cables that have lost their identity but maintained their geometry. Other moments motivate viewers to examine isolated conditions of the bridge, such as the sudden curvatures in the track that occur at the ends of the bridge. The varying speeds and juxtapositions of the original shot accentuate the contrast between the linearity of the main span of the bridge and the awkward geometries of its landings. Far more than the original shot, *Outerborough* depicts the bridge as a layered composition of varying densities and materialities, and as a system of regulating lines and proportional relationships. The film operates as a diagrammatic analysis that challenges a viewer's understanding of the bridge, not as an illusion of an experience of crossing it. Morrison thereby undermines the assumption that a single shot produces a single

impression. Like Leonardo, he constructs his work through a manipulation of a pure approach to pictorialization. Unlike Leonardo, his aim is not to heighten the realism of a pure form of the picture, but rather to abstract it further.

Earlier, I alluded to a distinction between pictures and drawings, and that distinction is important to clarify. Linear perspective is a method of pictorialization because it depicts a spatial environment from a specific point of view, but pictorializations may be either illusionistic or analytical. I refer to the former as *pictures* and to the latter as *drawings*. In the case of cinema, I make a similar distinction between *movies about architecture* (analogous to pictures) and *architectural movies* (analogous to drawings). Likewise, for both linear perspective and cinema, I use the terms *pictorial* and *analytical* to refer to these opposing approaches to pictorialization. In other words, drawings and architectural movies are analytical pictorializations that escape the limits of normative pictorial representation.

Directions of Projection

An additional commonality between linear perspective and cinema deserves special attention: both are modes of projection. Projection is a specific type of construction that is a central theme of this book, and its precise meaning in the context of architectural representation is important to clarify. In its most basic sense, a projection is a recording of an object as seen from a specific point of view. For example, a drawing of a box is a projection of that box as seen from a particular location, and this is an example of *drawing projection*. In this type of projection, the object and the point of view may be real or imagined; there may or may not be an actual box, and the point of view of a drawing may or may not be the point of view of the person who constructs the drawing; furthermore, a point of view may be experiential (like a perspective) or abstract (like a plan or an axonometric). Assuming that an actual box does exist, a light source may cast a shadow of the box onto a floor or wall surface, and this is an example of *shadow projection*. This type of projection is significantly different from drawing projection because neither the box nor the light source may be imagined. Both are real, and the physical relationship between the two determines the nature of the projection. Apart from that significant difference, both drawing projection and shadow projection are systems that consist of three parts (see Figures 0.2 and 0.3): a *point of projection* (the point of view in the former and the light source in the latter), an *object of projection* (the box in both

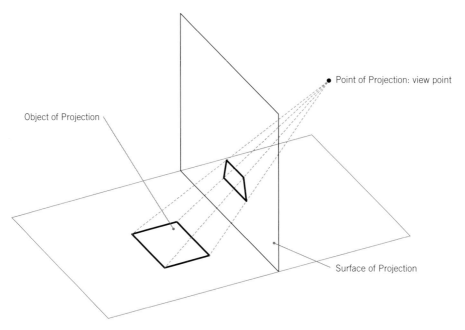

Point of Projection: view point

Object of Projection

Surface of Projection

Figure 0.2: Diagram of drawing projection

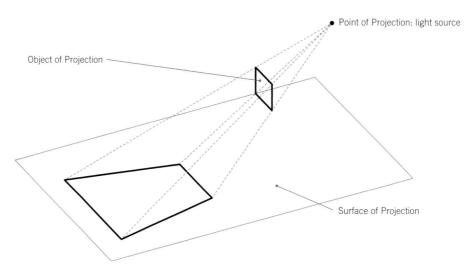

Point of Projection: light source

Object of Projection

Surface of Projection

Figure 0.3: Diagram of shadow projection

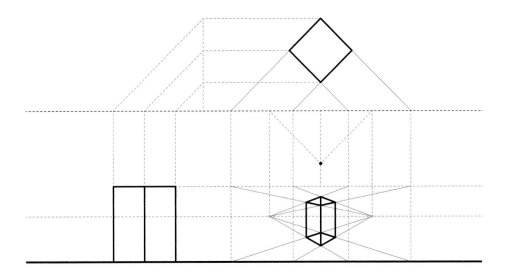

Figure 0.4: Diagram of the multiple projective operations in drawing

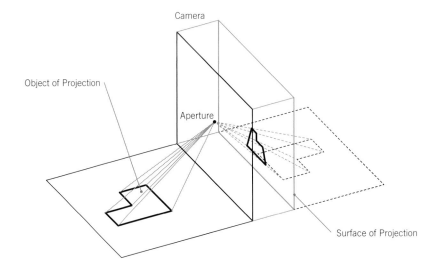

Figure 0.5: Diagram of the dual projective role of the aperture

cases), and a *surface of projection* (the drawing surface in the former and the floor or wall surface in the latter). Light is the vehicle of projection in both systems, but it operates differently in each. In shadow projection, light is physically present, and it is projected *from* a point of projection *toward* an objection of projection: physical light rays emanate from a light source, pass through an object, and cast a shadow on a surface. In drawing projection, light is metaphorically present, and it is projected *toward* a point of projection *from* an object of projection: metaphorical light rays from a real or imagined object pass through a drawing surface and converge at the real or imagined point of view of the drawing. Whereas drawing projection may be imagined, shadow projection is indexical. An *index* is a physical trace on a physical surface, such as a shadow on a wall, a fingerprint on an object, or an image on a photographic negative. Differences between indexical and imagined projections will figure prominently in this book's exploration of how linear perspective and cinema operate differently as projections of architecture.

Linear perspective and orthographic drawing are relatively straightforward examples of drawing projection; however, in this book, drawing projection will operate in a manner that does not perfectly adhere to the model described in Figure 0.2. In this book, drawing projection will not involve a single point of view, but rather multiple points of view that generate multiple acts of projection between plans, elevations, and linear perspectives (see Figure 0.4). In general, the process begins by projecting lines from orthographic drawings of a built environment (real or imagined) in order to construct a linear perspective. As will become evident, it is then possible to project additional lines through and between all of these drawings in order to construct more drawings of various types. A linear perspective, for example, may produce new plans and elevations through processes of extraction, and these new plans and elevations may lead to the construction of an entirely new linear perspective. The original plan and elevation of the built environment from which the original linear perspective was constructed may, in fact, become irrelevant as the drawing process evolves (similar to how the original archival shot in *Outerborough* becomes lost in the complexity of that movie). The construction of projections from projections has great analytical and creative potential, as it frees designers and researchers from any expectation that drawing leads to a single truth. Instead, drawing is understood as a constructive activity, both literally and figuratively, that allows for the investigation of spatial relationships and spatial possibilities that escape the limitations of a single point of view.

Cinema is an example of shadow projection, but an extremely complex one. All of the approaches to the medium that will be addressed in this book are indexical, meaning that the imagery results from the imprint of real light on light-sensitive surfaces. Animation and special effects compromise the indexicality of the cinematic image, and they are not addressed here because the resistance of the index is understood as a potential source of invention and creativity. Indexical movies, however, are not pure examples of shadow projection. Cinematic projection in fact shares an affinity with both shadow projection and drawing projection, as anyone familiar with the mechanism of a *camera obscura* may recognize (see Figure 0.5). The aperture of a camera acts as a dual point of projection. It projects light rays from itself onto a light-sensitive surface, not unlike a light source in shadow projection. The object of projection, however, is not physically in between the point and the surface of projection. Instead, the object of projection exists outside of the camera, and it is transmitted to the aperture through a secondary projection. In this secondary projection, light rays from the outside world are projected toward the aperture, similar to how metaphorical light rays are projected toward a point of view in drawing projection. The aperture, therefore, operates as a drawing point of view in one projection and as a shadow light source in a second projection. In its dual (or hybrid) role, the aperture receives a projection from outside light rays and sends a projection onto a light-sensitive surface inside the camera.

The role of the aperture as a point of view renders cinema as an image-making tool, not just a shadow-making tool. The role of the aperture as a light source renders cinema as an indexical act of projection that cannot escape the limits of physical reality. Points of view in the indexical approaches to cinema that will be considered in this book are never imagined. The camera is always placed somewhere, and the point of view is always experiential, not abstract. It is impossible, for example, to capture a pure plan or axonometric view of an object in an indexical movie because foreshortening is eliminated only if the camera is placed infinitely far away from the object, which of course is impossible to do. Imagined objects may be constructed as physical sets and placed in front of a camera, but they still must exist in order to project their light rays toward the aperture.

Although all of the original movies made for this book are digitally made, they are no less indexical than actual films; the surface of an image sensor simply replaces the surface of a filmstrip. The *medium of cinema*, therefore, is understood here not

in terms of the materiality of celluloid, but rather in terms of the substance of light. Throughout this book, I generally refrain from using the term *film*. Although the term is relevant to the vast majority of movies in history, it is less relevant to contemporary cinema. I use the terms *movie* and *moviemaker* in order to challenge the misuse of the term *film* by moviemakers who use solely video. Video is different from and no less respectable than film. To equate the two is to misunderstand the integrity of both. This book celebrates video and seek to discover its inherent craft.

Readers may wonder why it is beneficial to consider linear perspective and cinema as modes of projection, as opposed to simply modes of representation. Projection, after all, is more commonly understood as a process through which movies are exhibited in screening rooms, not as a process through which drawings are created, or as a process through which indexical imagery is captured in a camera. The distinction between projection and representation, however, calls attention to the fact that drawings and movies are constructions that involve complex relationships between intentions and results. They are processes that rely on correspondence, transformation, and regeneration, not mere products of translation. Robin Evans considers projection in this way:

> What connects thinking to imagination, imagination to drawing, drawing to building, and buildings to our eyes is projection in one guise or another, or processes we have chosen to model on projection. All are zones of instability.[8]

Projection, in the end, must be understood as a complex system of multiple directionalities. Physical and/or metaphorical light travels both away from and/or toward points and objects of projection, and projections have the potential to generate new projections that may return, like boomerangs, to alter the original ones. Processes of projection become analytical only once the processes that underlie them are understood. In its most literal sense, projection has the potential to throw ideas forward.

Another aspect of projectional directionality relates to whether or not an object of projection is real or imagined. The term *architectural projection* refers to instances of projection that address the built environment, and it is generally understood to occur in two directions: from a built environment into graphic material, and from graphic material into a built environment. Again, Robin Evans puts it well:

So it is not surprising that orthographic projections are more commonly encountered *on the way to* buildings, while perspectives are more commonly encountered *coming from* buildings. This gross truth has not prevented a high degree of mixing and slippage between the two, not least because those expert in the one have tended to be expert in the other. Such slippage cannot be allowed to obscure the fact that, in architecture, orthographic projection has been the preponderant method for devising, picturing, and transmitting ideas of buildings before they are built.[9]

Although Evans does not address cinema specifically, it may be assumed that he would interpret it as another mode of projection that is primarily "encountered coming from buildings." This book seeks to reverse the conventional directionality of architectural projection suggested by Evans—that is, to promote the use of linear perspective and cinema as generators of ideas *on the way to* architecture. The ultimate goal is to consider the fluidity and the complexity of directionality in projection as a sort of dance. My fondest memories of analog drawing involve the rhythm of the movements of a parallel bar, an adjustable triangle, and a pencil during the construction of a linear perspective. It is a form of dance that generates architectural thinking, not just a final drawing. Even without drawing boards, the spirit of that dance may be embedded within the logic of the construction of drawings and movies.

Part I—Construction Logic

The Demystification of Linear Perspective

An object reflects a pattern of light on to the eye. The light enters the eye through the pupil, is gathered by the lens, and thrown on the screen at the back of the eye, the retina. On the retina is a network of nerve fibers which pass the light through a system of cells to several millions of receptors, the cones. The cones are sensitive both to light and to colour, and they respond by carrying information about light and colour to the brain. It is at this point that human equipment for visual perception ceases to be uniform, from one man to the next.

Michael Baxandal, *Painting and Experience in Fifteenth-Century Italy*

The history of linear perspective is a complicated web of empirical discoveries and geometric proofs. It has two distinct identities, one as a practical tool in the service of image-making, and one as a theoretical discipline of mathematics. While many practitioners are unaware of the theoretical underpinnings of their tool, many theoreticians are unversed in the practical implications of their inquiries. In general, artists and architects execute methods, in varying degrees of correctness, that they do not understand, and mathematicians prove the correctness of methods that they do not execute. Significant exceptions exist—such as Piero della Francesca, whose fifteenth-century treatise on linear perspective makes significant contributions to both practice and theory—but artistic and scientific approaches to linear perspective usually do not overlap. Since the early twentieth century, overlap has been virtually non-existent because both art and science have increasingly disregarded the contemporary relevance of linear perspective. While some artists and architects regard the scientific nature of linear perspective as an oppressive obstacle to subjectivity, some mathematicians question its scientific significance in light of more complex understandings of geometry. To some, linear perspective is simply a matter of history that inspires wonderment and adoration, as well as confusion and disrespect. It is an enigmatic and, to some degree, nomadic specialty. Throughout this book, I refer to linear perspective as a *drawing system* (as opposed to a *field* or *discipline*) because it belongs to no one category of thought. Like architecture itself, it is both art and science, or perhaps neither. This book seeks not only to revive linear perspective as a relevant drawing practice, but also to blur the distinction between its artistic and its mathematical identities. In the context of architectural analysis and design, practice and theory must be integral to each other.

Most treatises on linear perspective since Alberti's begin with an arrogant (and usually correct) assumption that previous treatises fail to clearly and adequately describe the drawing system.[1] In 1754, for example, Joshua Kirby published an English language treatise whose title exemplifies this propensity: *Dr. Brook Taylor's Method of Perspective Made Easy, Both in Theory and Practice. In Two Books. Being An Attempt to make the Art of Perspective easy and familiar; To Adapt it intirely to the Arts of Design; And To make it an entertaining Study to any Gentleman who shall chuse so polite an Amusement.* In short, Kirby aims to correct the pedagogical shortcomings of his predecessor and to clarify the relevance of the drawing system to a specific audience. Variations of the phrase "perspective made easy" appear in treatise titles throughout history and as recently as 1999. The assumption behind

this tendency is that the drawing system is inherently difficult to understand and that a specific method unlocks the mystery. My explanation of linear perspective disputes these implications, even as I proclaim (exactly like my predecessors) to improve upon previous efforts to explicate the drawing system. My approach is to assume that linear perspective is a perfectly simple geometric system and that an understanding of a few basic properties allows for an effortless navigation through the entire system. What follows is neither a mathematical theory nor a practical method, but rather a construction logic that demystifies linear perspective and emphasizes inherent geometric relationships between linear perspective and orthographic drawing. Although the demonstration of my construction logic resembles a step-by-step procedure, the objective is to instill a deep comprehension of the drawing system that eliminates the necessity to memorize the given steps, or even to follow them. The theoretical explanation that follows the demonstration delves into mathematical properties more than most practical treatises, but it does not include the type of geometric proofs that accompany most theoretical treatises. It will therefore please neither the practitioner, who simply wants to make a picture, nor the mathematician, who expects complete geometric substantiation. Like Kirby, I seek to articulate the significance of the drawing system to a specific audience, which in my case consists of architects and architecture students, who are particularly qualified to understand the reciprocity between linear perspective and orthographic drawing.

The Geometric System

Euclidean geometry is a spatial system that is defined by three orthogonally orientated axes, commonly referred to as the x-axis, y-axis, and z-axis. Both orthographic drawing and linear perspective are modes of projection that provide views of a Euclidean spatial system (see Figure 1.1). The point of projection (or view point) in an orthographic view is located infinitely distant from and, by implication, somehow outside of the spatial system.[2] The point of projection in a linear perspective, by contrast, is located inside the spatial system. In both orthographic and perspectival projection, the point of projection may be located at an infinite number of locations, each of which provides a unique view of the given object of projection. In an orthographic projection, the location of the point of projection does not have proper coordinates because it lies at infinity. In a perspectival projection, the location of the point of projection is literally a Euclidean point with three coordinates (x, y, z). The projection itself, however, is non-Euclidean, as it violates one of the fundamental

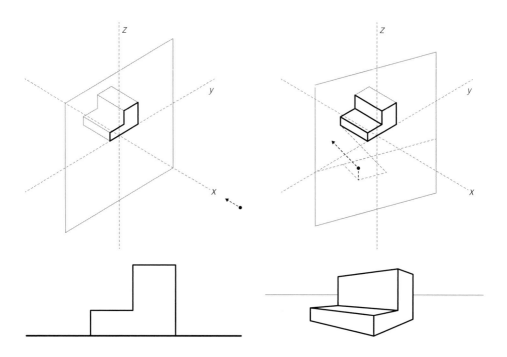

Figure 1.1: orthographic (left) and perspectival (right) projection

principles of Euclidean geometry: whereas parallel lines never converge in Euclidian geometry, parallel lines always converge in linear perspective. A linear perspective, therefore, may be understood as a non-Euclidean projection of a Euclidean space.

Linear perspective is typically understood as a subjective mode of projection, and orthographic drawing is typically understood as an objective mode of projection. Whereas the former is assumed to be phenomenological, the latter is assumed to be cognitive. This book challenges these assumptions and contends that the relationship between perspectival and orthographic projection is reciprocal, not exclusive. The point of view in a linear perspective may be drawn in plan, section, elevation, and axonometric. Likewise, orthographic drawings are embedded within a linear perspective and may be extracted from it. In Euclidean spatial systems, projective drawing promotes exchanges between interior (perspectival) and exterior (orthographic) points of view, as each type may be used to construct the other. To draw in linear perspective is to draw in plan and in elevation at the same time.

The beauty of this reciprocity eludes even most architects and architecture students, despite their familiarity with both modes of projection. This is because conventional explanations of linear perspective involve opaque and overly complex methods of construction that obscure the fundamental (and rather simple) geometric laws that underlie the drawing system. In this chapter, I remove the veil of mystery and lay bare the principles that underlie the drawing system. Chapter 3 further explores how a multitude of linear perspective construction methods all obey the same principles. The apparent differences lie in the ways in which the drawing system in entered and the ways through which it is navigated. There is, however, only one system, and a thorough understanding of the quasi-Euclidean nature of linear perspective eliminates the need to memorize any particular method.

Definitions and Parameters

Throughout this book, I will use specific terms to refer to various components and properties of linear perspective, and it is important to clarify the precise meaning of my usage of these terms. Many of the terms are common to other methods and explanations of the drawing system, but some of them are used in a way that diverges from common usage. Still others are unique to this book. Readers may find it useful to refer to the diagrams and drawings on pages 28–31 while they review the definitions. The diagrams illustrate the definitions in isometric projections in order to better communicate the relative locations of the components of the drawing system. It is important to note that the definitions apply only to linear perspectives in which the primary angle of viewing is parallel to the ground plane. This is the most commonly executed type, and the demonstration of the construction logic is an example of it; however, I include the phrase, "in the most basic orientation of linear perspective," repeatedly in this chapter in order to emphasize that there are other ways to operate the drawing system. At the end of this chapter, several construction variables will be considered, some of which, like perspectival projections in which the primary angle of viewing intersects the ground plane, adhere to slightly modified definitions. These more complex constructions may require more time and concentration than a basic construction, but no variable is too complex to address once the basic principles of linear perspective are understood. In all cases, the construction logic never varies because the mathematical laws never change.

The **ground plane** (in the most basic orientation of linear perspective) is a plane that is defined by the *x*-axis and the *y*-axis. Its position is determined arbitrarily, and this position sets the zero-value of the *z*-axis. Points above the ground plane have positive *z*-values, and points below it have negative *z*-values.

The **measuring plane** (in the most basic orientation of linear perspective) is a plane that is defined by the *x*-axis and the *z*-axis, so it is perpendicular to the ground plane. Its position is determined arbitrarily, and this position sets the zero-value of the *y*-axis. Points in front of the measuring plane have negative *y*-values, and points behind it have positive *y*-values. Its front and back are determined by the location of the viewing point (see below). In other methods, the measuring plane is known as the *picture plane*. Measuring plane is a more useful term because it emphasizes the fact that it is the only plane in a perspectival projection in which dimensions may be measured to scale. The term also deemphasizes the pictorial assumptions of linear perspective. The measuring plane is not a one-way window onto a scene, and objects on both sides of it may appear on it.

A **measuring point** is a point that lies on the measuring plane.

The **ground line** (in the most basic orientation of linear perspective) is the intersection of the ground plane and the measuring plane. Because the ground line lies within the measuring plane, its points and segments may be measured to scale. The ground line corresponds to the **baseline** in a linear perspective.

The **viewing point** is the point of projection in a linear perspective. In other methods, it is referred to as the *station point* and is typically described only in plan through an *x*-coordinate and a *y*-coordinate. A viewing point is, in fact, described in both plan and elevation through three coordinates (*x*, *y*, *z*). The position of the viewing point is determined arbitrarily, and this position sets the zero-value of the *x*-axis. Points to one side of the viewing point have negative *x*-values, and points to the other side of the viewing point have positive *x*-values (either side may be positive or negative). The viewing point may not be located on the measuring plane, and the side of the measuring on which it lies is referred to as the front of the measuring plane. It therefore always has a negative *y*-value. The viewing point may have any *z*-value.

The **origin** of the linear perspective is located at the coordinates (0, 0, 0).

Lines that intersect both the viewing point and the measuring plane and (in the most basic orientation of linear perspective) maintain a constant z-value are **viewing lines**.

The **viewing ray** is the viewing line that is perpendicular to the measuring plane. As will be discussed in Chapter 3, Alberti refers to this ray as the "prince of rays."

The **horizon plane** is a plane that contains the viewing lines and (in the most basic orientation of linear perspective) is parallel to the ground plane. The horizon plane is the only plane in the Euclidean spatial system that appears as a horizontal line in a linear perspective.

The **horizon line** is the infinitely distant edge of the horizon plane. It consists of an infinite number of **vanishing points**, which are theoretical points that have only two Euclidean coordinates (x, z). The y-values of vanishing points cannot be described because they lie at infinity.

Converging lines are a set of lines that are parallel to each other in plan, not parallel to the measuring plane in plan, and (in the most basic orientation of linear perspective) maintain a constant z-value. In linear perspective, all lines in a given set of converging lines converge to (or vanish at) a single vanishing point.

Orthogonals are converging lines that are perpendicular to the measuring plane in plan. In linear perspective, orthogonals converge to the **central vanishing point**, which lies at the theoretical intersection of the viewing ray and the horizon line.

Horizontals are lines that are parallel to each other in plan, parallel to the measuring plane in plan, and (in the most basic orientation of linear perspective) maintain a constant z-value. In linear perspective, horizontals do not converge to the horizon line, and they always appear as horizontal lines.

Verticals are lines that maintain a constant x-value and y-value and that have a varying z-value. In linear perspective, verticals always appear as vertical lines.

Diagonals are lines that have varying x-values, y-values, and z-values. **Horizontal diagonals** are lines that have varying x-values and z-values. Horizontal diagonals are parallel to the measuring plane.

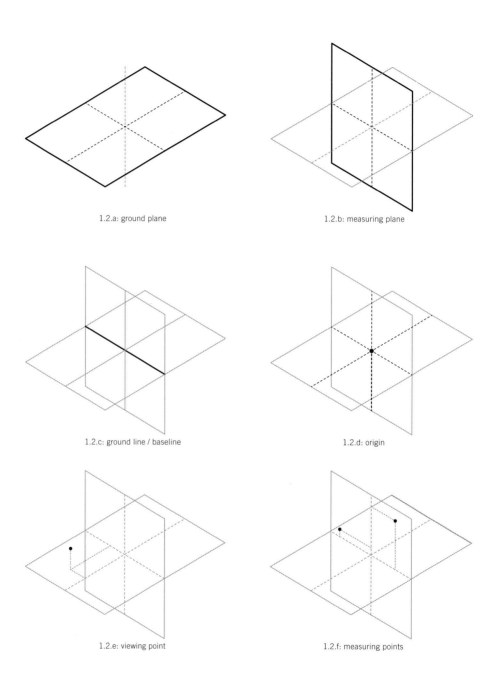

1.2.a: ground plane

1.2.b: measuring plane

1.2.c: ground line / baseline

1.2.d: origin

1.2.e: viewing point

1.2.f: measuring points

Figure 1.2: components of linear perspective

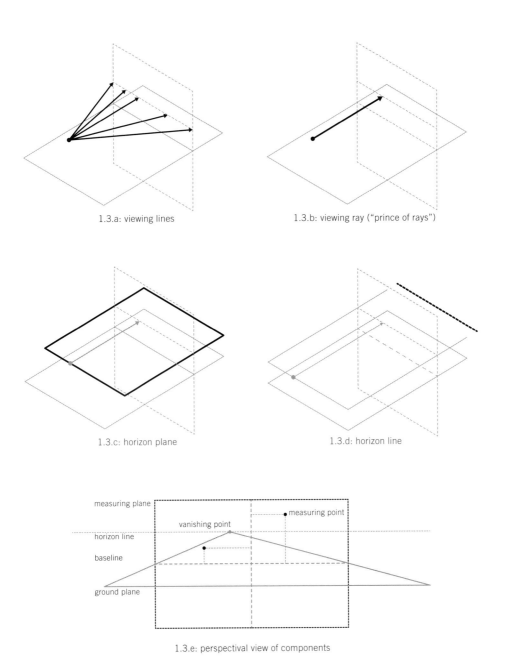

1.3.a: viewing lines

1.3.b: viewing ray ("prince of rays")

1.3.c: horizon plane

1.3.d: horizon line

measuring plane

measuring point

vanishing point

horizon line

baseline

ground plane

1.3.e: perspectival view of components

Figure 1.3: components of linear perspective

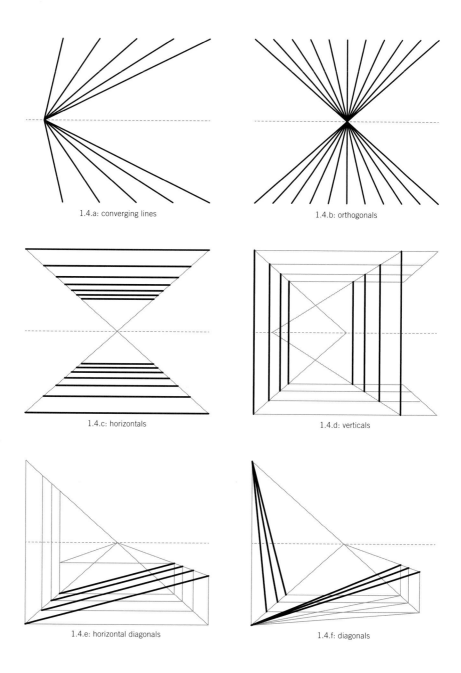

1.4.a: converging lines

1.4.b: orthogonals

1.4.c: horizontals

1.4.d: verticals

1.4.e: horizontal diagonals

1.4.f: diagonals

Figure 1.4: images of lines

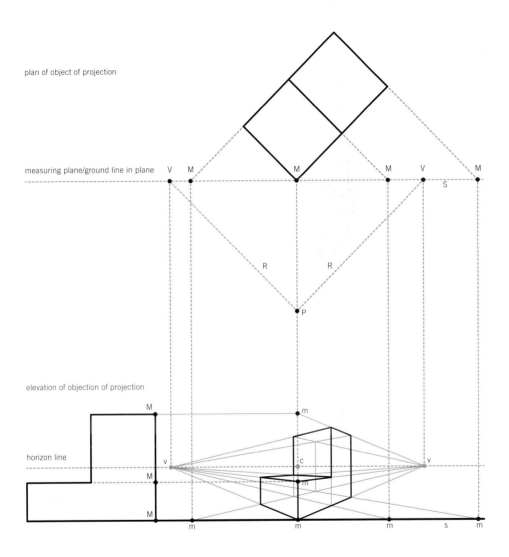

plan of object of projection

measuring plane/ground line in plane

elevation of objection of projection

horizon line

S: ground line in plan
s: baseline in perspective

M: measuring points in plan and elevation
m: measuring points in perspective

P: viewing point in plan
R: viewing rays parallel to sides of the object of projection

V: points of intersection between viewing rays and measuring plane
v: vanishing points
c: central vanishing point and viewing point in elevation

Figure 1.5: rebatment

The Demonstration of the Logic

In order to distinguish between the geometric elements of an orthographic drawing and those of a linear perspective, a terminology that is commonly used in mathematical treatises on linear perspective will be adopted. Whereas orthographic drawings contain **points** and **lines**, linear perspectives contain **images of points** and **images of lines**. The figures in this book use uppercase letters to denote points and lines and lowercase letters to denote images of points and images of lines. *A* is a point in an orthographic drawing, and *a* is the image of that point in a linear perspective. This linguistic distinction between a geometric element and its image emphasizes the inherent reciprocity between orthographic and perspectival projection.

The image of a point is always a point, and the construction logic demonstrated in this book is based on the strategic location of the images of points. All objects of projection may be described by a collection of orthographic vertices, each of which is a Euclidean point that corresponds to an image of a point within a linear perspective of that object. The method, therefore, locates the images of points that describe the vertices of an object of projection. Once the images of the vertices are located, the image of the object is achieved through a simple process of connecting the dots (i.e., drawing lines between the images of the points that define the vertices). Perspectival projections of complex objects may require greater concentration and organization than those of simple objects, but the construction logic never varies. Images of points on regular and irregular objects are mathematically identical.

At least two orthographic views of an object of projection are required to construct a linear perspective of that object. The precise number of views depends upon the management and the thoroughness of the views. Together, the views must describe the three Euclidean coordinates (x, y, z) of every point that is required to complete the construction. There are multiple correct ways to manage the orthographic views required for a correct construction. Normative plans and elevations may be used or coordinates may be extracted from normative drawings and reassembled in a less obvious format. Views may be layered on top of each other or aligned in various types of adjacencies. The overall composition of the perspectival and orthographic views is referred to as the **rebatment** of the method. In this book, all constructions adhere to a straightforward rebatment that elucidates the reciprocity between orthographic drawing and linear perspective (see Figure 1.5). Two isolated views

(one plan and one elevation) describe the three coordinates of the points that are needed in order to complete the construction. The plan view lies at the top of the construction (directly above the perspectival projection), and the elevation view lies on one side of the construction (directly adjacent to the perspectival projection). The perspectival projection itself appears in the center of the composition. The baseline of the perspective aligns horizontally with the ground line in the elevation and vertically with the measuring plane in the plan.

The constriction process of a linear perspective begins with a series of decisions regarding construction parameters. Construction variables are arbitrary decisions that do not affect the construction logic in any way. Three primary parameters apply to all methods and explanations of the drawing system, and the variables of these parameters dramatically affect the nature of the final drawing. The first parameter is the location and orientation of the measuring plane with respect to the object of projection. The second parameter is the location of the viewing point in plan. These two parameters determine which faces of the object will appear in the drawing, as well as their relative foreshortening (or distortion). The third parameter is the location of the viewing point in elevation, which also determines the height of the horizon plane and the horizon line above the ground plane. This height is generally understood to be the eye-level of a human observer, but that is a pictorial assumption. Most artists and architects calibrate the construction variables of a linear perspective in order to maximize realism and minimize distortion; however, linear perspective may be understood as an analytical tool, not a pictorial device, in which case decisions regarding the variables must complement specific analytical objectives. The height of the horizon line, for example, is a variable with great analytical potential.

The following illustrated step-by-step process introduces the principles of the construction logic. After this demonstration, the construction logic will be investigated in a more theoretical (or mathematical) manner. The practical demonstration precedes the theoretical explanation because readers will find it easier to comprehend; however, it is critical not to rely on the demonstration and to forego the theory. The practice and the theory are parallel components of a broader argument that relies on cross-referencing. I insist that the beauty of the drawing system lies in its simplicity, but to see its simplicity requires a full understanding of how the method and the theory complement each other, and this requires patience and perseverance. Expect frustration, but do not be discouraged by it. The reward is significant.

Figure 1.6: the orthographic description of the object of projection

The plan and elevation views that guide the construction process depict the object of projection as transparent. The plan view collapses all of the relevant plan lines onto a single plane, and the elevation view collapses all of the relevant elevation lines onto a single plane. These two "base drawings" provide all of the necessary coordinate information necessary to perform the construction.

The construction occurs in two phases. The objective of the first phase is to describe the image of the plan as if it were on the ground plane. The objective of the second phase is to describe the volume of the object in three dimensions. Advanced practitioners typically consider all three axes simultaneously, but the following strategy helps beginners to recognize the underlying reciprocity between orthographic drawing and linear perspective.

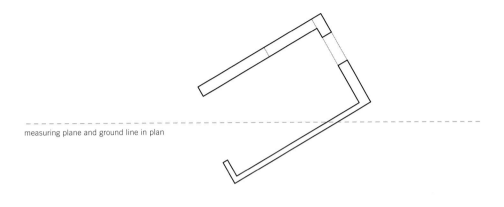

measuring plane and ground line in plan

• viewing point in plan

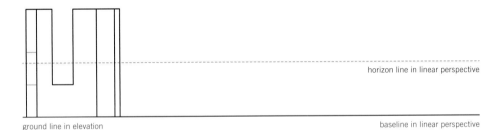

horizon line in linear perspective

ground line in elevation

baseline in linear perspective

Figure 1.7: establishing the parameters

Before the construction of the perspectival projection may begin, it is necessary to establish the parameters of the drawing: the location and orientation of the object of projection with respect to the measuring plane; the location of the viewing point with respect to the object of projection and measuring plane; and the height of the horizon line. These parameters interact with each other, and there is no correct order in which to establish the values of them.

It is important to negotiate between the variables of these parameters, and it is wise to construct the images of a few primary lines that describe the object of projection in advance of the construction of the full drawing. A few quick tests may prevent unwelcome distortions and other surprises.

Figure 1.8: locating a vanishing point

Given this rebatment, simple projective procedures locate the vanishing points that are necessary in order to construct the drawing. Because this object of projection is described by two sets of parallel lines in plan, two vanishing points are required for the construction, one for each set of lines.

In order to locate a vanishing point that corresponds to a set of parallel lines in plan, the viewing line that belongs to that set of parallel lines is projected from the viewing point to the measuring plane in plan.

From the point of intersection between the viewing line and the measuring plane, a vertical line is projected to the horizon line. The intersection of this vertical line and the horizon line is the location of the vanishing point.

Figure 1.9: locating a vanishing point

The second vanishing point is located in the same manner as the first. Indeed, given this rebatment, the process is the same for all sets of parallel lines in the geometric system that are parallel to the ground plane.

Later in this chapter, the geometric properties of the rebatment that allow for the location of vanishing points in this manner will be explored in more depth. For now, the legitimacy of the process must be taken for granted.

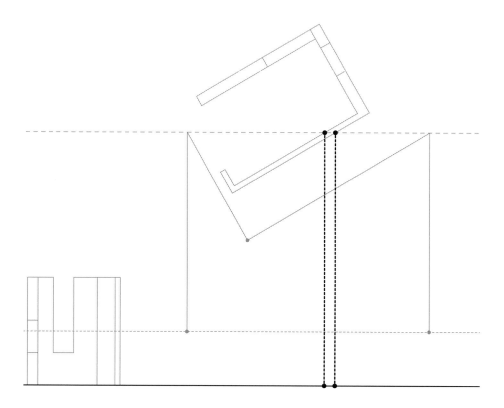

**Figure 1.10: phase one, step one:
project the measuring points on the ground line onto the baseline**

Measuring points, in both orthographic projection and linear perspective, are points that lie within the measuring plane. All orthographic measuring points correspond directly to all perspectival measuring points, and, in this rebatment, these points may be projected directly onto the linear perspective (or they may be measured and plotted directly onto the linear perspective).

When the plan of the object of projection, as in this case, lies on the ground plane, the points of intersection between the plan and the measuring plane lie on the ground line and therefore also on the baseline in the linear perspective. The measuring points on the ground line in orthographic projection happen to correspond to the measuring points on the baseline in linear perspective. In this plan, two points intersect the measuring plane (and ground line), and these points may be projected onto the baseline in the perspective.

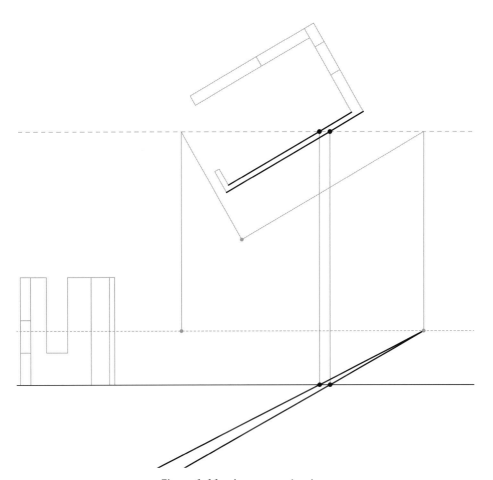

Figure 1.11: phase one, step two:
project the images of the lines that intersect the measuring points

The lines in the plan that contain the two measuring points are parallel to the viewing line that was projected in Figure 1.8 in order to locate the vanishing point on the right side of the drawing; the images of these lines therefore converge to that vanishing point. The images of these lines may be drawn simply by projecting lines from the vanishing point on the horizon line through the measuring points on the ground line.

Because these lines extend in front of the measuring plane in plan, the images of these lines must be extended in front of the baseline in the linear perspective. The points in front of the baseline where the lines end are not yet known (and these points cannot be measured), so the lines are extended without a sense of how long they need to be.

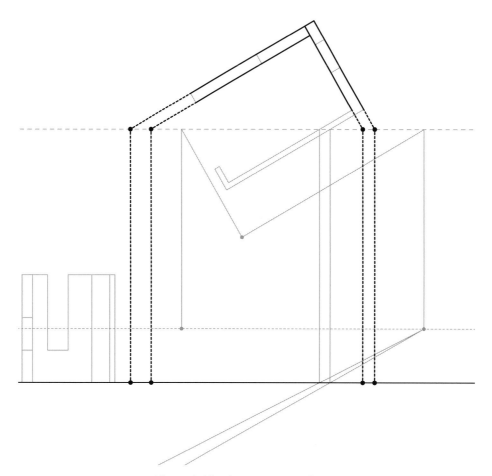

Figure 1.12: phase one, step three:
project lines in plan in order to locate "surrogate measuring points"

No other points on the plan of the object of projection lie on the measuring plane, but lines of the plan may be projected (or extended) until they intersect the measuring plane. These extensions will be referred to as "surrogate line segments." The points of intersection between the measuring plane and the surrogate line segments create "surrogate measuring points."

Surrogate measuring points on the ground line in orthographic projection may be projected onto the baseline in the linear perspective, similar to how the "normal" measuring points were projected onto the baseline in phase one, step one.

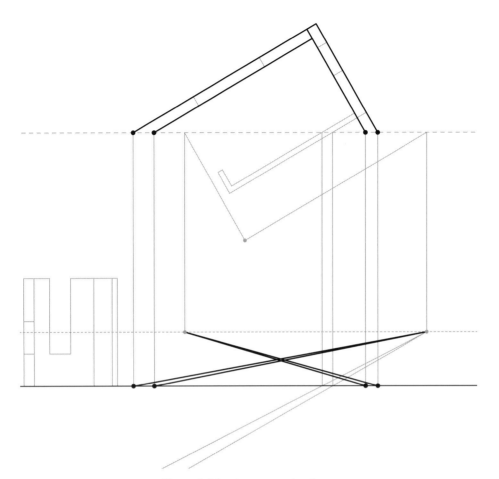

Figure 1.13: phase one, step four:
project the images of lines from the "surrogate measuring points"

Two of the surrogate line segments are parallel to the viewing line that corresponds to the vanishing point on the right side of the drawing (see Figure 1.8); the images of these lines therefore converge to that vanishing point. The other two surrogate line segments are parallel to the viewing line that corresponds to the vanishing point on the left side of the drawing (see Figure 1.9); the images of these lines therefore converge to that vanishing point. As in phase one, step two, the images of all of these lines may be drawn simply by projecting lines from the corresponding vanishing points on the horizon line through the surrogate measuring points on the ground line.

Because these lines describe portions of the object of projection that lie entirely behind the measuring plane in plan, there is no need to project the images of the lines in front of the measuring plane/baseline in the linear perspective.

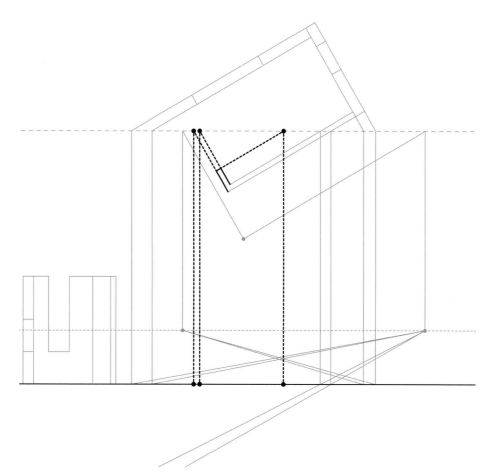

Figure 1.14: phase one, step five:
project lines in plan in order to locate "surrogate measuring points"

The procedures in this step are identical to the ones performed in phase one, step three, with one exception: the surrogate line segments lie in front of the measuring plane in plan instead of behind it.

Lines that describe the object of projection in plan, in fact, may be extended in both directions with respect to the measuring plane in order to locate surrogate measuring points. The measuring plane is not a one-way picture window, but rather a two-sided datum.

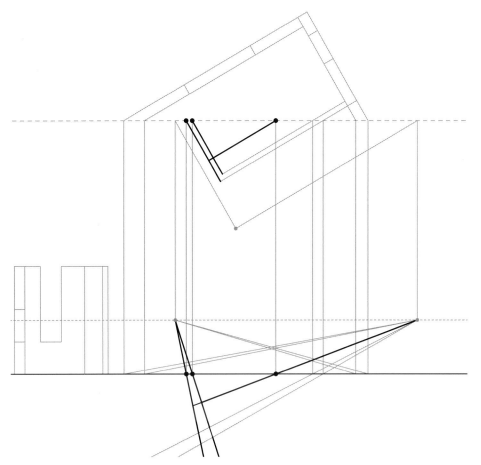

Figure 1.15: phase one, step six:
project the images of lines from the "surrogate measuring points"

The procedures in this step are identical to the ones performed in phase one, step four, again with one exception: the lines that describe the object of projection lie in front of the measuring plane in plan, so the images of the lines need to be projected in front of the measuring plane/baseline in the linear perspective.

At this point, the image of the footprint of the objection of the projection is beginning to emerge, and the implications of the decisions that were made in the initial set up may be judged. If the image of the footprint does not fulfil the objective of the drawing, it may be necessary to reset the parameters and to begin a new drawing construction. In this case, the image suits the objective of the drawing, so the process continues.

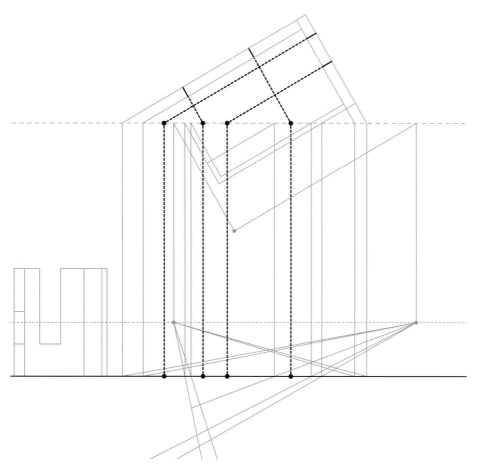

**Figure 1.16: phase one, step seven:
project lines in plan in order to locate "surrogate measuring points"**

The procedures in this step are identical to the ones performed in phase one, steps three and five.

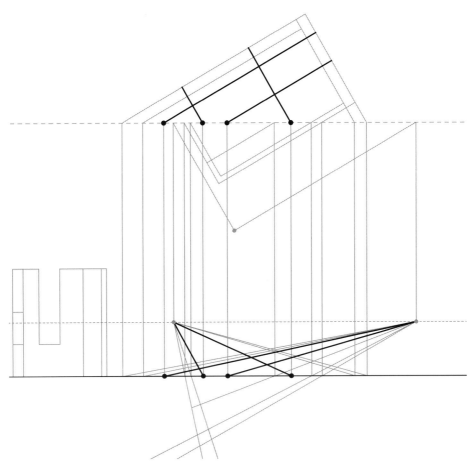

Figure 1.17: phase one, step eight:
project the images of lines from the "surrogate measuring points"

The procedures in this step are identical to the ones performed in phase one, steps four and six.

By now, a basic property of linear perspective should be clear: the intersections of lines in orthographic projection correspond directly to the intersections of the images of the same lines in linear perspective.

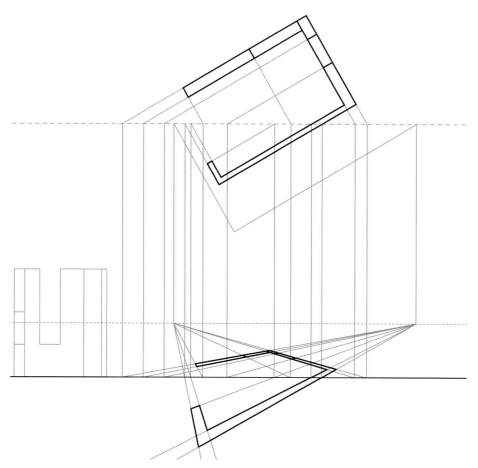

Figure 1.18: phase one clean up: redrawing the lines

Once the images of the lines that describe the entire plan of the object of projection have been projected, those lines may be redrawn in order to construct a clean image of the plan.

It is important to construct new lines on top of the construction lines and to place them on a separate layer in the digital drawing file (or on a separate sheet of paper in an analog drawing environment). To delete (or to erase) construction lines is to undermine the analytical potential of the drawing system. As a general rule, all construction lines should be preserved so that they may be used later for analytical and creative purposes.

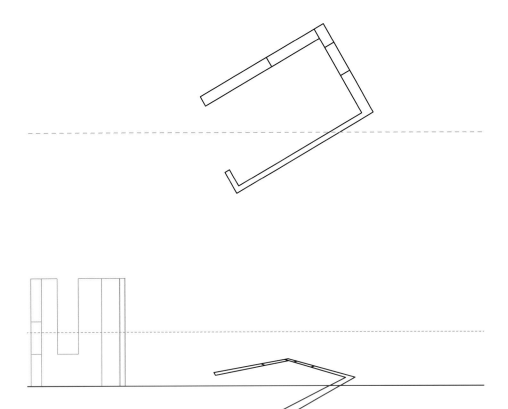

Figure 1.19: phase two set up: hiding the construction

Linear perspective relies on precision, and lines from previous steps may be mistaken for lines in a current step. Before the second phase begins, the layer in the digital drawing file that contains the construction lines from the first phase should be hidden (or the sheet of paper that contains these lines in an analog drawing environment should be covered or removed). A clean copy of the plan helps to prevent confusion and to avoid errors.

Similarly, in a digital environment, it is essential to monitor the snap settings, so that the ends of new lines do not snap to the wrong point. Even a miniscule misalignment may reek havoc on a construction process.

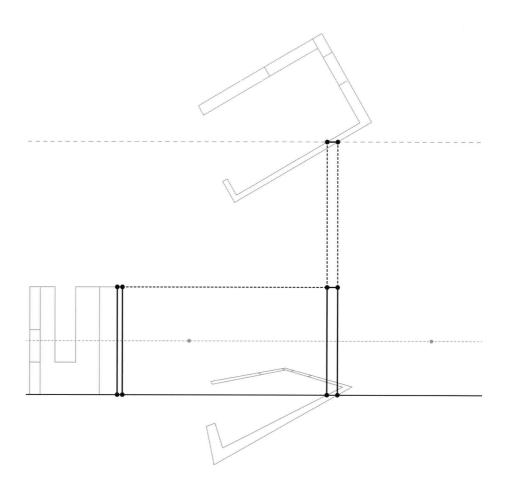

**Figure 1.20: phase two, step one:
project measuring points onto the elevation into the perspective**

In linear perspective, the measuring plane operates as a two-dimensional cutting plane similar to an orthographic section view. The object of projection, in a sense, is cut by the measuring plane, and the resulting edge of the cut may be projected (or measured and plotted) directly within the linear perspective. Points within this section-cut are the only points within the object of projection that may be measured in the linear perspective. All other points must be located through acts of perspectival projection.

In this case, the section-cut is described by four primary measuring points, two of which lie on the bottom edge of the object of projection (see phase one, step one), and two of which lie on the top edge of the object of projection. The z-value of the latter may be projected from the elevation in this rebatment (or measured and plotted).

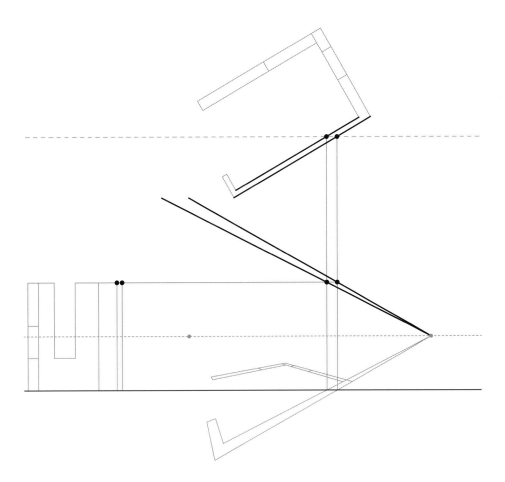

Figure 1.21: phase two, step two:
project the images of lines that intersect the measuring points

The procedures in this step are identical to the ones performed in phase one, step two, except for the fact that the projected images of lines describe a top edge of the object of projection, as opposed to an edge on the base of the object.

It is not necessary to locate a new vanishing point because the lines that describe the top edge of the object of projection are parallel in plan to the lines that describe the bottom edge of the object of projection. All lines that are parallel to each other in plan and that have a constant z-value correspond to the same vanishing point. If the lines that describe the top edge of the object of projection were not parallel to the ones that describe the bottom edge (or, if they were not parallel to the ground plane) it would be necessary to locate additional vanishing points.

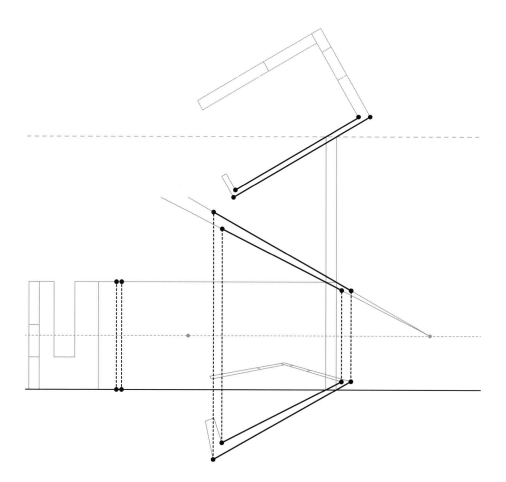

Figure 1.22: phase two, step three:
project the images of vertical edges of the object of projection

In a linear perspective in which the viewing ray is parallel to the ground plane, the images of vertical lines are vertical lines—that is, lines that intersect the ground plane at 90° in orthographic projection (such as the ones that describe the vertical edges of the object of projection) correspond to images of lines that intersect the baseline at 90° in linear perspective.

The images of the vertical edges of the object of projection, therefore, may be described by vertical lines that are projected from the images of the vertices of the plan. In this step, vertical lines are projected from the images of four vertices that describe the image of a wall within the object of projection. The intersection of these vertical lines and the lines projected in the previous step describe the images of the vertices on the top edge of this wall.

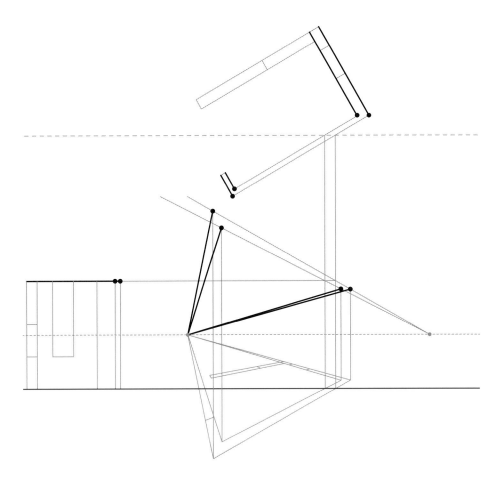

Figure 1.23: phase two, step four:
project the images of lines that intersect the newly discovered vertices

The newly discovered vertices on the top edge of the wall allow for the projection of the images of lines that describe the top edges of two more walls of the object of projection.

Again, it is not necessary to locate a new vanishing point because the lines that describe these edges have a constant z-value, and they are parallel in plan to the lines that correspond to the vanishing point on the left side of the drawing,

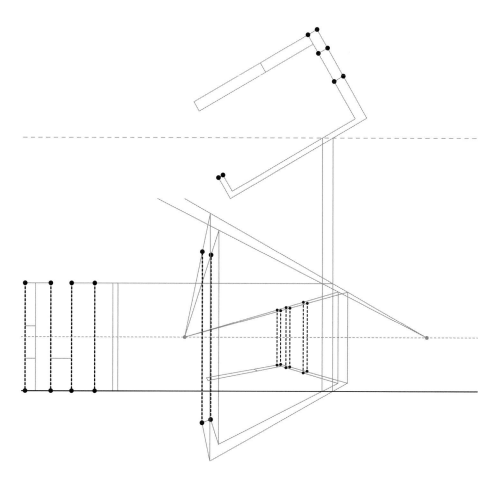

Figure 1.24: phase two, step five:
project the images of vertical edges of the object of projection

The procedures in this step are identical to the ones performed in phase two, step three.

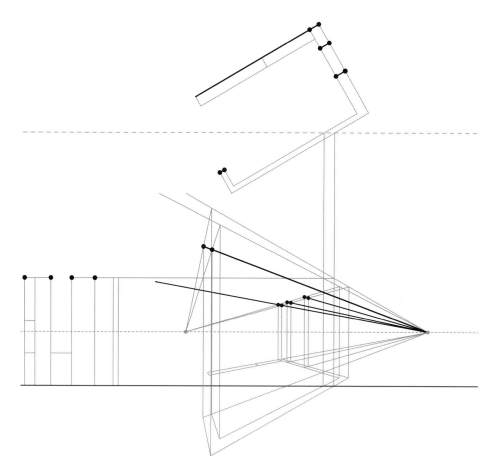

**Figure 1.25: phase two, step six:
project the images of lines that intersect the newly discovered vertices**

The procedures in this step are identical to the ones performed in phase two,
step four.

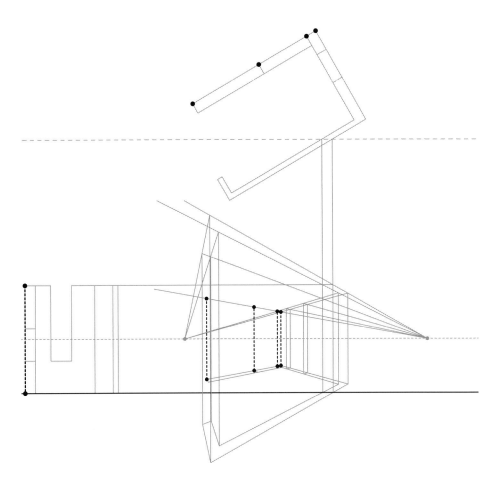

**Figure 1.26: phase two, step seven:
project the images of vertical edges of the object of projection**

The procedures in this step are identical to the ones performed in phase two, steps three and five.

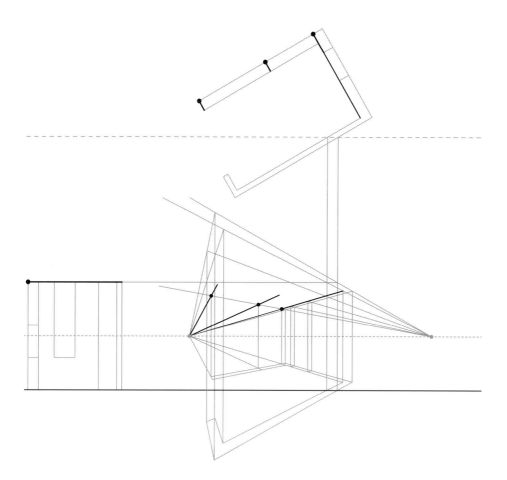

**Figure 1.27: phase two, step eight:
project the images of lines that intersect the newly discovered vertices**

The procedures in this step are identical to the ones performed in phase two, steps four and six.

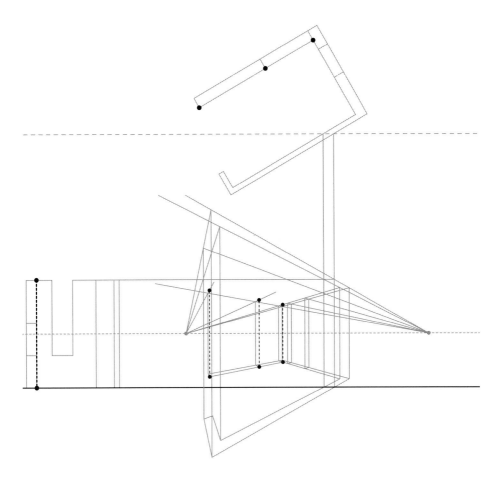

Figure 1.28: phase two, step nine:
project the images of vertical edges of the object of projection

The procedures in this step are identical to the ones performed in phase two, steps three, five, and seven.

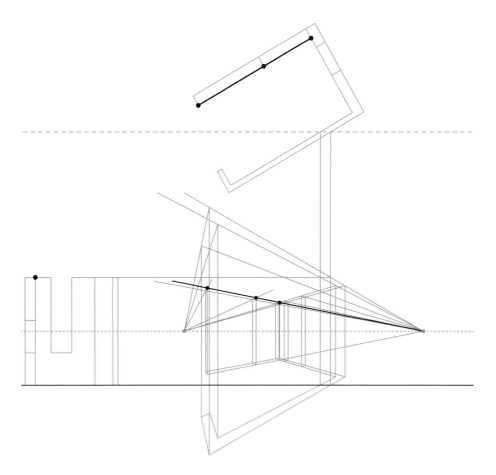

**Figure 1.29: phase two, step ten:
project the images of lines that intersect the newly discovered vertices**

The procedures in this step are identical to the ones performed in phase two, steps four, six, and eight.

At this point, the entire overall volume of the object of projection has been described in linear perspective.

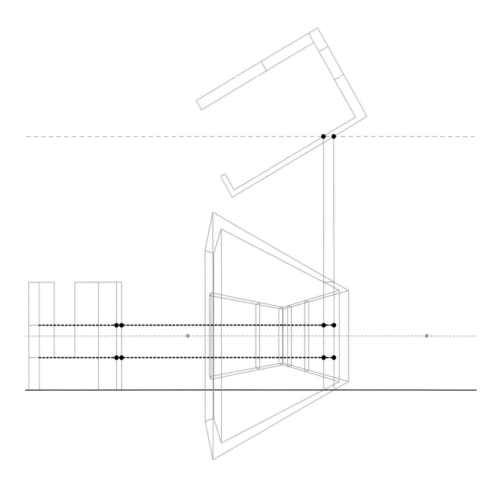

Figure 1.30: phase two, step eleven:
project measuring points on the elevation into the perspective

The next step is to describe the heights of the window openings within the object of projection. In order to measure these heights, it is necessary to return to the section-cut on the measuring plane, as the measuring plane is the only location within a linear perspective where measurements are accurate.

The fact that these openings do not lie on the measuring plane is irrelevant. The procedure is to locate the necessary heights on the measuring plane and then to project these heights into their relevant locations within the object of projection.

In this step (similar to phase two, step one), the heights of the openings are projected from the elevation onto the measuring plane of the linear perspective (they also could have been measured and plotted onto the measuring plane).

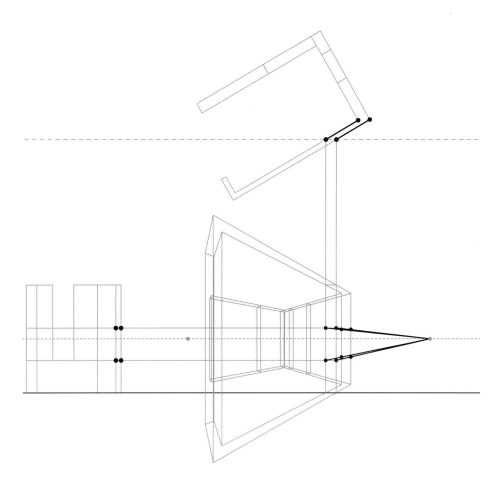

**Figure 1.31: phase two, step twelve:
project the images of lines that intersect the measuring points**

The procedures in this step are identical to the ones performed in phase two, step two, except for the fact that these images of lines do not correspond to actual edges of the object of projection, but rather to regulating lines that correspond to the heights of the window openings.

The lines here trace the heights of the window openings onto the object of projection. Every point along these lines has the same z-value. The intersections of these lines and the lines that describe the vertical edges of the object of projection describe the images of vertices on the object at the height of the window openings.

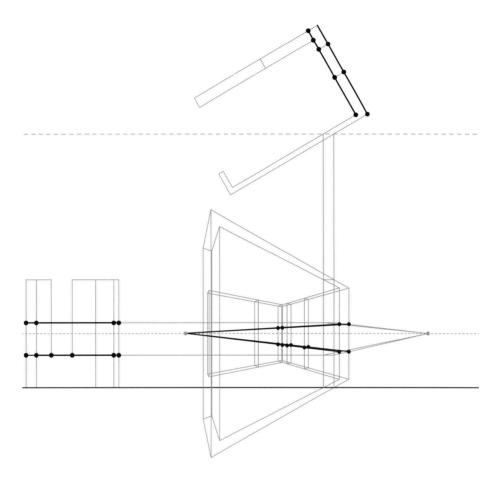

**Figure 1.32: phase two, step thirteen:
project the images of lines that intersect vertices**

Lines may be projected from the newly discovered images of vertices to the appropriate vanishing point in order to continue the tracing of the heights of the window openings onto the object of projection.

Once again, the intersections of these lines and the lines that describe the vertical edges of the object of projection describe the images of vertices on the object at the height of the window openings.

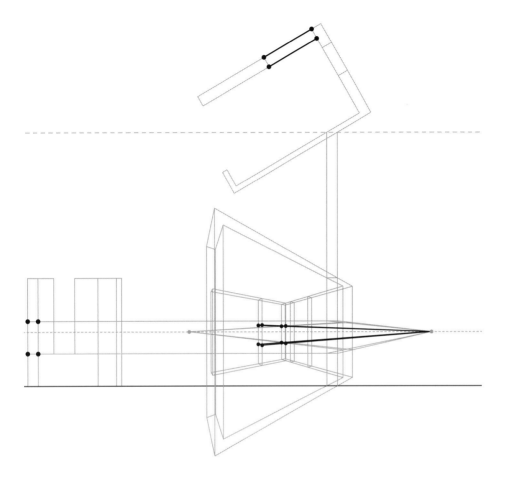

**Figure 1.33: phase two, step fourteen:
project the images of lines that intersect vertices**

The procedures in this step are identical to the ones performed in the previous step. At this point, all of the relevant regulating lines relating to the heights of the window openings have been projected onto the object.

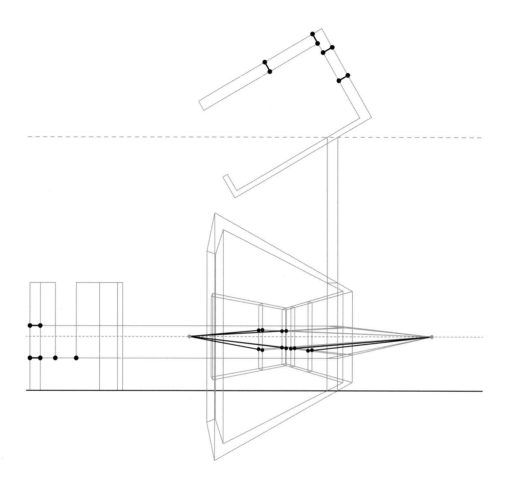

**Figure 1.34: phase two, step fifteen:
final description of the window openings**

The final step is to describe the edges of the window openings through the
projection of the images of lines from the vertices of the openings to the
appropriate vanishing point.

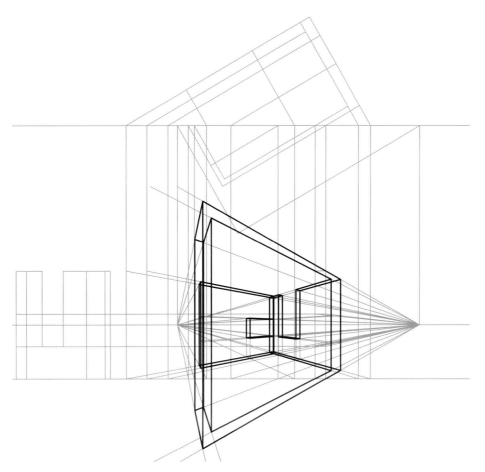

Figure 1.35: completed drawing and its construction lines

In this drawing, the object of projection is depicted in a manner that is similar to the way in which digital models are depicted in wireframe mode (as a transparent object). Every line that describes the object, as well as every construction line, may be rendered (or hidden) in various ways in order to communicate a specific understanding of the object of projection

Chapter 5 explores how to render both an object of projection and its construction lines in analytical (i.e., non-literal) manners.

Theory of the Location of Points

Now that the basic construction logic has been demonstrated in operation, the deeper meaning behind it may be examined. Figures 1.36 and 1.37 depict a cube in various orthographic, isometric, and perspectival views. The goal is to fully understand the reciprocity between the orthographic cube and the perspectival cube. How are the images of points located in a more general sense, and why does it work?

Points on the cube that lie on the measuring plane, such as A and C, are measuring points. The images of measuring points, such as a and c, are easy to locate. The drawing system allows their x and z coordinates to be measured with respect to the origin of the linear perspective and plotted directly onto the measuring plane within the perspectival projection. More often, as in Figures 1.10 and 1.20, measuring points are located through the use of orthographic projective procedures within a rebatment; the plan locates the x-coordinate, and the elevation locates the z-coordinate.

Points on the cube that do not lie on the measuring plane, such as B, are somewhat more complex. The images of these points, such as b, cannot be measured or projected orthographically in a rebatment because depth in linear perspective is foreshortened (or distorted). It is therefore necessary to discover the location of b indirectly. This is achievable through the use of two simple geometric properties, both of which were applied throughout the preceding demonstration.

> Property One: in orthographic drawing, two non-parallel lines intersect each other at one and only one point; in linear perspective, the images of two non-parallel lines intersect each other at one and only one image of a point.

> Property Two: in orthographic drawing, two points define one and only one line; in linear perspective, the images of two points define one and only one image of a line.

In Figures 1.36 and 1.37, lines M and N intersect at point B. According to Property One, the images of these lines, m and n, will intersect at the image of point B, which is b. LInes M and N are convenient choices because they coincide with edges of the object of projection; however, any two lines that intersect both point B and the measuring plane are equally valid; the horizontal line through point B is invalid because it does not intersect the measuring plane. The construction of lines m and n, which will reveal the location of point b, relies on Property Two. Points A and P

describe line *M*, and points *C* and *Q* describe line *N*; points *a* and *p* will therefore describe line *m*, and points *c* and *q* will therefore describe line *n*; however, it is impossible to locate *p* and *q* because *P* and *Q* do not lie on the measuring plane and may not be located without the application of Property One. The two properties seem to create an endless loop: in order to locate the image of a point that does not lie on the measuring plane, it is necessary to construct the images of two lines; in order to construct the image of a line, it is necessary to locate the images of two points, only one of which may be a measuring point.

Fortunately, an exceptional type of point in the drawing system provides an escape from the loop. Vanishing points, like measuring points, may be located without a measurement of depth. Lines *M* and *N* theoretically extend to infinity and meet on the horizon line; they therefore contain the theoretical points *VM* and *VN* respectively. These "points" may not be drawn orthographically because they lie at infinity, but they may be diagrammed. Their perspectival counterparts, *vm* and *vn*, are not precisely images of points because, again, *VM* and *VN* are not precisely points. Regardless, *vm* and *vn* may be located in a linear perspective through direct projective procedures (see Figures 1.8 and 1.9). The vanishing points, *vm* and *vn*, take the place of *a* and *p* in Property Two and provide the second point that allows for the construction of *m* and *n*. It is useful, therefore, to modify that property as follows:

> Property Two: in orthographic drawing, two points define one and only one line; in linear perspective, the images of two points define one and only one image of a line. If necessary, a vanishing point may take the place of the image of one of the two images of a point.

The Mystery of the Vanishing Point

So far, the projective method to locate vanishing points has been used without an explanation of why it works. Although a full mathematical proof of the operation is beyond the scope of this book, a more detailed analysis of the operation helps to demystify the drawing system. Most practical explanations of linear perspective provide short-cut operations without such explanations, but the goal here is to instill a deep understanding of the drawing system, not simply a working knowledge of it. For artists and architects who seek to make pictures, the abstraction of the drawing system is surely unnecessary. For architects who seek to exploit the analytical potential of the drawing system, abstraction is fundamental.

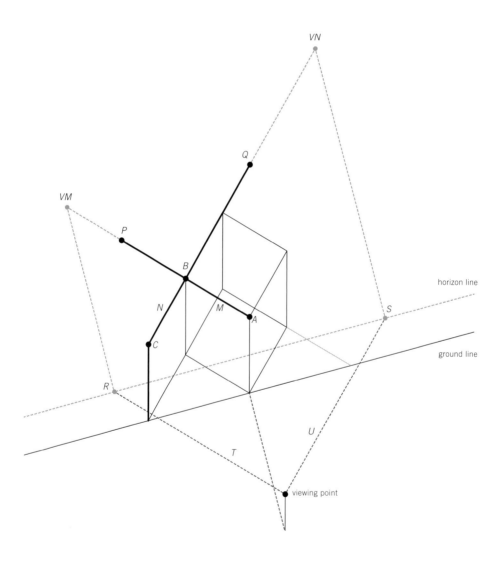

Figure 1.36: location of points isometric

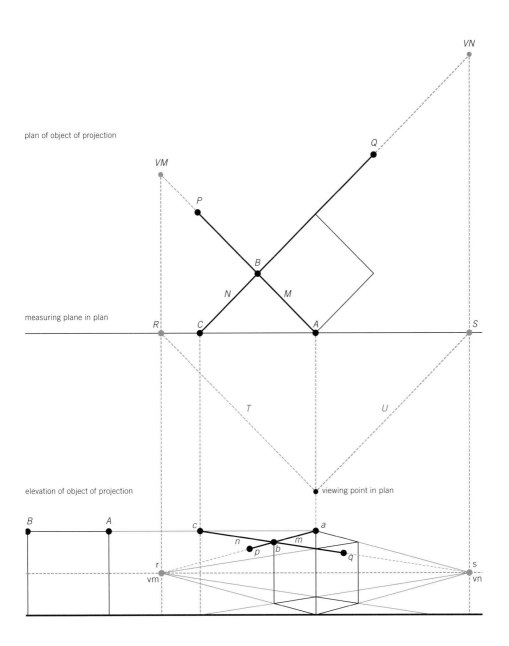

plan of object of projection

measuring plane in plan

elevation of object of projection

viewing point in plan

Figure 1.37: location of points rebatment

In Figures 1.36 and 1.37, lines *T* and *U* are viewing lines that correspond, respectively, to the sets of converging lines that contain lines *M* and *N*: *T* is parallel to *M*, and *U* is parallel to *N*. Points *R* and *S* are the points of intersection between these two viewing lines and the measuring plane. Points *R* and *S* are measuring points, and their images (points *r* and *s*) may be projected or plotted directly onto the measuring plane in the linear perspective. According to the procedures in Figures 1.8 and 1.9, the vanishing point *vm* (which corresponds to lines *T* and *M*) and the vanishing point *vn* (which corresponds to lines *U* and *N)* coincide, respectively, with points *r* and *s*. The implications of this coincidence are significant. If *vm* and *r* are coincident, then the image of line *T* is a single point. Line *T* begins at the viewing point, passes through *R*, and extends to infinity (*VM*); in perspective, line *t* begins at the viewing point, passes through *r*, and extends to infinity (*vm*). The images of all viewing lines are therefore single points, which means they intersect the measuring plane at 90° and never intersect each other. Lines that meet at the viewing point in Euclidean space never meet in linear perspective.

The image of line *T* (and therefore of every viewing line) appears as a single point because the images of its *x* and *z*-coordinates never vary. The constant *z*-value of line *t* make sense because line *T* lies entirely within the horizon plane, which, as stated earlier, is the only plane in the entire drawing system whose image appears as a horizontal line. The image of this horizontal plane is a horizontal line because its *z*-coordinate is aligned with the *z*-coordinate of the viewing point. The reasoning behind the constant *x*-value of line *t* is somewhat more complex. Just as line *T* belongs to a special type of horizontal plane (the horizon plane), it also belongs to a special type of vertical plane, a **viewing plane**, which (like the horizon plane) is aligned with the viewing point. Viewing planes intersect both the viewing point and the measuring plane, and (in the most basic orientation of linear perspective) they are perpendicular to the ground plane (Figure 1.38). The image of a viewing plane is a vertical line (lines *G* and *H* in the figure), which means that the image of every point on a given viewing plane has the same *x*-value. Line *T* lies entirely within a viewing plane, so it image, line *t*, must have a constant *x*-value. Line T (and therefore every viewing line) appears as a single point because its image has a constant *x* and *z*-coordinate. Put another way, line *T* is the intersection of two planes (the horizon plane and a viewing plane), and the images of both of these planes is a single line. Simple geometry dictates that the intersection of the images of two non-parallel lines describe the image of a single point.

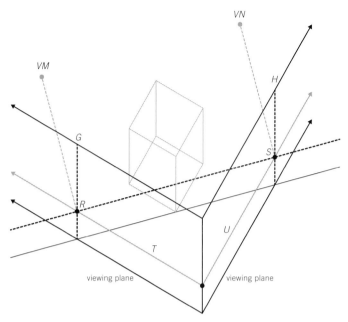

Figure 1.38: the image of a viewing plane is a vertical line (*G* and *H*)

Figure 1.39 demonstrates the reciprocity between the horizon plane and viewing planes in a different manner—as the reciprocity between vanishing points and the viewing point. The upper half of the drawing depicts a rebatment that includes a plan of lines on the ground plane that converge at the viewing point and the images of those lines in linear perspective, which are perpendicular to the baseline. The lower half of the drawing depicts a rebatment that includes a plan of lines that are perpendicular to the measuring plane and the images of those lines in linear perspective, which converge to a single (and central) vanishing point that aligns with the viewing point. Figure 1.40, meanwhile, demonstrates the special case of horizontals, which are the only lines in the drawing system that do not converge to a vanishing point. My discovery of these instances of reciprocity (or lack thereof) occurred by accident through a series of drawing experiments that eventually led to the mathematical understanding of linear perspective demonstrated in this book, as well as to my overall approach to analytical perspectival drawing. The historical precedents of these drawings lie in the work of Gérard Desargues and Jean Poncelet, which will be discussed in Chapter 3. The drawings, in fact, reflect a much greater reciprocity that underlies all orthographic and projective drawing.

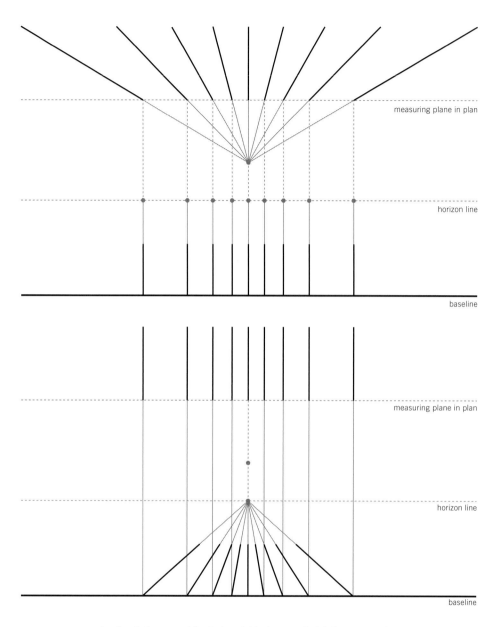

measuring plane in plan

horizon line

baseline

measuring plane in plan

horizon line

baseline

top: lines that converge at the viewing point in plan are verticals in linear perspective

bottom: lines that are perpendicular to the measuring plane in plan converge to a central vanishing point linear perspective

Figure 1.39: reciprocity between orthographic and perspectival projection

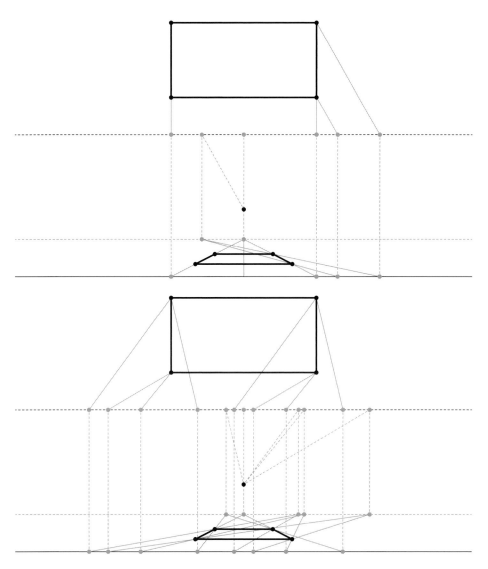

Figure 1.40: the special case of the images of horizontals

Because horizontals do not cross the measuring plane, their images may be described only through the location of two points, neither of which lie on the measuring plane and both of which may be located only through the location of the intersection of the images of two lines. The images of four lines, therefore, are required to locate the image of a horizontal line. In the top drawing, two of the lines coincide with the object of projection. In the lower drawing, the results are the same, but none of the lines coincide with the object of projection.

Postulates, Conclusions, and Variables

The literal demonstration and the abstract explanation of the point-location construction logic may be synthesized into a set of postulates on the nature of linear perspective.

I. A Euclidean object may be described orthographically as a set of three-coordinate points, and the image of a Euclidean object may be described perspectivally as a set of the images of three-coordinate points.

II. The image of a point that lies on the measuring plane may be located directly on the measuring plane in linear perspective in one of two ways: it may be plotted directly onto the measuring plane, or it may be projected onto the measuring from a plan and an elevation in a certain rebatment.

III. The image of a point that does not lie on the measuring plane may be described as the intersection of the images of two lines, neither of which may be a horizontal.

IV. The image of a line that is not a horizontal may be described through two special types of points in the drawing system: a point on the measuring plane and a vanishing point on the horizon line. The measuring point may be located as described in Postulate II, and the vanishing point may be located through a projective procedure involving viewing lines in a certain rebatment.

V. The image of a horizontal that does not lie within the measuring plane may be described through the images of two points. Neither of these points may lie on the measuring plane, so the images of each of these points must be described through the images of two lines. In other words, the image of a horizontal that does not lie on the measuring plane may be described through the images of four lines, two of which define the image of one point, and two of which described the image of the other point.

A thorough understanding of these postulates frees a draftsperson from the necessity to memorize, or even refer to, a step-by-step demonstration. Even novice practitioners of linear perspective should strive to navigate the drawing system in multiple ways. Once the images of certain points and lines have been located, the

location of the images of other points and lines becomes easier because (except in extremely complex geometries) points and lines in a given object of projection often align with each other in obvious ways. Multiple points and lines, therefore, may be located through a relatively small number of operations.

Every line in Euclidean space has a corresponding vanishing point that lies on the horizon line in a linear perspective. The drawing system, therefore, has an infinite number of vanishing points, only some of which are employed during a given construction process. The commonly used terms *one-point perspective* and *two-point perspective* are somewhat incompatible with a mathematical understanding of the drawing system, and they wrongly imply that there are two distinct types of linear perspective. In fact, there is only one type of linear perspective that is capable of a variety of viewing directions with respect to the object of projection, including frontal (so-called one-point) and oblique (so-called two-point) directions. The term one-point perspective is, in fact, an oxymoron, except in the extremely unusual case in which a linear perspective consists only of the image of a single line that extends to infinity. To locate the image of any point that does not lie on the measuring plane, it is necessary to construct the images of two non-parallel lines, each of which has a corresponding vanishing point. Thus, linear perspectives are not possible if only one vanishing point is located. In the case of a frontal perspective, the additional vanishing point (or points) that are used to locate depth are not always explicitly understood as vanishing points. For example, diagonal lines may be used to construct the depth of squares in proper foreshortening, and these diagonals may or may be not be extended to the horizon line, where they would describe a vanishing point that corresponds to lines that intersect the measuring plane at 45° in plan. These diagonal lines, however, still have an implicit vanishing point. Depending on the geometric nature of the object of projection, it may be necessary to locate multiple vanishing points explicitly, and there is no need to be intimidated by the apparent complexity of such a drawing. All points obey the same simple rules.

In a frontal linear perspective, at least one plane within the object of projection is parallel to the measuring plane and perpendicular to the viewing ray. The plane may or may not lie within the measuring plane, so the dimensions of the image of the plane may or may not be measureable in linear perspective. Regardless, the image of the plane will appear as an undistorted orthographic elevation in linear perspective. Planes that appear to be orthographic in a linear perspective have a

 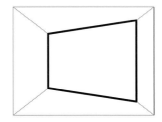

Figure 1.41: the distortion of planes (right) or lack thereof (left)

unique mathematical property. The images of these planes consist only of images of verticals, horizontals, and diagonal horizontals, none of which converge at a vanishing point, and none of which, therefore, have any distortion other than their size (Figure 1.41). This is why Alberti refers to the viewing ray as "the prince of rays."

As alluded to throughout this chapter, all of the linear perspectives that have been considered so far involve a measuring plane that is perpendicular to the ground plane. In such drawings, viewing rays have a constant z-value and are therefore parallel to the ground plane. The construction of other orientations of the viewing rays (such as cases in which the viewer is "looking up" or "looking down") may seem confusing at first, but they do not in fact violate any of the postulates. Figure 1.42 illustrates the case of a viewing ray that intersects the ground plane. The measuring plane is always perpendicular the viewing ray, so in this case it is not perpendicular to the ground plane. It is therefore necessary to rotate the entire spatial system and to impose a surrogate ground plane that is perpendicular to the titled measuring plane, so that the measuring plane and the surrogate ground plane conform to the standard rebatment of the other examples. The drawing is then a straightforward construction of a tilted cube. The plan and elevation of the tilted cube appear rectangular, as opposed to square, and they operate in the same mathematical manner as the plan and the elevation in the step-by-step demonstration. The construction is more complex and requires more concentration than that of a cube that is not tilted, but it is not a different type of drawing. In linear perspective, there are always multiple ways in which to achieve the same end. Whereas the rotation of the spatial system makes sense given this rebatment, other rebatments may motivate different adjustments. In all cases, the point-based logic applies. Points in a Euclidean system have three coordinates, and the goal is to locate the images of the coordinates for a given viewing point and a given viewing direction.

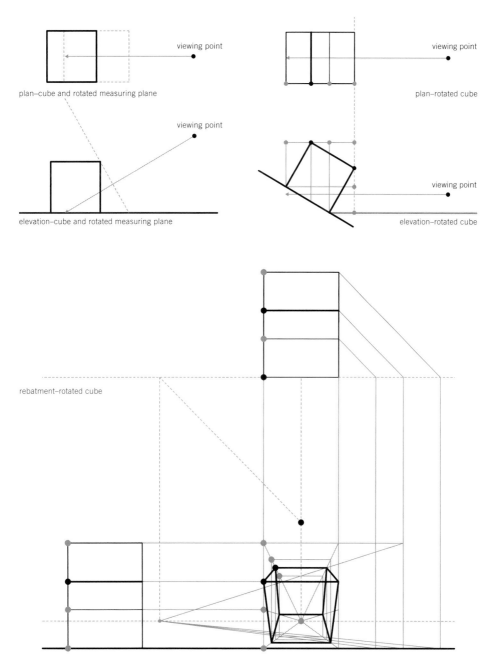

plan–cube and rotated measuring plane

viewing point

plan–rotated cube

viewing point

elevation–cube and rotated measuring plane

viewing point

elevation–rotated cube

viewing point

rebatment–rotated cube

Figure 1.42: looking up or looking down

When the viewing ray has a varying z-value, as in the case in Figure 1.42, the images of vertical lines are not vertical, but rather slanted. Figure 1.43.a demonstrates that, in such a construction, vertical lines that are parallel to each other (such as those that describe a cube) converge to a single point. This phenomenon is often referred to as *three-point perspective*, which (like *one-point perspective* and *two-point perspective*) is a misleading term. It would be mathematically incorrect, for example, to simply add a "third" vanishing point that corresponds to the vertical edges of the object of projection considered in the demonstration earlier in this chapter. In that case, the vertical edges of the object of projection are perpendicular to the viewing ray, and the images of all lines that are perpendicular to the viewing ray are vertical lines that will never converge to (or meet) each other. At the same time, it is important to acknowledge that points of convergence that correspond to sets of parallel lines may appear in places other than the primary horizon line. It has already been acknowledged that horizon lines contain an infinite number of vanishing points, only some of which we utilize for any given drawing. It is now important to acknowledge that linear perspectives contain an infinite number of horizon lines, only some (and typically only one) of which is utilized for any given drawing. The biases of terms like one-point, two-point, and three-point perspective hinder recognition of such universal properties of the drawing system.

As Figures 1.43.a and 1.43.b illustrate, points of convergence for different sets of parallel lines may define a non-horizontal line of convergence points at infinity (a non-horizontal horizon line). Lines that have a constant x-value, for example, converge to the same non-horizontal horizon line (which is, in fact, the image of a viewing plane), and some of these lines share a vanishing point because they are parallel to each other in elevation and/or plan. In Figure 1.43.a, the lines are either parallel or perpendicular to the ground plane, and the viewing ray is a diagonal. In Figure 1.43.b, the lines are diagonal to the ground plane, and the viewing ray is parallel to the ground plane. These two conditions are inverses of each other, as each contains one parameter that is parallel to the ground plane and one that is not.

The non-horizontal horizon line that corresponds to lines that have a constant x-value of zero is aligned with the x-value of the viewing point, and this is no coincidence. The historical awareness of these types of mathematical alignments will be addressed in Chapter 3, as will the general type of inverse relationship between Figures 1.43.a and 1.43.b. The important fact to recognize here is that linear perspective is one drawing

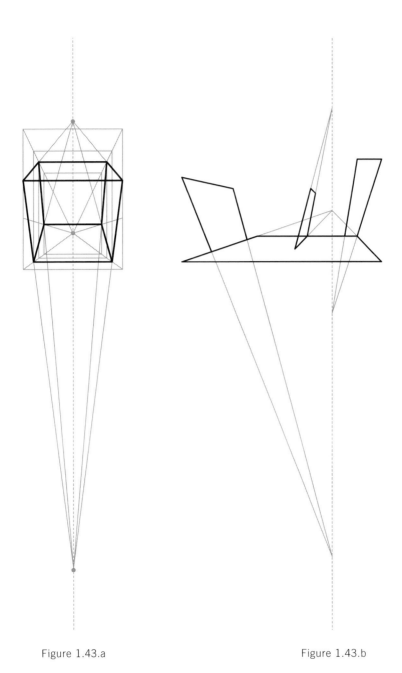

Figure 1.43.a

Figure 1.43.b

Figure 1.43: non-horizontal horizon lines

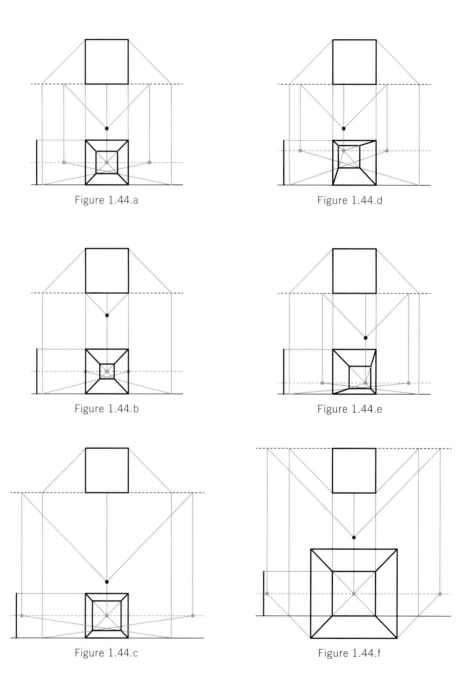

Figure 1.44.a

Figure 1.44.d

Figure 1.44.b

Figure 1.44.e

Figure 1.44.c

Figure 1.44.f

Figure 1.44: variations of the parameters and their effects

system that follows the same mathematical rules, regardless of the geometrical nature of the object of projection and regardless of the values of the parameters of a drawing (e.g., location of viewing point, direction of viewing ray, et cetera).

Figure 1.44 demonstrates the effects of varying the basic parameters of a linear perspective construction: the locations of the viewing point and the measuring plane and the orientation of the object of projection. All of the drawings depict the same object in correct ways, and each one communicates a different understanding of it. The distance of the viewing point from the object of projection affects the apparent depth of the object. A closer proximity appears to exaggerate the depth of the object, and a further proximity appears to flatten the object (Figures 1.44.b and 1.44.c). The height of the viewing point and the lateral relationship between the viewing point and the object of projection affect the way in which the drawing depicts various aspects of the object (Figures 1.44.d and 1.44.e). The position of the measuring plane in plan affects the size but not the proportion of the image of the object of projection (Figure 1.44.f). In analog drawing, the size of the drawing matters because of the limited surface area of the working environment. In digital drawing, however, the size of the drawing is irrelevant because the size of the drawing environment is infinite, and the resulting drawing may be easily re-scaled for purposes of printing or other modes of dissemination. In digital drawing, therefore, the position of the measuring plane in plan is, more or less, irrelevant.

Chapter 2

The Making of a Movie

Here is where the madness is, for until this day no representation could assure me of the past of a thing except by intermediaries; but with the Photograph, my certainty is immediate; no one in the world can undeceive me. The Photograph then becomes a bizarre medium, a new form of hallucination: false on the level of perception, true on the level of time: a temporal hallucination, so to speak, a modest, shared hallucination (on the one hand "it is not there," on the other "but it has indeed been"): a mad image, chafed by reality ... In the cinema, no doubt, there is always a photographic referent, but this referent shifts, it does not make a claim in favor of its reality, it does not protest its former existence; it does not cling to me: it is not a specter ... the experience will constantly continue to flow by in the same constitutive style ... it is then, simply "normal," like life.

Roland Barthes, *Camera Lucida*

Cinema is an actively evolving discipline. Artists, entrepreneurs, and philosophers continually reinterpret its nature, and digital technology is reconfiguring how the medium operates in profound ways. Even the meaning of the term *cinema* is increasingly difficult to discern in a dizzying culture of ubiquitous screens. Three primary conditions of the medium provide potential criteria through which to distinguish a work of cinema from a routine moving image. The first is the materiality of the moviemaking process: celluloid film, videotape, digital media, et cetera. The second is the intention of the moviemaker: art, entertainment, information, advertisement, et cetera. The third is the venue of moviegoing: public movie theater, outdoor public space, home theater, television, laptop computer, handheld device, et cetera. These variables may lead to disparate interpretations of *cinema*, none of which is more correct or valid than any other. Similar to how linear perspective lies ambiguously within, without, and between the fields of art and mathematics, cinema informs multiple disciplines of image-making. One may argue, for example, that cinema occurs when, and only when, celluloid prints of narrative movies are projected in movie theaters. Someone else, meanwhile, may argue that cinema occurs even when digital screens at bus stops show advertisements. In this book, I reconsider the parameters within which the medium may operate as a practice of architectural projection. My objective is to challenge how and where cinema may occur within the disciplines of architectural and urban design. Architecture has always been a favorite pictorial subject of moviemakers, but architects typically do not understand cinema as an analytical tool of their profession. Cinema, I argue, is relevant both to design professionals and to researchers who seek to interrogate spatial and temporal conditions of the built environment. What follows is a primer on the fundamental principles of movie construction that is written specifically for designers and scholars of design. It provides a foundation on which to consider the potential of motion pictures to infiltrate design and research methodologies.

Cinematic Hierarchy

Cinema consists of two primary scales: the shot and the movie. A **shot** is a single, uninterrupted moving image that may last anywhere from a fraction of a second to several hours, or even longer. The physical length of celluloid film stock used to limit the potential duration of a shot to about ten minutes (depending on the era), but digital technology now allows shots to continue (theoretically at least) ad infinitum. A **movie** is a collection of shots that are assembled into a sequence that has an

identity as a complete work. The length of a movie, again, may range from a fraction of a second to several hours, or even longer. In rare cases, a movie may consist of only one shot, but the vast majority of movies contain multiple shots. The role of a shot within a movie is somewhat analogous to the role of an individual architectural component within a building. In both architecture and cinema, a strategic assembly of components results in a composition that transcends the collection of its parts, and a dialog between scales leads to great design. A **scene** is either a single shot or a collection of shots within a movie that has a distinct identity relative to shots or collections of shots that precede or succeed it. Scenes may be compared to rooms within a building, but they may also have less straightforward boundaries, especially in the types of movies that are the focus of this book. Scenes are therefore a secondary scale that may or may not be relevant to a given movie.

Cinema, like architecture, involves the construction of a **hierarchy**, which in this book is understood not as a ranking of superior and inferior components, but rather as a system of relationships between a complex set of attributes. It is not incorrect to consider hierarchy as a ranking system, but there are other types of hierarchy that are particularly relevant to both architecture and cinema. Consider the collection of spaces in a typical house. It is common to designate a living room as *more important than* or *dominant over* a hallway that connects the living room to other spaces in the house; however, the hallway has enormous influence over the spatial hierarchy of the house. Its influence may be less obvious than that of the living room, but it is no less significant. Assumptions of equality are similarly problematic. Consider a row of ten identical houses that are aligned along an east–west axis. It is common to designate the houses as *equals*; however, each house is subtly unique because of its position within the row, as the fourth house, for example, is the only one that has three neighbors on its east side and six neighbors on its west side.

In a cinematic composition, the issues are similar. Throughout the duration of a movie, the nature of shots and scenes will inevitably vary, and designations of importance and equality undermine the integrity of the overall composition. No one shot is ever more important than any other shot, and every shot in a movie is essential to the hierarchy of that movie, regardless of its content or length. Shots may be either important (in which they case they remain in the movie) or not important (in which case they are removed from the movie), but never *less important*. Similarly, no one shot is ever the same as the other, even if the same exact shot is reused in the same

movie. Fallacies of importance and equality oversimplify the creative process, and the notion of hierarchy encompasses far more subtle and specific differences.

Walter Benjamin's seminal essay on photography and cinema, "The Work of Art in the Age of Mechanical Reproduction," suggests an understanding of cinematic hierarchy that is especially useful to an interest in the distinction between pictorial and analytical modes of architectural projection. Benjamin describes moviegoers as "absent-minded examiners" who, throughout the course of a single movie, engage in alternating modes of pictorial and analytical perception.[1] During a pictorial mode of perception, moviegoers enter into the illusion of the screen and mentally occupy the space described by the cinematic image. During an analytical mode of perception, moviegoers recognize the illusion of the screen and scrutinize the space described by the cinematic image. According to Benjamin, analytical modes of perception are exceptional moments that occur when "shock effects" disrupt the otherwise pictorial disposition of a movie.[2] The disruption, however, is a modest one, which is why the viewer is an absent-minded, as opposed to a focused, examiner. Whereas a painting is perceived in an overall state of concentration, a movie is perceived in an overall state of distraction. Shock effects motivate moments of heightened awareness, but they do not threaten the distracted nature of the experience. Movies, in this sense, are dialectical constructions in which different types of moments interact with each other in a strategic manner that maintains the overall illusion of the screen but also instills it with meaning. Neither the analytical moments nor the pictorial moments are more important than the other because each type relies on the other. A purely pictorial movie with no shock effects would be too disengaging, and a purely analytical movie with unrelenting shock effects would be too overwhelming.

The vast majority of movies throughout history adhere to some version of Benjamin's model of cinematic hierarchy, which means they take advantage, in varying degrees, of both the realism and the artifice of the medium. The indexicality of cinema establishes an inextricable link to the real world, and techniques of shot making and editing allow moviemakers to defamiliarize and recontextualize that world. The movies that most people see on a regular basis are primarily pictorial and only secondarily analytical; however, certain genres of cinema invert this hierarchal relationship, so that movies become primarily, and sometimes even entirely, analytical. The common umbrella term for these approaches is either *experimental cinema* or *avant-garde cinema*. Both of these terms imply a deviation from, or a reaction against, a normative

standard, in this case *commercial cinema* or *the movies*. While experimental and avant-garde movies are, in fact, non-normative and non-commercial, negative definitions fail to capture the vital attributes of these approaches to cinema. A more constructive umbrella term for cinematic hierarchies in which analytical modes of perception outweigh pictorial modes of perception is, of course, *analytical cinema*. In turn, cinematic hierarchies in which pictorial modes of perception outweigh analytical modes of perception may be referred to as *pictorial cinema*. Whereas the primary objective of pictorial movies is to displace the audience into the screen, the primary objective of analytical movies is to motivate the audience to interpret the screen. It is important to recognize the relativity of these designations. While some cinematic hierarchies occupy the extremes of the analytical–pictorial scale, others are less absolute and simply gravitate toward one of the extremes. The "right" balance between realism and artifice depends on the objectives of a given movie.

This book promotes the construction of movies that reveal the underlying spatial and temporal conditions of built environments, not ones that create illusionistic impressions of them. The goal, therefore, is to construct cinematic hierarchies that induce significant degrees of analytical perception. This objective runs counter to the majority of movies that comprise the historical discourse on architecture and cinema. Many of the examples in the discourse are primarily pictorial movies, which are well suited to architectural subjects because they simulate the experience of existing and/ or imaginary spatial environments. Some of the movies in the discourse are analytical to a certain degree, but few of these exploit the analytical potential of the medium as fully as approaches to moviemaking that (until now) have been excluded from the discourse. The intention here is not to deny the experiential qualities of the cinematic medium (or to reach a state of purely concentrated perception, as in Benjamin's notion of the perception of a painting), but rather to deploy them in less illusionistic ways that are akin to architectural drawing and diagramming. The ultimate goal is to forego the conventions of *movies about architecture* (analogous to pictorial drawing) and to construct *architectural movies* (analogous to analytical drawing).

The Enigma of Analytical Cinema

Before a discussion of analytical cinema may begin, it is necessary to acknowledge that analytical cinema and pictorial cinema share many common methods and conventions.[3] Throughout this chapter, references are made to how certain methods

of shooting and editing tend to be more compatible with either an analytical or a pictorial intention, but contingencies always apply, and exceptions always exist. One issue is the potential discrepancy between the analytical nature of a shot and the analytical nature of an overall movie. For example, an analytical movie may be composed entirely of pictorial shots that become analytical only through the way in which they are composed into a hierarchy at the scale of the movie. Another issue is the fact that pictorial moviemakers tend to appropriate inherently analytical methods and to redeploy them as pictorial conventions. For example, many conventions of pictorial storytelling (such as the flashback and the dream sequence) derive from methods that, when deployed in a different context, may disrupt the pictorial illusion of the image. Whereas a conventionalized use of an analytical method may create a pictorial shot, a raw use of the same method may create an analytical shot. In short, context and intent far outweigh objective formal attributes. It is therefore impossible to provide a list of methods and conventions that automatically lead to analytical moviemaking. It is, however, possible to provide a comprehensive description of how the medium operates, and such a foundation is essential in order to develop a specific approach to moviemaking that addresses architectural and urban subjects in an analytical manner. In lieu of a precise definition of analytical cinema, examples from Chapters 4 and 6 help to demonstrate its nature and potential.

Digital Primitive

The basic formal grammar of cinema is less absolute than the mathematical laws that govern the approach to drawing illustrated in the last chapter. This chapter, therefore, does not include either a step-by-step demonstration or a set of immutable principles. Instead, it provides a general introduction to relatively straightforward practices of shot making, scene making, and moviemaking, most of which would have seemed familiar in the first few decades of cinema. A few of the methods first appeared somewhat later in the history of cinema, but none of them stray far from the spirit of the pioneering years of the medium. To contemporary eyes, early movies may appear formally crude and conceptually naïve; however, few technological innovations or aesthetic developments since 1930 have fundamentally changed the underlying nature of movie construction. The basic syntax of cinema has been remarkably resilient, and the foundational construction logic of the medium is important to recognize. In addition, the culture of early cinema complements the objectives of this book. Architects and architecture students who seek to explore an

unfulfilled potential of the fundamental nature of the medium have much in common with the early pioneers of the medium. They should aspire to be, like the pioneers, independent and unregulated by biases, conventions, and preconceptions. Also like them, they should work either alone or in small groups, not alongside crews of professional technicians or batteries of specialized equipment. In this sense, they belong to a long line of moviemaking subcultures that have summoned the roots of the medium in order to reinvent it. Their amateur standing is an asset, not a liability.

Contemporary practices of cinema, of course, are digital, so the following discussion refers extensively to the technology of digital cinema. While an embrace of this contemporary technology may seem incompatible with a return to the roots of the medium, digital tools in fact may be used to channel the primal spirit of the medium that flourished before the emergence of complex practices of moviemaking. Inexpensive digital cameras and entry-level editing platforms have democratized the practice of moviemaking and consequently revitalized the creative basis of the medium. To non-professional moviemakers, the indexical nature of the medium is still a source of wonder, and conventions are less restricting. The key to a primal use of digital cinema is to understand its basic construction logic. Digital cameras and editors are typically easy to operate without instructions or practice, and this may give users a false impression of competence. Moving images are easy to make and to manipulate, but it takes considerable time, patience, and experimentation in order to take control of the digital processes that appear to be so effortless.

One aspect of digital culture that this book does not promote is computer-generated imagery. In the same spirit, it does not promote any type of set design or use of props. While there is a rich history of fictional architectural environments created for the movies (see Chapter 4), the approaches promoted here are limited to the use of indexical images of real environments (see Chapter 6). This obstruction may seem more applicable to architectural analysis than to architectural design, but the aforementioned potential of cinema to defamiliarize and recontextualize its subject matter cannot be overstated. The basic construction principles of the medium are profoundly powerful in this respect, and the use of fictional environments would hinder a full interrogation of this potential. Furthermore, the limitations of indexical imagery may give rise to design ideas that would not have emerged from an unmediated imagination.

The Pure Shot

Digital cinema threatens both the craft of shooting and the integrity of the index. Automatic settings on digital cameras allow shooters to disregard critical decisions regarding the parameters of an original shot, and the nature of digital editing allows editors to manipulate an original shot beyond recognition. Neither of these capacities is unique to the digital era, but both are far more pervasive in digital cinema than in analog cinema. Overall, a digital shooting process is less consequential than an analog one, and a digital moving image is less contingent upon the reality that created it. This book upholds the intentionality of the shooting process and the indexicality of the cinematic image, despite its acceptance of digital tools. The intent is not to eliminate all types of digital mediation, but rather to maintain full control over their mechanisms during both the shooting and the editing processes.

The first step is to capture a pure indexical image. Of course, no image is entirely pure, but all cameras have a base condition that is regulated by its sensors, lenses, and other technologies. The capabilities and limitations of a camera are important to identify and to respect, even if certain editing processes will eventually override them. A full understanding of the base condition of a particular camera is necessary in order to manage its use. The best way to reveal this base condition is to forego the use of all automatic settings that affect the properties of the image. Most cameras have two types of automatic settings: ones that override manually controllable settings that are specific to the shooting process and ones apply color and graphic effects that, if desired at all, may also be applied during the editing process. The latter type, examples of which include *black-and-white* and *old movie*, is easy to dismiss for two reasons. First, their effects may be created with far more precision and intentionality during the digital editing process, which allows for manual control over many of the variables of a given effect. Second, digital editing is a non-destructive process, which means that an original shot is left unaltered when effects are applied to it. Original shots, therefore, should remain as pure (i.e., as true to the basic specifications of the camera) as possible. The other type of automatic setting on most cameras, examples of which include *exposure* and *focus*, is more difficult to disregard because the manual controls related to these settings are relatively difficult for amateurs to operate. Most users will need to consult instructions and to practice. The payoff, however, is considerable.

Automatic settings that control exposure and focus often cause abrupt and unfortunate changes to the nature of the image, such as when an object passes in front of a camera. In the case of exposure, the passing object causes a change in the brightness of the light that reaches the light sensor in the camera, and the exposure setting of the camera is adjusted to compensate for the change in luminosity. After the object passes, the original exposure setting is restored. In the case of focus, the passing object changes the focal distance of the image, and the focus setting is adjusted to compensate for the change in focal distance. After the object passes, the original focus setting is restored. The same types of adjustments occur when a mobile camera passes in front of subjects of varying luminosity and focal distance. Such abrupt and unpredictable changes to an image's exposure and focus values reflect a lack of control over the behavior of the image, as well as a general disregard for the craft of the image capturing process. One may argue that chance adjustments caused by automatic settings disrupt the pictorial illusionism of cinema in a productive manner; however, manual adjustments to exposure and focus settings have the potential to disrupt pictorial illusionism in a more intentional and analytical manner.[4] Moviemakers may choose which parts of an image are over, under, or perfectly exposed and which parts are in or out of focus. Exposure and focus may also be manipulated during the editing process, but not in ways that replicate the type of adjustments possible during the shooting process. For example, an image may be brightened or darkened during editing, but certain lighting conditions must be captured during shooting, which is why manual control of a camera is so important.[5]

Shot Resolution

Most digital cameras now have the capacity to capture high-definition moving images, and standard-definition video is slowly disappearing as both an industry and an amateur staple. The difference between high-definition and standard-definition video is the pixel dimension, or resolution, of each frame of the movie. The resolution of high-definition video is measured in pixels, and its two most common pixel dimensions are 1280 x 720 (which is referred to as **720p**) and 1920 x 1080 (which is referred to **1080p**).[6] The resolution of standard-definition video is measured in a slightly different way: each frame has a pixel width dimension of either 720 (in the case of square pixels) or 680 (in the case of rectangular pixels), and the height of the frame in each case consists of 480 lines of pixels. Although novice moviemakers may avoid this technical information without much peril, a basic understanding of how

pixels operate as the building blocks of digital images is essential to the analytical objectives that inform this book. All digital shots have an original pixel dimension; all digital movies have a precise pixel dimension; and all digital screens and projectors have a precise pixel dimension. Many attributes of the shot involve pixel distribution. A numerical management of pixels during the digital editing process allows for a high degree of intentionality regarding these shot attributes.

The aspect ratio of high-definition video is 16:9, which is significantly wider than the 4:3 aspect ratio of standard-definition video, and this difference impacts the aesthetics of moviemaking far more significantly than the discrepancy in image quality. The wider aspect ratio changes many of the compositional variables of moviemaking, and it must not be taken for granted. Meanwhile, the issue of quality is somewhat of a red herring. Although the greater number of pixels in a high-definition image as compared to a standard-definition image undoubtedly leads to an improvement in image quality, not all high-definition video is professional quality, or even prosumer quality (*prosumer* is a hybrid of *professional* and *consumer*, and it refers to higher-end amateur grade equipment). Most amateur high-definition cameras, despite their pixel capacities, lack the sophisticated sensors and lenses that are common on most professional high-definition cameras. In fact, some professional standard-definition cameras achieve objectively superior images as compared to many amateur high-definition cameras. There are also certain standard-definition cameras (both professional and amateur) that perform better in special conditions, such as low light, than some high-definition cameras. Various components of a camera contribute to the nature and quality of the moving images that it creates, and designations such as high-definition and super-megapixel are ultimately less meaningful than they sometime seem. Beautiful movies may be made on any camera, especially in the hands of a moviemaker who understands its capacity.

Given the trend toward high-definition cameras, it is safe to assume that, in the near future, digital movies will be viewed exclusively on high-definition screens or through high-definition projectors. The 16:9 aspect ratio of a high-definition movie, therefore, is the proportion of the canvas on which the movies of most contemporary moviemakers will be placed. Currently, the two most common pixel dimensions for a high-definition movie are 1280 x 720 and 1920 x 1080, which correspond to the two most common pixel dimensions for high-definition shots. The exact resolution of a movie is typically a function of the resolution of the shots that compose it. When

Figure 2.1: aspect ratio and image resolutions

the pixel dimension of a shot matches that of a movie, the image is at full resolution, which is often but not always the desired condition. Most moviemakers, for example, would not want to enlarge 720p images in order to fit them into a 1080p movie.

It is critical to recognize that the number of pixels in an original shot is the number of pure pixels that are available during the digital editing process. When the pixel dimension of a shot is greater than that of a movie (for example, when a 1080p image is placed within a 720p frame), the image bleeds beyond the borders of the movie frame, and it needs to be reduced in order to fit within the frame. When the pixel dimension of a shot is less than that of a movie (for example, when a 720p image is placed within a 1080p frame), the image floats within the borders of the movie frame, and it needs to be enlarged in order to fill the frame. In order to align the pixel dimensions of a shot and a movie, the resolution of a shot may be either reduced through an algorithmic process of **downsampling**, which eliminates pixels, or enlarged through an algorithmic process of **interpolation**, which adds pixels.

Downsampling and interpolation may also be used in creative and analytical ways that are unrelated to the potential discrepancy between the resolution of a shot and the resolution of a movie. Enlargement through interpolation during the editing process, for example, may be used as a form of digital zooming that is more precise than the digital zooming capacity of a camera. Digital cameras typically have both optical and digital zoom capacities. Whereas the optical zoom capacity is a factor of the physical geometry of the lens, the digital zoom capacity is achieved through interpolation within the camera. Shots that are captured within the optical capacity of the lens, of course, are purer images than those subjected to an interpolative process within the camera, which is why it is wise to disable the digital zoom function on a camera. To repeat, the goal is to capture images that are as unadulterated as possible by automatic operations that occur inside the camera. The algorithmic procedures of interpolation that may occur during the editing process are far more sophisticated, controllable, and potentially analytical than those possible inside the camera. Even if algorithms are beyond the skillset of a moviemaker, interpolation may be executed numerically through a relatively straightforward management of pixels. For example, a shot may be subjected to a series of proportional enlargements of its original pixel dimension (100%; 150%; 225%; 337.5%; et cetera) in a way that addresses issues of scale and distance. A camera typically displays its zoom factor as a graphic bar, not as a numerical value.

Reduction through downsampling during the editing process may be used as a form of **letterboxing** and **pillarboxing**. True letterboxing and pillarboxing involve scaling and positioning an image within a frame that has a different aspect ratio than that of the frame (so that the entire image may be shown without distortion). If the aspect ratio of an image is proportionally wider than that of the frame in which it is placed, letterboxing is used: black bars are placed above and below the image. If the aspect ratio of an image is taller than that of the frame in which it is placed, pillarboxing is used: black bars are placed on both sides of the image. In both cases, a secondary framing occurs within the primary frame of the movie. Letterboxing is used to display widescreen movies on standard-definition television sets, and pillarboxing is used to display standard-definition video images on high-definition screens.

The ease of downsampling in digital editing has led to less practical and more creative uses of secondary framings within a movie frame, which are sometimes referred to as **windowboxing**. An image, for example, may be reduced by a significant

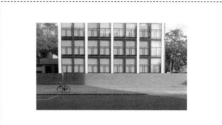

1080p image in 720p movie
without downsampling

1080p image in 720p movie
with downsampling

Figure 2.2.a: downsampling

720p image in 1080p movie
without interpolation

720p image in 1080p movie
with interpolation

Figure 2.2.b: interpolation

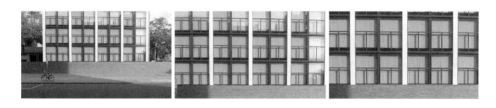

100% 150% 200%

Figure 2.2.c: "digital zooming" through interpolation

Note: all of the images in this chapter derive from shots that were taken by the author solely for the purpose of illustrating basic cinematic properties—some appear in the movies discussed in Chapter 6, but others do not belong to a completed movie.

factor and positioned on an empty background like a postage stamp, or it may be positioned with other framed images like television sets stacked on top of each other in an electronics store. The positioning of images in a digital movie involves a simple two-dimensional coordinate system based on pixel dimensions. Images that are downsampled or interpolated may be positioned anywhere within the frame and may bleed beyond the borders in any way.

The appearance of letterboxing, pillarboxing, and windowboxing may be achieved through another type of numerical pixel management: the cropping of a full resolution image. Black bars of any number and proportion may be placed figuratively "on top of" an image. The intention may be to block part of an image for a short period of time, or it may be to alter the aspect ratio of an entire movie. In both cases, the analytical potential of cropping is significant, especially given the precision of manual pixel management. In the former case, the temporary redaction of a portion of an image would disrupt pictorial illusion; in the latter case, an unorthodox aspect ratio (such as one that is vertically oriented) would undermine nearly every compositional convention in the history of cinema. A full resolution image may also be repositioned so that it bleeds beyond the border of the movie frame. The effect will look similar to a cropping. An image may also be cropped in ways that complement or enhance the compositional qualities of the image, similar to how a mask simultaneously covers a face and reveals its underlying geometry. Crops may assume various shapes, and they may also be different colors, graphic patterns, still images, and even other moving images. The danger of so many variables is that they have the potential to become more ornate than analytical, and a limited application of these variables will better preserve the integrity of the index.

Interpolation and downsampling may also be used together as a way to analytically distort an image. Successive enlargements and reductions (again through deliberate pixel management) will degrade the clarity of an image in a way that is as easy to understand as basic math, and far more immediate than the "blur" and "distort" filters that are commonly included in digital editing software. Interpolation and downsampling may also occur in only one dimension of an image. For example, an image that has a 16:9 aspect ratio may be stretched through an interpolative process into an image that has a 32:9 aspect ratio. The resulting distorted image may bleed beyond the borders of a 16:9 movie frame or undergo a process of downsampling and appear as a letterboxed image.

Figure 2.3.a: letterboxing

Figure 2.3.b: pillarboxing

Figure 2.3.c: windowboxing

While these methods of distortion may seem to violate the parameters of a "basic cinema" methodology because they exploit the nature of digital editing, they are, in fact, straightforward operations that epitomize the type of hands-on moviemaking to which the methodology aspires. The hands in this case operate on a keyboard, not a piece of actual film, but a numerical management of pixels is practically tactile in comparison to the automatic settings that uninformed digital editors use. As always, intention is the key. An unintentional example of the stretching operation described above occurs regularly on many high-definition television sets, which have a default setting that stretches images with relatively narrow aspect ratios so that they fill the 16:9 aspect ratio of the screen. The assumption seems to be that most viewers will not notice, or mind, the distortion. Architecture, however, is a matter of proportion, and it is impossible for architectural moviemakers to disregard the proportional logic of the various frames that regulate moviemaking.

Proportion and Geometry

The vast majority of moving images in the history of cinema and television have a 4:3 (or 1.33:1) aspect ratio.[7] In the 1950s, partially in response to the invention of television, cinema adopted wider aspect ratios, such as Cinemascope and Panavision, which range roughly from 2.35:1 to 2.55:1. Several different aspect ratios have become industry standards since that time, all of which are wider than 1.33 in order to maintain a distinction between film and video. Until the recent rise of high-definition video, television maintained the use of the standard 4:3 aspect ratio that defined the first half-century of cinema. Although cinephiles typically deride television as a lesser form of image-making and image dissemination, standard-definition television preserved the proportional origins of the cinematic image in the eyes of the general public. The 4:3 aspect ratio also found refuge in the work of artists and independent moviemakers, but television influenced the visual culture of the twentieth century far more than such work. The extent to which the 4:3 aspect ratio conditioned the history of the reception of moving images in underappreciated. The enormous aesthetic impact of the recent democratization of high-definition video lies in the fact it signals the demise of this aspect ratio. Without the support of an industry to finance the production of the equipment and raw materials necessary to sustain 4:3 image-making, this classic ratio will be relegated to renegade acts of digital pillarboxing.[8]

2.75:1 2.39:1 1.85:1 1.78:1 1.66:1 1.33:1

Figure 2.4: cinematic proportion - aspect ratios

Architectural movies should be such acts. Although the canvas size of a digital movie, as previously discussed, typically has an aspect ratio of 16:9, architectural moviemakers may engage in a strategic dialogue with other aspect ratios, including the classic proportion of 4:3. Different combinations of interpolation, downsampling, cropping, and positioning may achieve the different aspect ratios. The point would be to investigate the effect of image proportion on the depiction of architectural and urban subjects. Built environments raise special issues relating to aspect ratio and the composition of moving images because they are proportional compositions in themselves. They may or may not adhere to a classical or to a mathematically complex notion of proportion, but they nonetheless have a proportional logic that shots may either reinforce or undermine. Heinz Emigholz, an Austrian moviemaker who often addresses architectural subjects, has noted that his recent adoption of the 16:9 aspect ratio has changed the way that he shoots his movies.[9] In his 4:3 works, for example, he often uses tilted camera angles to weaken the power of a building's vertical and horizontal axes, but he refrains from such angles in his 16:9 works because they impart too much imbalance into the wider images.

Certain architectural and urban subjects may suggest an obvious aspect ratio and compositional strategy, but less evident choices may also be explored. For example, a series of narrow and/or close-up shots of a horizontally orientated space may communicate architectural quality that would be less discernible in a single wide shot

that depicts the entire horizontal expanse of the space. The compositional qualities of the built environment that are important to consider include: overall proportions, proportions of various components, axial conditions, structural and material rhythms, human scale, symmetries and asymmetries, and the underlying spatial order of the environment (sometimes referred to as its regulating lines).

Digital cinema affords an enormous amount of flexibility regarding aspect ratio and composition, and this leeway threatens the traditional sanctity of the shooting process. Emigholz, like most moviemakers trained before the advent of digital cinema, calibrates the composition of his shots during the shooting process as carefully as he determines the exposure and focus settings of the shots. He also takes for granted that the aspect ratio of a movie is a function of the aspect ratio of the shots that compose it. An opposing (and no less valid) approach to shot composition and aspect ratio is to shoot footage in a less precise manner and to recompose a shot during the editing process through various combinations of interpolation, downsampling, cropping, and positioning. Such a process may result in a fine-tuning of the composition of an image or in more dramatic changes, including a possible alteration to the original aspect ratio of a shot. Significant changes to the original pixel dimension of a shot, of course, will compromise the quality of the image, but a loss of quality may be acceptable given the objective of the shot in the overall logic of the movie. Each of these opposing approaches to shot composition and aspect ratio may lead to creative and analytical interpretations of a subject that would have been unattainable in the other method, and novice moviemakers should explore both methods, as well as hybrid combinations of them. The act of shooting should never be disregarded as perfunctory, and the potential of editing should never be suppressed for the sake of an ethical position on the nature of true cinema.

The matter of aspect ratio is relatively difficult to manage during the shooting process because cameras typically have a limited capacity to display different aspect ratios. Investigations related to aspect ratio may be best suited to the editing process, but there may be times when an *in situ* aspect ratio analysis is desirable. The most rigorous way to consider aspect ratio variables during shooting is to shoot in full resolution, which will likely be a 16:9 proportion, and to place a simple handmade cropping device over the LCD screen that displays the image. It is important to verify before shooting the extent to which the LCD screen or viewfinder of a given camera reveals the entire image that is captured by the camera. All screens and viewfinders

vary in this respect. Some cameras have settings that letterbox or pillarbox the image on the LCD screen, but these settings add another layer of unreliability and some of them eliminate pixels from the shot. As always, the goal is to capture the fullest and purest shot possible.

File storage, as opposed to celluloid film, is virtually free, and the negligible cost of producing digital shots should affect the moviemaking process in a positive way. At any given site, a moviemaker may capture a multitude of shots, some of which may appear to be better during the shooting process and some of which may reveal their value later during the editing process. The eyes of the shooter and the eyes of the editor are never the same, even if the shooter and the editor are the same person. Shooting and editing provide moviemakers with different types of knowledge about their shots, and the ability to capture multiple shots inexpensively is potentially one of the great assets of digital moviemaking. The danger of this approach is that it is relatively difficult to manage a multitude of shots of a given subject. One way to limit to number of shots that are made is to scrutinize various shot compositions through the lens of the camera but to record only a limited number of them. Every moviemaker needs to find a particular balance between possibility and limitation.

Stasis and Movement

The composition of a moving image is complicated by the fact that it has duration. A shot may be stationary, meaning that the camera does not move and the focal length of the lens does not change throughout its entire duration, or it may be mobile, meaning that either the camera moves and/or the focal length of the lens changes, either at some point during its duration or for its entire duration. A **stationary shot** has relatively few compositional variables. People or objects may move within the shot, or they may enter or exit the shot, but the framing of the space is constant. In the case of a stationary shot of an architectural or urban subject, the shot should communicate an understanding of the built environment that would not be evident in a similarly composed photograph: a lighting condition may change; some form of movement may occur that accentuates a particular spatial quality of the space; a component of the built environment, such as a door or window, may move; et cetera. Sound, which will be addressed in more detail below, may also contribute to the reading of a stationary shot, but it typically should not be the only significant factor that distinguishes a moving image from a still image. The silent film era provides

many examples of richly composed stationary shots with meaningful elements of movement. *The Arrival of a Train at La Ciotat Station* (Lumière Brothers, 1895) uses the platform of the station as the anchor of a diagonal composition that dramatically complements the movement of the train as it enters the frame. A frontal or lateral view of the same scene would have been far less compelling. This is not to say that all stationary shots need to contain spectacular elements of movement, but rather that the composition of a stationary shot should somehow complement the elements of movement or change that occur within it. A complete absence of motion or change in a shot may be acceptable if the shot is used in a sequence in which its preceding and succeeding shots give it meaning. *La Jetée* (Chris Marker, 1962) is composed almost entirely of still images, yet it is extremely cinematic because of the manner in which the shots relate to each other.

Stationary shots typically require a tripod. The placement of a tripod and the zoom setting of the camera are two important variables to consider when composing a stationary shot. Architects who shoot built environments should scrutinize these variables to analytical ends. Stationary shots, for example, may be understood as an act of surveying. The position of the camera lens in a built environment may be considered orthographically as a point in a three-coordinate spatial system, and its distance from certain elements of the built environment may be measured (either precisely or loosely) in all three dimensions. Like an engineering survey, a methodical collection of stationary shots may be used to dissect the underlying geometric condition of a built environment. Adjustments to the coordinates, to the direction of the lens, and to the focal length of the lens may be recorded and studied as variables that affect the nature of the architectural projection in different ways. Such **surveying shots**, to coin a term, are akin to measured drawing, as opposed to freehand sketching, despite the fact that they lack the mathematical precision of true measured drawing. Even if a complete survey of a built environment is not the goal, the position of the camera may still be considered as a point within a geometric system, and a general understanding of the orthographic relationship between the lens and the subject is appropriate to an architectural objective.

In lieu of a tripod, moviemakers may use surfaces within the shooting location as stabilizing devices in order to compose stationary shots. Perhaps even more than strategically placed tripods, these surfaces may add an analytical dimension to the shooting of architectural and urban subjects. Walls, floors, columns, stairs, and other

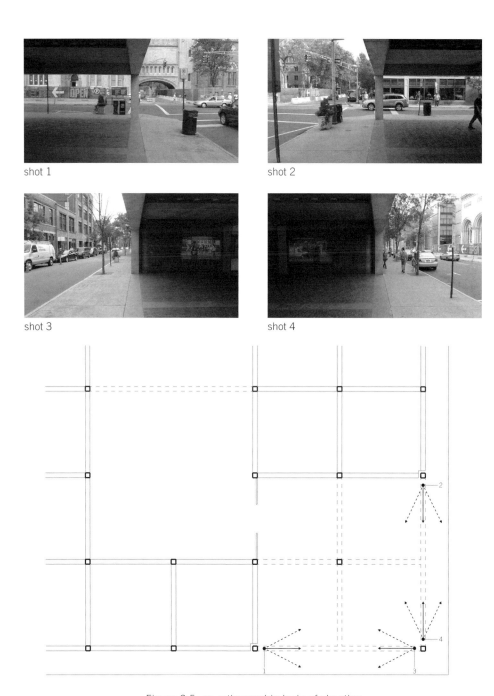

shot 1

shot 2

shot 3

shot 4

Figure 2.5: an orthographic logic of shooting

surfaces within a built environment are already integrated into the compositional logic of that environment, so their use as tripods may capture qualities and relationships that escape typical camera positions. Instead of merely *looking at* the architecture, the camera becomes *part of* the architecture. For example, a camera may be placed in the center of a series of identical windowsills throughout a building in order to record and to compare the interior and exterior spatial views from these locations. Likewise, a camera may be placed on a series of walls or columns, facing both up and down, so that it catalogs different ways in which vertical and horizontal surfaces and elements intersect. The use of architectural elements with different orientations (walls, floors, ramps, railings, et cetera) also has the potential to defamiliarize the depiction of a built environment in compelling ways. Walls appear as floors, and ceiling appear as walls. This sort of inversion is particularly useful for design explorations, as it decontextualizes spatial conditions in ways that may stimulate design ideas.

In addition to the type of movement and change that may occur in a stationary shot, a mobile shot has two additional attributes: the nature of the camera's mobility and the extent to which mobility occurs during the shot. Two types of camera mobility require the use of a tripod with a rotating head: **panning** involves the horizontal rotation of an otherwise stationary camera, and **tilting** involves the vertical rotation of an otherwise stationary camera. **Tracking** involves the linear movement of a somehow stabilized camera along a path (or track) that is typically either parallel or perpendicular to the orientation of the lens. This type of movement requires either a tripod or a stabilizing device, as well as some sort of vehicle on which, or in which, the tripod or device is placed. In early cinema, tracking devices had a handmade quality that novice moviemakers are wise to emulate. Professional tracking equipment is not necessary, and handmade shooting apparatuses have the potential to enhance the creativity and specificity of the shooting process. For example, a tripod may be affixed to a specially designed cart in order to shoot a particular environment in a strategic manner. A **handheld shot**, no matter how stable, does not qualify as a stationary shot because it always involves some movement of the camera, even if it is subtle or negligible to the overall composition of the shot. Handheld shooting typically produces an intentionally rough movement of the camera that does not follow a prescribed path or adhere to a clear geometric logic. Handheld shooting may mimic panning, tilting, and tracking, but it should never try to simulate stationary tripod shooting. The handheld quality of a shot may be subtle or obvious, but it cannot be suppressed altogether. Handheld shooting has an aesthetic that is unique and valuable, and its analytical potential is

worth exploring. **Zooming** is not a type of camera mobility per se, but it simulates movement through an adjustment to the focal length of the lens. Certain types of camera mobility, or simulated mobility, may be combined within a single shot, and it is important to consider how the variables of speed and direction of movement affect each other.

The extent to which a camera moves during a shot is a rich variable: a shot may be mobile for its entire duration; it may be primarily mobile except for a brief moment of stillness; it may be primarily stationary except for a brief moment of movement; it may be mobile only at the beginning or the end of its duration; et cetera. Because mobile shots contain far more compositional variables than stationary shots, it is unreasonable to assume that every frame of a mobile shot may be as carefully composed as a stationary shot. The first and last frames of a mobile shot may be considered bookends that receive more compositional attention, and moments of stillness during the shot, which allow viewers to analyze the compositional qualities more closely, may be considered markers along the duration of the shot. The mobile portion of a shot may feel as though its only purpose is to bring the viewer to a moment of stillness, during which the compositional concerns that affect stationary shots take affect, or the mobility of the camera itself may be the primary objective of a shot, and the compositional concerns that affect stationary shots may be irrelevant. The making of architectural movies is compatible both with carefully composed shots and with more reckless types of composition that privilege movement and rhythm over geometry and proportion.

Sound and Silence

Sound may seem to be the ultimate attribute of pictorial illusionism in a cinematic shot. In fact, the audio of a shot is a variable that may complement either a pictorial or an analytical approach to cinema. There are two categories of sound in cinema: diegetic and non-diegetic. **Diegetic sound** is aligned with (or seems to come from) the environment depicted in the image; sound and image match. An example of diegetic sound is the dialogue between two characters on the screen and the ambient sounds of the space in which they are speaking. **Non-diegetic sound** is misaligned with (or seems not to come from) the environment depicted in the image; sound and image do not match. An example of non-diegetic sound is a voiceover or a musical soundtrack. The distinction between these two approaches to sound, however, is complicated,

as diegetic sound may not necessarily be captured at the same time, or on the same media, as the image with which it is associated. Diegetic sound seems to match the image, but it may come from the soundtrack of another image or from a source that does not even have an image. A diegetic approach to sound, then, may involve either a simple use of the sound that was captured during shooting or an enormous amount of layering and manipulation that belie the apparent direct correspondence between sound and image. A non-diegetic approach to sound similarly may involve either a simple application of a single sound source or a complex set of operations from multiple sources. Some moviemakers use external audio recorders during shooting, as well as independently of shooting, as a way to build a library of sound clips that may be used on various projects in both diegetic and non-diegetic ways. A catalogue of sounds may also be amassed through the use of a camera as an audio device; most, but not all, cameras allow recording to occur with the lens cap still attached to the lens.

Another complication involves the potential ambiguity between diegetic and non-diegetic sound, which commercial movies sometime acknowledge in playful ways. In *Detour* (Edgar G. Olmer, 1945), the sound of a saxophone in the background seems to be a classic example of non-diegetic music, as it is the type of music that pervades the background of nearly every film from its era and genre. When a character in the scene eventually complains about the music, the audience realizes that it is an ambient sound within the environment of the scene and therefore diegetic.[10] Playfulness aside, this example underscores two important factors relating to sound in a cinematic shot. First, a shot may contain both diegetic and non-diegetic sound at the same time. Second, ambiguous relationships between sound and image may be exploited, as the reading of a sound may change throughout the duration of a shot or scene for a particular effect.

In the case of architectural and urban subjects, both diegetic and non-diegetic approaches to sound may be deployed either analytically or pictorially. One may assume that diegetic sound is more realistic and thereby more pictorial, and that non-diegetic sound is more abstract and thereby more analytical, but these are false assumptions. Realistic sound may contribute to an analytical reading of an environment, and conventional uses of abstract sound (such as voiceovers) do not threaten the pictorial illusion of an environment. Architectural movies must mediate between the two types of sound for analytical effects. For example, diegetic sound

Figure 2.6: titles and text

may reveal a spatial quality or parameter, such as depth or distance, that is not apparent in an image, and non-diegetic sound may motivate a reinterpretation of the environment through an obvious allusion to a different, perhaps even opposing, type of environment. The potential ways to create a dialogue between sound and image are limitless, and the most effective analytical uses of sound derive from a specific objective of a given analysis. The important principle to understand is the general capacity to dissociate sound and image.

Silence, of course, is one of the most powerful sounds, in cinema as in life. In an approach to cinema that is somehow akin to architectural drawing and diagramming, it is useful to consider how either a temporary or a complete absence of sound might affect the reading of a moving image of a built environment. The silent film era demonstrates the power of soundless imagery, and its use of text as a supplement to the image is another potential source of inspiration. Although conventional inter-titles simply communicate necessary information that an image fails to convey on its own, text may be used in more creative and analytical ways as well. Titles, for example, may operate as a sort of silent, non-diegetic voice-over or narration. Titles may also operate in a diegetic manner, like a subtitle that translates (or interprets) an aspect of the shot in which it appears.

What is Time?

Even the most casual moviegoer understands that a moving image is merely a simulation of movement, one that is achieved through a succession of still images at a certain rate. Cinema is, then, both a kinetic art and a temporal art, and it is interesting to consider why commercial cinema is referred to as *the movies* as opposed to as *the timies*. The simulation of movement, as opposed to the simulation

of the passage of time, is the defining characteristic of the medium perhaps because the passage of time, simulated or real, is generally ignored. As Saint Augstine writes, "What then is time? If no one asks me, I know: if I wish to explain it to one that asketh, I know not."[11] Moviemakers face a perhaps more complex question: what is simulated time? Gilles Delueze has investigated the meaning of simulated movement and temporal duration in cinema in great depth from a philosophical perspective, most notably in *Cinema 1: The Movement-Image* and *Cinema 2: The Time-Image*. While this book investigates similar issues from a more practical perspective, it generally does not quote from, or even refer to, specific works of philosophy. The methods espoused in this book are simply some of the possible ways to interpret the temporal dimension of the medium, not illustrations of a fully developed theory on the elusive nature of human temporal perception. Moviemaking is inherently a philosophical enterprise, but the ideas on cinematic temporality presented here derive from practical experience and historical analysis, not philosophical inquiries (which are best left to actual philosophers). The extent to which the ideas in this book resonate with certain philosophical traditions is ultimately less important than the extent to which they motivate novice architectural moviemakers to rethink the potential of cinematic duration as an analytical component of architectural projection.

Temporal Resolution

The optical properties that regulate cinema are relatively simple to understand. Movies shot on film generally contain at least twenty-four images per second, or *frames per second* (fps). Moving images that contain fewer than twenty-four fps still appear to be continuous, but not in a manner that suppresses the individuality of the images and gives the illusion of smooth movement. Although the human eye can perceive more than twenty-four fps (exactly how many more is not known for sure), part of the beauty of cinema is attributable to the fact that it does not replicate human vision exactly. Moving images that contain more than twenty-four fps are common in television and may be considered too smooth and too realistic for cinema. Twenty-four fps is a threshold that welcomes us into the illusion of cinema but prevents us from completely abandoning its abstraction. Most digital cameras and editing platforms allow moviemakers, like moviegoers, to disregard the fact that movies are made of frames, and it is important to challenge this tendency. Just as the pixel is the essential building block of the spatial dimension of an image, the frame is the essential building block of the temporal dimension of a moving image. Frame

management is as important as pixel management, and (again) a numerical handling of its temporal resolution offers the moviemaker more control over the process.

The intricacies of frame rates in digital video are well beyond the scope of the amateur, but a few principles are important to note. Unlike the physical frames on a piece of celluloid film that may be managed as individual units in a straightforward and universal manner, video frames are electronic signals that vary according to standards that are region specific. Whereas European countries generally use a video format called PAL, which records and displays images at a rate of twenty-five fps, North American countries generally use a video format called NTSC, which records and displays images at a rate of just under thirty fps (29.97 fps to be exact). To add to the complexity, most high-definition movie cameras have the capacity to record video footage at multiple frame rates. In NTSC countries, the most common are referred to as 24p, 30p, 60p, and 60i. I recommend the use of 30p, which is in fact 29.97 fps, because it is the rate that is most compatible with the NTSC format. Some NTSC moviemakers opt to use 24p, which is in fact 23.98 fps, because they assume that it creates an image that looks more like a film image (because of the classic twenty-four fps rate of cinema). The *look* of film, however, is a factor of many variables, not only its frame rate, and video should be used to its own end, not as a surrogate to film. The higher frame rates of 60i and 60p, which are in fact 59.94 fps, are generally used for "reality like" smoothness. The difference between 60i and 60p is related to how the images are captured and rendered; 60p gives a higher quality image because it uses full frames as opposed to half-frames. In PAL countries, the most common frame rates are referred to as 25p, 50i and 50p. Again, I recommend the use of 25p, which is twenty-five fps. The higher frame rates of 50i and 50p behave similarly to 60i and 60p in the NTSC format.

The principles of frame rate that are important in this context are the frame rate of the shot as captured by the camera and the frame rate of the movie as established by the settings of the digital editing platform. Ideally, movies will be captured at either 30p (NTSC) or 25p (PAL), and they will be edited at the same frame rate. The frame, as opposed to the second, is the most precise unit of measurement for the length of a shot or a movie, and it is important for moviemakers to manage lengths in terms of frames. The notational system for length in digital cinema is referred to as **timecode**. Timecode is measured in eight digits, which are arranged in four pairs: 00:00:00:00. The first pair of digits refers to hours; the second pair refers to minutes; the third pair

refers to seconds; and the final pair refers to frames. All timecode values are always whole numbers. In NTSC movies, the highest frame number is 30, and the fractional nature of the NTSC frame rate is overridden in one of two ways, neither of which concerns the amateur. In PAL movies, the highest frame number is 25. Timecodes are temporal addresses. Every frame within a movie has both a **shot timecode**, related to the timecode assigned to the frame in the camera during shooting, and a **movie timecode**, related to the position of the frame within an edited movie. For example, a frame may have a shot timecode of 00:00:01:12 and a movie timecode of 00:23:14:12. This notation system, which resembles a digital clock, emphasizes the fact that frames in digital cinema operate as the finest unit of time.

Shot Length

In most cases, the length of an original shot is modified when it is inserted into a movie. The possible degrees of modification vary dramatically. An original shot may contain only a small amount of usable footage relative to its overall length, in which case most of the shot is discarded. An original shot may also contain various types of footage that are usable in different ways, in which case the shot is split into several **sub-shots** that are positioned throughout the course of a movie as if they were different shots. The common origin of sub-shots may or may not be obvious. Even when the entire length of an original shot is inserted into a movie, a finer degree of modification should be considered. The fine-tuning of a shot's length through the addition or subtraction of a few frames may affect the nature of a shot in a dramatic way, which is why frame management is so important to moviemaking. During the shooting process, it is always beneficial to extend a shot longer than desired, as excess length is easy to trim, but missing length is impossible to recapture.

The length of an original shot may also be affected by a modification to the apparent speed of the shot. Slow motion effects duplicate frames, and fast motion effects eliminate frames. The easiest way to manage these effects is to adjust the speed of the shot during the editing process. Unfortunately, the speed command in most editing programs is not as controllable as pixel distribution and aspect ratio; nonetheless, it typically provides a reasonably precise percentage-based management of speed. Shots may be sped up or slowed down by a certain percentage, and editors may manage relative percentages between shots or between multiple uses of the same shot. More advanced platforms and plug-ins allow for frame rate management, but,

even if the absence of technology or editing experience, frames may be managed, duplicated, and deleted on a frame-by-frame basis in a relatively straightforward manner. Intention, as always, is important. Silent films were often filmed at sixteen fps and projected at forty-eight fps in order to increase the smoothness of the moving image; each original frame of a shot occupied three consecutive frames of a movie. Some analytical moviemakers, such as Michael Snow, deliberately produce and project films at relatively slow fps rates in order to heighten the abstraction of the moving image in a subtle way. Small adjustments to frame rates and shot speed often have a greater impact than obvious ones, which are susceptible to gimmickry.

Shot length may (or may not) affect the degree to which a moving image is either analytically or pictorial inclined. Relatively long shots may be understood as more pictorial than analytical because they better simulate the continuity of true human perception, and relatively short shots may be understood as more analytical than pictorial because editing cuts may call attention to the artifice of the image; however, long shots may be highly analytical due to their other objective attributes or to their context within a scene or a movie, and short shots may be edited together in ways that heighten the pictorial nature of a scene or a movie.

Shot Adjacencies

Given that the context of a shot within a scene or a movie may be more indicative of its analytical or pictorial nature than its objective attributes, it is important to consider some fundamental issues regarding the adjacency of shots. A cinematic shot is a depiction of a continuous spatio-temporal environment. I use the phrase *spatio-temporal environment* instead of the phrase *space and time* in order to emphasize the inseparability of space and time. Unlike the visual and the aural attributes of a cinematic shot, which may relate to each other in either diegetic or non-diegetic ways, the spatial and temporal dimensions of a cinematic shot are always integral to each other. The ways in which the spatio-temporality of a shot may relate to the spatio-temporality of an adjacent shot are far more negotiable, as adjacent shots may imply various continuities and discontinuities in both space and time.

Two adjacent shots that depict a single spatial environment that exists within a single temporal moment are **spatio-temporally continuous**. The position of the camera in the depicted environment may change in either a slight or a dramatic manner, but

it remains in the same environment. Furthermore, the last frame of the first shot depicts the moment that immediately precedes the first frame of the second shot. Although a significant amount of time may have elapsed between the shooting of the two shots, the illusion of editing gives the impression that no time has elapsed between them. The **shot-reverse-shot** convention of commercial movies is a classic example of spatio-temporal continuity. Typically used for dialogue scenes, the convention involves the construction of two distinct but related camera positions: the first position frames a view of Character A's face and the back of Character B's head; the second position frames a view of Character B's face and the back of Character A's head. The first position is used when Character A is speaking, and the second position is used when Character B is speaking. In the edited scene, the shots from the two positions alternate during the conversation and give the impression of spatio-temporal continuity. The timing of the cuts between shots is meticulously calibrated to the scale of the frame, and the position of the characters' eyes and the directions of their views are precisely composed, all in order to suppress the artifice of the scene's construction, which is significant. Each of the two shots requires a unique positioning of characters and camera/lighting equipment, and all of the shots from the first camera position are captured consecutively before any of the shots from the second camera position are captured. In a sense, these so-called realistic scenes are some of the most abstract examples of moviemaking, as the construction of spatio-temporal continuity requires rather unnatural calculation and coordination.

The easiest way to avoid the tedium of spatio-temporal continuity editing is to avoid editing altogether and to capture long shots that contain the entire scene. Carefully constructed long shots, however, may require an equal amount of tedium of a different sort, and they limit the extent to which a moviemaker may manage the temporal rhythm of a scene or a movie. The **jump-cut** is an editing technique that achieves a less stringent type of continuity, and it creates a type of adjacency that is **spatially continuous and temporally discontinuous**. A jump-cut removes a temporal moment from a spatio-temporally continuous environment in a manner that allows viewers to understand that only a moment has been removed. The scale of the removed moment may vary from a few frames to several seconds or even minutes, depending on the factors that allow viewers to understand the underlying continuity between the two shots. At a certain point, the scale of the removal will no longer qualify as a jump-cut, but it may still qualify as an example of a spatially continuous and temporally discontinuous editing technique. For example, two adjacent shots

last frame of shot 1 first frame of shot 2

Figure 2.7.a: spatial-temporal continuity (shot-reverse-shot)

last frame of shot 1 first frame of shot 2

Figure 2.7.b: spatial-temporal continuity

last frame of shot 1 first frame of shot 2

Figure 2.7.c: spatial continuity/temporal discontinuity (jump-cut)

Figure 2.7: shot adjacencies

may show the same space in noticeably different conditions that imply a passage of time, either forward or backward.

Two adjacent shots that depict different spatial environments that exist within a single temporal moment are **spatially discontinuous and temporally continuous**. A **cross-cut** or **parallel edit** implies this type of adjacency through several back-and-forth cuts between shots of two or more unique spatial environments. In the case of two environments, the rhythm of the cross-cutting is typically regular (A; B; A; B; et cetera). In the case of more than two environments, the rhythm of the cross-cutting may be regular (A; B; C; A; B; C; et cetera) or irregular (A; B; A; C; B; C; et cetera). In all cases, the depiction of an environment in each cycle of the rhythm may include a single shot or multiple shots, but the total length of a cycle is typically relatively short, so that viewers understand the temporal connection. A single cut between two depicted spaces (A; B) typically will not convey the sense of simultaneity that is the goal of this type of adjacency, unless a sound effect, a clock prop, or a supplemental editing device is used to imply temporal continuity. For example, the sound of distant church bells or a common radio broadcast may forge a temporal continuity between two shots after only a single cut. Otherwise, multiple cuts between depicted spaces are necessary in order to imply simultaneity.

Two adjacent shots that depict different spatial environments that exist within different temporal moments are **spatio-temporally discontinuous**. The spatio-temporal gap may be slight or significant, and it may or may not disorient a viewer. A cut between two spatio-temporal environments, for example, may be a simple change of location to which a viewer quickly adjusts. The duration of the temporal lapse may or may not be important, and it may be either implied or explicitly communicated through a title such as "one week later." A more abstract type of spatio-temporal discontinuity derives from the Soviet method of montage, which was developed by Sergei Eisenstein and his colleagues during the 1920s. In *Strike* (Eisenstein, 1925), images of war are quickly juxtaposed with images of a slaughterhouse, so as to imply that war is a form of butchering. In other films, quick cuts between disparate environments simulate the fragmented way in which the mind often absorbs and processes information through association and metaphor. Discontinuities in montage provide meaning that escapes everyday environments. The method is a form of psychological, as opposed to spatio-temporal, realism, and its goal is to communicate messages that engage the viewer, not to create seamless environments that absorb the viewer. Throughout

shot 1 shot 2 shot 3 shot 4

Figure 2.8.a: spatial discontinuity/temporal continuity (cross-cut)

shot 1 shot 2 shot 3 shot 4

Figure 2.8.b: spatio-temporal discontinuity (montage)

Figure 2.8: shot adjacenicies

the history of cinema, the principles of Soviet Montage have been incorporated into many different approaches to cinema, and abrupt spatio-temporal discontinuities do not always communicate definitive messages or clear associations. They may create disruptions that have more ambiguous meanings, if any at all.

All of the adjacencies so far mentioned uphold the illusionistic basis of the cinematic medium because both of the adjacent shots in every case are depictions of spatio-temporal environments. A type of adjacency that will be referred to as **pure discontinuity** occurs only when neither adjacent shot is long enough to qualify as a depiction of a spatio-temporal environment. For example, shots that measure only a few frames long will appear as briefly exposed still images during the course of a movie, and extended sequences of such shots may result in a completely abstract composition. Even indexical images may dissolve into pure rhythms of color, pattern, texture, and light. Although movie frames are generally understood as fragments of an illusionary spatio-temporal continuum, they may also be interpreted as actual graphic images that unfold during an actual period of time in an actual space. In other words, cinema is not necessarily an illusionistic medium. Pure discontinuity may occur throughout the entire duration of a movie, or it may be limited to scenes that are inserted into otherwise illusionistic movies.

It is easy (and problematic) to assume that spatio-temporal continuity epitomizes pictorial moviemaking and that spatio-temporal discontinuity epitomizes analytical moviemaking. Although such generalizations may provide a basis for understanding and exploring analytical moviemaking practices, it is important to resist easy classifications and to recognize ways in which pictorial conventions may be applied to an analytical intention, and vice versa. One way to challenge a common assumption is to undermine the expectations associated with it. For example, a scene that alternates between two spatio-temporal environments in a back-and-forth manner will appear to be an instance of cross-cutting and an example of a spatially discontinuous and temporally continuous adjacency. It may eventually, however, become apparent that it is a different type of adjacency, and the viewer will be forced to analyze it more closely (perhaps similar to the sound of the saxophone in *Detour*).

Transitions

The boundary between two adjacent shots is not always the infinitesimal gap between two adjacent frames. In some cases, moviemakers use a transition that unfolds over multiple frames. During the course of a transition, both shots are visible in a limited manner. A transition may occur quickly (within a matter of frames) or slowly (within a matter of minutes, or even longer) depending on its objective. A transition may also be reversed before it is completed, in which case the second shot never fully takes over the first shot. Most digital editing platforms have both automatic and manual ways to execute transitions, and it is important to use the manual capacity in order to maintain full control over the effect.

A **dissolve** is a transition that gradually adjusts the opacity of two adjacent shots. At a certain frame, the opacity of the first shot begins to decline from 100% to 0%, and the opacity of the second shot begins to rise from 0% to 100%. The decline and the rise typically occur at the same rate, so that they begin and end on the same frame. Dissolves may also occur between a shot and a still black image. These types of dissolves are typically referred to as **fade-ins** (when the black image is the first shot) and **fade-outs** (when the black image is the second shot). The opacity values of images may also be manipulated without the use of a dissolve. For example, two or more shots may be placed on top of each other, and their opacity levels may be adjusted to create a **superimposition**. The extent to which the shots that comprise the superimposition retain their integrity as separate shots is a potentially analytical

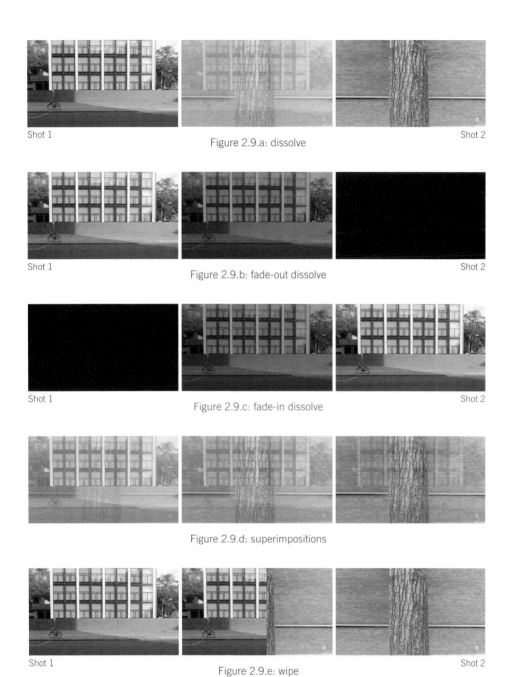

Shot 1

Figure 2.9.a: dissolve

Shot 2

Shot 1

Figure 2.9.b: fade-out dissolve

Shot 2

Shot 1

Figure 2.9.c: fade-in dissolve

Shot 2

Figure 2.9.d: superimpositions

Shot 1

Figure 2.9.e: wipe

Shot 2

Figure 2.9: shot transitions

variable. A superimposition may appear as a series of unrelated layers, or it may appear as a single and cohesive shot. A **wipe** is a transition during which the second shot slowly replaces the first shot along a prescribed path, usually a horizontal or vertical line. In the middle of a wipe, exactly half of each shot is exposed.

Movie Structure

Movies begin and end, either linearly or cyclically. Most movies are organized in a linear manner with a clear beginning and ending, but some are organized as a continuous loop that, nonetheless, will eventually be recognized as a discrete cycle. In linear movies, the beginning and the ending are opportunities to manage the relationship between viewers and the screen. Movies may begin and/or end in a gradual manner that eases viewers into and/or out of the screen. Title and credit sequences, for example, commonly serve as transitional devices between the real world and the world of the movie. An **establishing shot** at the beginning of a movie, such as a wide view of a city skyline or a landscape, may introduce viewers to the context of their new temporary world before they enter it more fully. A similar type of shot at the end of a movie may be used as a gentle farewell to that world. Conversely, movies may begin and/or end in an abrupt manner that jolts an audience into and/ or out of the screen. A movie, for example, may forego the use of a title sequence and immediately throw its viewers into the middle of an action that is clearly already underway. An abrupt ending may have a similarly disorienting effect that renders the movie as a fragment of a world, as opposed to a complete vision of one. Regardless of how a moviemaker manages the beginning and the ending of a linear movie, it is undeniable that the first frame and the last frame of a movie are unique. As the primary thresholds into and out of a movie, they should not be taken for granted. What are the first thing and the last thing that a viewer sees? In cyclical movies, it is important to consider whether the evidence of the beginning and the end of the cycle is accentuated or obscured. Is the cycle a clearly defined sequence that recurs, or does it suggest that beginnings and endings are irrelevant?

In between the first and the last frame of a movie lies a composition of frames. The structures and lengths of movie compositions, like those of musical compositions, vary considerably. A movie may adhere to a known structural formula, as would a short pop song or an epic classical symphony, or it may resist structural clarity, as would a jazz improvisation or a guitar solo. An extremely mathematical approach to

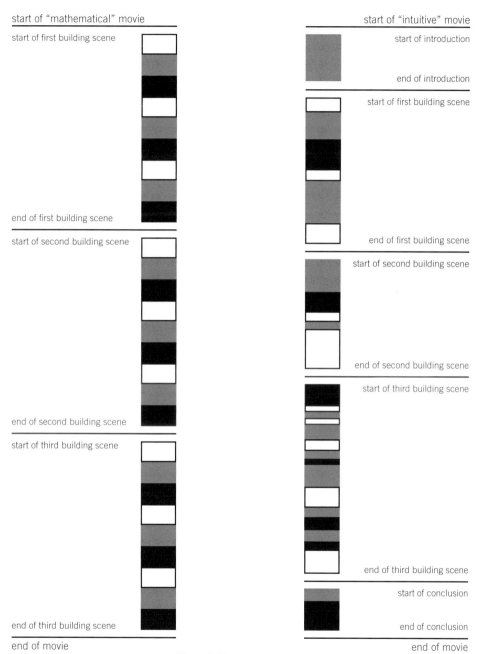

Figure 2.10: movie structure
color of box denotes type of shot; height of box denotes relative length of shot

composition would be to predetermine the length and the type of every shot according to a system of proportion. For example (Figure 2.10), a movie that investigates building thresholds may be designed to have three primary sections, each of which focuses on a particular building type. In each section, there may be nine shots that depict three buildings of a particular type in exactly the same manner: shots one, four, and seven may be stationary shots of the buildings' elevations; shots two, five, and eight may be handheld tracking shots that pass through the threshold of the building; shots three, six, and nine may be overhead shots of the threshold conditions taken from the roofs of the buildings. This entire structure may be designed prior to the shooting process, which becomes a relatively, though not entirely, mechanistic process. Conversely, the same movie premise may be achieved through an extremely intuitive approach to composition, and the structural nature of the movie may depend entirely upon the results of the shooting process. The same nine buildings may be shot according to the logics of their thresholds, and the number, length, and type of shots may vary according to those logics. Whereas the mathematic approach may allow a viewer to compare and contrast the buildings through a controlled set of variables, the intuitive approach may allow a viewer to compare and contrast the buildings through the different shooting methods that they motivated. Both of these extreme approaches to movie composition, as well as all of the possible variables in between, may be equally structured and rigorous. The difference lies merely in the criteria that regulate the structure and inform the rigor. Mathematical approaches may seem more meticulous than intuitive approaches, but that appearance may not be true in every case.

It is, again, easy to assume that mathematical approaches to movie composition are more analytical than pictorial, and that intuitive approaches to movie composition are more pictorial than analytical. After all, the evidence of structure in the mathematical approach calls attention to the artifice of the medium and to the fact that movies are composed, while the apparent lack of structure in the intuitive approach suppresses the same qualities. Mathematically composed scenes, in fact, may be inserted into an otherwise intuitively composed movie in order to create what Benjamin referred to as analytical shock effects. Likewise, intuitively composed scenes may be inserted into an otherwise mathematically composed movie in order to create what may be referred to as pictorial anti-shock effects. It is important, however, to remember that several factors contribute to the analytical or pictorial nature of a scene of a movie. A movie, for example, may adhere to a strictly mathematical structure that is somewhat obscured by the use of relatively long shots. The proportional rhythms underlying the

structure of the movie may be less obvious but no less strict than ones in movies that consist of relatively short shots. Conversely, an intuitive process of editing may result in a highly analytical movie because of the intentions of the cuts. Every shot, for example, may be cut twenty-four frames after the first appearance of a human figure in the image.

Film Form

The preceding notes on movie construction briefly touch upon many general issues that may be (and have been) written about at great length. This book is not meant as an instruction manual for moviemaking, but rather as a mode of demystification. One of the best ways to learn moviemaking is to watch movies, including ones that are not part of mainstream cinema. Obscure and difficult movies often reveal some of the most inventive ways to depict spatial and temporal conditions. Even mainstream movies, however, offer astute viewers a wealth of learning opportunities. The key is to analyze the processes behind the creation of the imagery. Of course, learning involves a loss of innocence, as knowledge of the underlying logic of moviemaking may prevent viewers from enjoying movies in the manner that they used to enjoy them. To make the most of this new knowledge, informed viewers should become avid (albeit perhaps amateur) moviemakers themselves. As already mentioned, digital tools allow amateurs to develop a distinct craft and to explore the potential of cinematic imagery in unprecedented ways. How can architects, researchers, and students of both design and history use the foundational logic of the medium to build a new approach to the medium that engages their unique understanding of spatial and temporal experience?

Part II—Matters of History

The Non-linear Progression of Linear Perspective

Most of what I have to say is, of course, in substance an old story; but it is a story which can, I think, be told again with profit, so as the better to lead up to the matter that is comparatively new. That I have anything to offer that is absolutely new, that I have in my explorations found any field absolutely untrodden by my predecessors, I can hardly suppose: I am too used, in these regions, to discover the footprints of unknown or forgotten pioneers in what I had taken to be really *terra incognita*. But I am sure that if the reader will accompany me, he will come to some things that, if not absolutely novel, are new to him, and that he will reach some points of view from which the more familiar ground will present an unaccustomed aspect.

William Ware, *Modern Perspective: A Treatise*

The construction logic illustrated in Chapter 1 has an ambiguous relationship to the history of linear perspective. On the one hand, it is the result of uninformed experimentation. On the other hand, every aspect of it may be located in the historical record. All of my empirical discoveries regarding the drawing system were, in fact, rediscoveries, and my contribution to the discourse on linear perspective is thereby limited to the way in which I have organized a collection of preexisting properties and operations. This chapter explores the historical origins of some of those properties and operations, as well as some historical examples of architecture and urbanism that derive directly from a use of linear perspective in the design process. The goal is to mine the history of linear perspective for themes that resonate with the objectives of this book, not to provide either a comprehensive history or a theoretical interpretation of the drawing system. Historical inquiry may be unnecessary for a rudimentary practice of linear perspective, but it is invaluable to a consideration of drawing as a creative act. The potential of linear perspective to inform architectural thinking is equal to (or perhaps even greater than) its usefulness as a graphic implement. As mathematician Morris Kline says of projective geometry, "The science born of art proved to be an art."[1] Contrary to its reputation as a deterministic procedure, linear perspective is an interpretative process. While it is a spatial system that adheres to strict conventions, it nonetheless provides multiple points of entry and allows for multiple modes of navigation. Even a brief historical sketch of linear perspective, such as this one, reveals it to be both astonishingly simple and impossibly complex. If linear perspective is an art at all, it is an art of the sublime. Even after years of drawing, reading, and teaching on the subject, I find myself at times lost in the drawing system and doubting that I truly understand it. Once I regain my orientation, which so far I have always managed to do, I assume that I have reached the bottom of an abyss. Inevitably, it reopens and pulls me deeper.

My somewhat dysfunctional relationship with linear perspective began against my will and with no regard for its historical richness or conceptual ambiguity. It was part of the curriculum where I first taught, and I was in no position to challenge its inclusion. At first, perpetuating my ignorance on the subject, I communicated a construction method from a textbook and avoided any theoretical discussion of geometry. Students occasionally asked questions that neither my colleagues nor I could answer, so I began to conduct drawing experiments and to discuss the drawing system with my colleagues. Subsequent rounds of instruction led to more questions and more drawing experiments. I slowly discovered geometric properties of the

drawing system, but I considered my drawing experiments to be little more than a fascinating and frustrating hobby. At some point (I cannot recall when), linear perspective became something more. When I was no longer required to teach it, I found myself continuing to do so. I even expanded its role in the curriculum and defended it against accusations of irrelevance from skeptical students and colleagues. After several more cycles of teaching and drawing, I realized that I had unwittingly and incrementally developed a distinct method of instruction—perhaps not unique, but at least more original and conceptual than common textbook methods. At that point, I finally delved into history and recognized deep correspondences between my evolution as a drawing instructor and the historical development of the drawing system. One example is my discovery of the properties of the so-called distance point. For years, I used a distance point method to construct correct drawings, but I did not understand the geometric properties of the distant point. Once I uncovered the geometric mysteries of the distant point, I was able to abandon its use and to develop a more mathematically and sophisticated method. A parallel development is evident in history: practitioners of linear perspective in the Renaissance (and perhaps even before) used distance point methods successfully, but they were unaware of how or why such points worked; by the seventeenth century, theorists understood the distance point, but their advanced methods made little of use it.[2] Other parallels between my empirical discoveries and the historical record are discussed later in this chapter. The point I want to make here is that the history of linear perspective, while intimidating in its complexity, is a source of endless wonder for people who love to draw. Without the burden of trying to understand every historical intricacy, architects may enjoy the rediscovery of the historical traces of their drawing conventions.

Rabatment

A rebatment is a rotation of one orthographic view into the plane of another orthographic view, specifically along an axis of intersection between the two views. For example, rebatment occurs when a plan of a building is rotated into one of its elevations, or when a side elevation is rotated into a front elevation. Rabatment allows for the projection of lines between views and, consequently, for the construction of drawings from other drawings. Rabatment may also refer to the results of such a rotation: a composition of interrelated views within a single drawing surface (analog or digital).[3] All linear perspective construction methods involve some sort of rabatment, some of which are more legible than others. A specific rebatment is

effective when it facilitates a preferred method of construction, but the nature of Euclidean Space allows for variability. Any given rebatment may be used to execute multiple construction methods, and any given construction method may be executed through multiple rebatments. Still, the variables are limited, and the rebatment of a construction method informs both its practical and theoretical logic.

The construction method introduced in Chapter 1 stipulates a precise rabatment: a plan lies at the top of the composition; an elevation lies below and to one side of the plan; a linear perspective emerges below the plan and to the side of the elevation. This rabatment allows for the construction of any variation of any type of linear perspective (frontal or oblique) in the same manner. Its flexibility suits my pedagogical objective of demonstrating that different types of views obey the same geometric properties. In the given demonstration, the plan and elevation are assumed, and a specific series of operations leads to the gradual emergence of the linear perspective; however, inverse and less cumulative constructions are also possible. Lines may be projected between these three views in multiple directions and may create an infinite number of new views, both orthographic and perspectival. The construction of each additional view results in the creation of a new rebatment, as the composition of the views on the drawing surface changes through the addition of new views.

Historical examples of rebatment reveal an incredible diversity of approaches to the construction of a linear perspective. Many are difficult to understand at first glance, and some are so abstract that they appear like characters from an unknown graphic alphabet. Every rabatment may be interpreted as a dialect of the geometric language of linear perspective, many of which are no longer active. Some of them offer insights into the drawing system; others offer warnings to heed while drawing; still others are simply beautiful works of graphic logic and craft. The following pages contain a selection of rebatments from various periods. I have redrawn them, simplified some of them, and coded their line weights for the sake of comparison. In each diagram, heavy black lines describe the baseline and the object of projection (in both orthographic and perspectival views); gray lines describe perspectival construction lines; dashed lines describe the ground line, the measuring plane, and the horizon line; black circles describe the viewing point, and gray circles describe vanishing points.

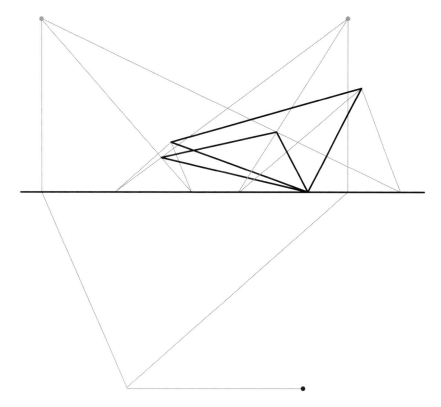

Figure 3.1: Rebatment of Guidobaldo del Monte, 1600 (redrawn by author)

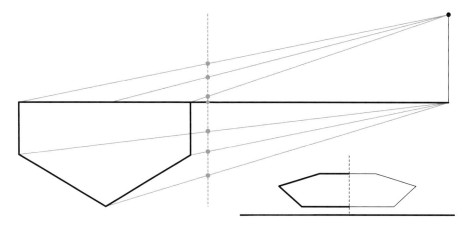

Figure 3.2: Rebatment of Lorenzo Sirigatti, 1596 (redrawn by author)

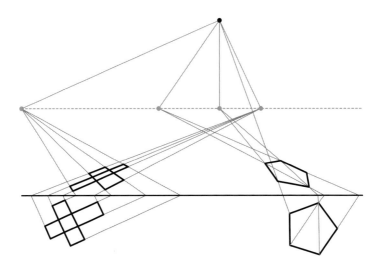

Figure 3.3: Rebatment of Brook Taylor, 1715 (redrawn by author)

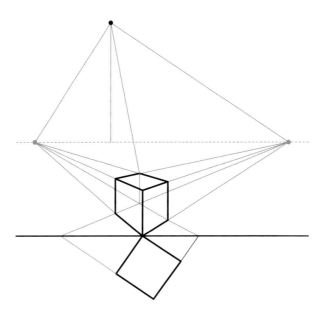

Figure 3.4: Rebatment of Joseph Highmore, 1763 (redrawn by author)

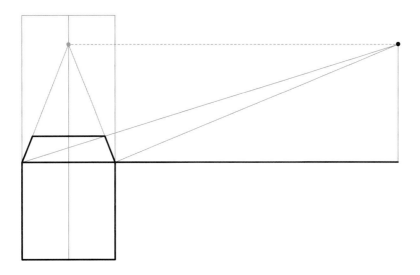

Figure 3.5: Rebatment of Pietro Accolti, 1625 (redrawn by author)

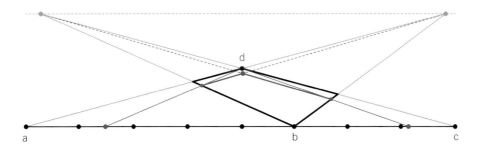

Figure 3.6: Rebatment of Joachim Ringelberg, 1531 (redrawn and altered by author)

Given his goal to draw the image of a rectangular that has a true measurement of five-by-three units, Ringelberg's rebatment is incorrect. The distances between the measuring points on the baseline are five units (a:b) and three units (b:c), and it may be assumed that the vanishing points in the drawing correspond to lines in plan that intersect the measuring plane at 45°. In orthographic projection, the triangles ADB and BCD are therefore isosceles triangles, and their sides may not be the same length as their base. The image of a rectangle that has a true measurement of five-by-three units has been superimposed over Ringelberg's construction (in gray); it is described by construction lines that use the central vanishing point and an unseen plan view. Ringelberg's error is warning against assumptions. Commonsense may defy math.

Discovery or Invention

Filippo Brunelleschi constructed the first linear perspectives in the beginning of the fifteenth century. The exact date is debatable, but it is universally accepted that he constructed views of two buildings in Florence, the Baptistery and the Palazzo dei Signori, sometime around 1410. The view of the Baptistery was a frontal perspective (commonly, and incorrectly, referred to as a one-point perspective), and the view of the Palazzo dei Signori was an oblique perspective (commonly, and incorrectly, referred to as a two-point perspective).[4] In late-medieval painting, both frontal and oblique views of architecture are common (albeit without the "correctness" of linear perspective), so it is possible to interpret Brunelleschi's views as direct references to the late-medieval tradition of painting. He was not, however, a painter, and his constructions were not exactly paintings. Although his constructions have been lost, written accounts describe them as handheld panels, each with a property that distinguishes it from normative painting. In the Baptistery panel, Brunelleschi inserted a peephole. Viewers looked through the peephole from the back of the panel in order to see the image of the Baptistery on a mirror, which the viewer held at arm's length in the front of the panel. The Palazzo dei Signori panel was too large to accommodate the same type of mirror viewing, as the viewer's arm would not have been long enough to hold the mirror in the correct position.[5] As if unsatisfied with a straightforward panel, Brunelleschi removed the portion of the panel that would have contained the sky above the buildings. Viewers used the real sky to "complete" the view. In each case, although the type of architectural view may have been familiar, the venue and mode of viewing were unlike those of traditional painting.

The exact processes that Brunelleschi used to construct the panels, as well as some of their details, are matters of endless debate among art historians. The theological and scientific objectives that motivated Brunelleschi are even less clear. It is known that he was a devote Christian, an engineer, and an architect, but it is difficult to assume how those attributes may have complemented (or contradicted) each other at that time. A more relevant debate in the context of this book is to consider whether Brunelleschi's constructions amount to the discovery or to the invention of linear perspective. Samuel Y. Edgerton summarizes the matter this way:

> The distinction between the words "discover" and "invent" here is
> intentionally provocative. "Discover" implies that linear perspective is
> an absolute scientific truth, universal to all men regardless of cultural

background or historical period. "Invent," on the other hand, suggests that linear perspective is only a convention, the understanding or adoption of which is relative to the particular anthropological and psychology needs of a given culture.[6]

This debate reflects the emergence during the Renaissance of a distinction between perspectiva naturalis (the way that we naturally see) and *perspectiva artificialis* (an artistic convention that simulates, but does not replicate, how we see).[7] While I unequivocally consider linear perspective to be an invention, *perspectiva artificialis* is not the goal here. Realistic depictions of embodied seeing limit the analytical potential of architectural imagery, and the goal here is to *reinvent* linear perspective as a mode of architectural inquiry. Brunelleschi's apparatus-like panels are a great source of inspiration. Regardless of his sources of inspiration, he practiced a radical mode of image construction and overturned expectations of pictorial viewing. The objectives and results of contemporary architects and architecture students may be more modest, but the spirit of the panels may persist. How can new modes of drawing motivate a new understanding of architecture that escapes current drawing practices? Whatever larger meaning linear perspective fulfills in Western civilization, how may its properties and operations be managed in order to construct imagery of architectural qualities that escape normative vision? Another source of inspiration may be the so-called corruption of classical proportion in the seventeenth century that led to the battle between the Ancients and the Moderns (between figures who upheld classical models as immutable ideals and those who viewed them as precedents for further development). Claude Perrault, a leading Modern who designed the innovative east façade of the Louvre, argued for interpretation (or invention) in architectural design.[8] Instead of following rigid rules regarding the proportion of columns and the composition of architectural elements, Perrault incorporated a variety of influences, including Gothic architecture, into his Classical vocabulary. Similarly, practitioners and students may consider established uses of linear perspective as precedents that invite interpretation, not as deterministic models.

Tiles

Immediately following the appearance of Brunelleschi's constructions, Florentine artists began to copy and/or adapt whatever method he had used, with varying degrees of precision. Masaccio's *The Holy Trinity* (1425), for example, is a masterwork of this period. The quick adoption of linear perspective into the discipline of art slightly

precedes the first written account of linear perspective, Alberti's *On Painting* (1435). This treatise codifies a method for the construction of a linear perspective, but it fails to provide any mathematical justification for the legitimacy of its *costruzione legittima*. Alberti acknowledges the omission and implies that his readers would probably not understand (or care to understand) the complexities behind the method: "I usually explain these things to my friends with certain prolix geometric demonstrations which in this commentary it seemed to me better to omit for the sake of brevity."[9] Instead of a tedious geometric explanation (which may have shed some light on Brunelleschi's actual construction method), Alberti provides a formulaic construction method based on the notion of a visual pyramid (Figure 3.7). The eye of the observer is the apex of the pyramid; a shape on the ground is the base of the pyramid; and the painting surface is a slice (perpendicular to the ground) through the body of the pyramid. The concept of Alberti's visual pyramid adheres precisely to the principles of projection discussed in the introduction of this book: the eye is the point of projection; the shape on the ground is the object of projection; and the painting is the surface of projection (Figure 0.2).

Alberti does not include drawings or diagrams in his treatise, but it is clear that the construction method described by his text involves two separate drawings (Figure 3.8). The first drawing is a frontal view of a rectangular ground plane (or floor) that recedes to what may be called a vanishing point on a horizon line that lies at infinity; Alberti uses the term "centric point" and describes its location as being on the painting (or picture plane) itself, not at infinity.[10] The width of the painting determines the width of the floor, which is divided (according to a measured scale) into linear segments that correspond to the width of a tile. The second drawing is a side view of the orthographic relationship between the viewing point, the measuring plane, and the floor. The floor line in this view includes points that correspond to depth of the floor tiles, which are measured in the same scale that determines the width of the tiles in the first drawing. Projection lines from the viewing point to the tile points on the floor line intersect the measuring plane, and these points of intersection are transferred to the first drawing in order to locate the foreshortened depth of the floor tiles in the frontal view of the receding floor plane. Once a painter understands how to construct the image of a square-tiled floor in a rectangular room, more complex floor patterns and room shapes are well within reach, but Alberti provides details on only basic forms of construction. It is interesting to note that Alberti's method does not include a projective operation to locate heights. His concept of the visual

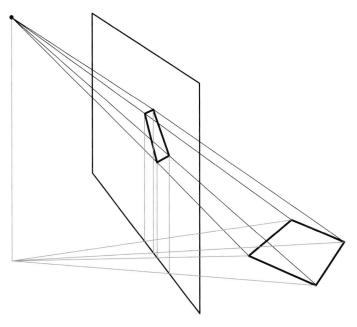

Figure 3.7: The visual pyramid metaphor of vision

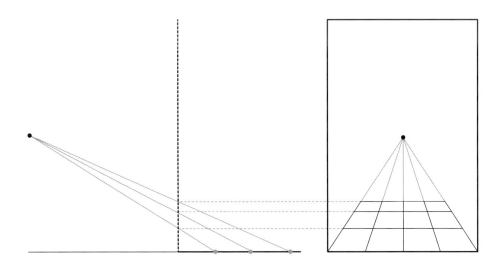

Figure 3.8: Visual pyramid construction method as described by Alberti

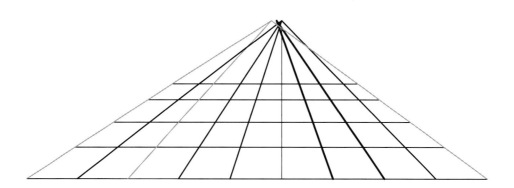

Figure 3.9: Diagram of a tiled floor in "proto-perspective"

pyramid presupposes a flat shape on the ground, not a three-dimensional object. To address the vertical dimension, he provides a ratio that allows the painter to locate heights above a point on the floor through a physical measurement on the painting.[11] Ironically, although Alberti's visual pyramid method is famous for its understanding of the canvas as a window, it is an entirely floor-based operation. Projective procedures to locate heights appear only in later treatises.

Alberti's emphasis on the floor must have seemed familiar to early Renaissance painters. In the late-medieval era, prior to the codification of proper linear perspective, tiled floors (and beamed ceilings) play an important role in the construction of paintings. They allowed painters to achieve a reasonable degree of pictorial accuracy even in the absence of mathematical correctness. In Ambrogio Lorenzetti's *Annunciation* (c. 1344), the patterned floor tiles regulate spatial depth, define the back edge of the depicted space, and provide a richly detailed stage for the meeting of the Virgin and the angel Gabriel. The construction is by no means a "correct" linear perspective in the mathematical sense of the term, as the lines of the floor tiles do not converge at a single point, and as the depths of the tiles do not recede in a proportional manner. I refer to this type of construction as a *proto-perspective* (Figure 3.9). The painting is a

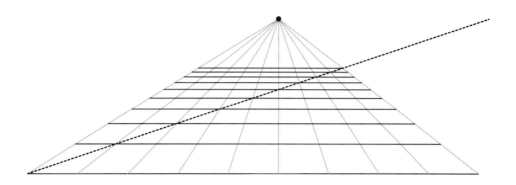

Figure 3.10: Diagram of Alberti's diagonal verification

convincing illusion of space, and Lorenzetti imbues the floor with a special narrative significance through the use of detail and color. Even the gold leaf background of the painting cannot detract from the intensity of the floor. Duccio's *The Last Supper* (c. 1308) makes use of a tiled ceiling in a comparable manner. Again, it is a horizontally oriented architectural surface that frames or "holds" the scene, and it demonstrates a degree of understanding about the convergence of parallel lines in space. Given the subject matter of a densely packed group of men sitting around a table, the floor in this case is barely visible, and Duccio treats the horizontal surface of the tabletop almost as a vertical canvas-within-a-canvas that displays the supper. To Modern eyes, the table appears as though it is being tipped, and the parallel lines of the tablecloth actually diverge instead of converge. The ceiling, therefore, is the primary spatial regulator. In both of these examples, the roots of Alberti's floor-based visual pyramid method are evident, albeit without the mathematical precision: a horizontal (and architectural) surface orders the spatial depth of the painting.

Alberti provides his readers with a way to verify the correctness of their tiled floors (Figure 3.10): if a diagonal line through a tile in the nearest row is extended into the depth of the painting, the same line should act as a diagonal line through all

of the tiles that it crosses. Alberti sees this line only a means of verification, but if this line is extended until it reaches the horizon line, it marks the location of a vanishing point that corresponds to pure diagonal lines in plan (ones that intersect the measuring plane at 45°).[12] This point is referred to both as a diagonal point (for obvious reasons) and as a distance point (for less obvious reasons). Diagonal point methods appear early in the history of the drawing system, and scholars assume that they emerged from workshop traditions and, thereby, from empirical discoveries.[13] In these methods, one or two diagonal points are used to construct gridded surfaces with accurate foreshortening of the depth of each row of the grid; it was understood that the use of a diagonal line regulates the determination of depth. Drawings in a French treatise by Viator, *De artificiala perspectiva* (*On Artificial Perspective*, 1505), demonstrate that, again, it is a floor-based operation (Figure 3.11). The grid derived from a diagonal point method provides a ground map on which to locate different components within the scene of the painting. Such a grid may or may not have a known scale. Alberti defines the scale of his grid precisely in terms of a common Florentine measure, the braccia, but the construction of a floor grid does not require the determination of a precise scale. If accurately executed, a diagonal point method is far more sophisticated than the attempts at convergence by Lorenzetti and Duccio, but not as mathematically informed as a visual pyramid construction. In some instances, that was exactly the point. Hieronymus Rodler published a diagonal point method by Johann II von Simmern in 1531 because he considered Albrecht Dürer's mathematical method to be too complicated for painters to execute.[14]

During the sixteenth century, diagonal points became widely understood as distance points.[15] There is absolutely no mathematical difference between the two types of points. The difference, instead, lies in the acknowledgement that the location of the distance point on the horizon line is a function of the location of the viewing point in plan. The distant point is a vanishing point for diagonals because its distance from the central vanishing point is equal to the distance between the viewing point and the measuring plane in plan: the viewing point, the distance point, and the intersection of the viewing ray and the measuring plane form an isosceles right-angled triangle (Figure 3.12). The distance between the viewing point and the measuring plane affects distortion in linear perspective, so it is understandable why painters would adopt a more sophisticated understanding of the diagonal point. Viator, for example, recognizes that an increase in the distance between two diagonal points on the horizon line creates an effect that is equivalent to the eye of the observer moving

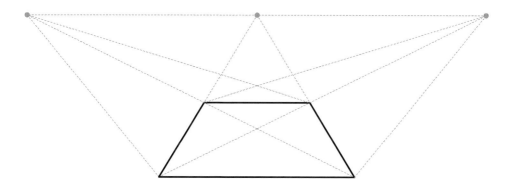

Figure 3.11: Viator's diagonal point method (redrawn by author)

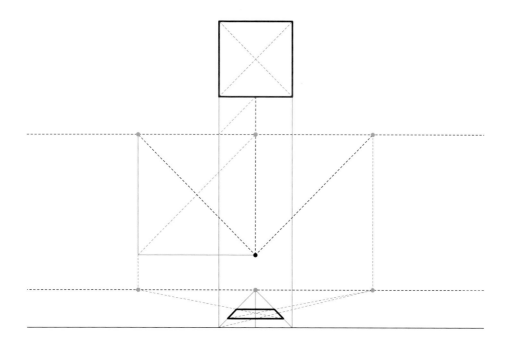

Figure 3.12: Distance point method

further away from the object of projection, but he does not care to precisely define his diagonal points as distance points.[16] His aim is to make pictures, not to contemplate or to achieve mathematical correctness. An ability to manipulate the distortion of a tiled floor was sufficient, and the need to calculate it was not necessary.

Despite varying degrees of correctness and sophistication, gridded architectural surfaces are critical both to the emergence of proto-perspective prior to Brunelleschi and to the practice of Albertian perspective throughout the fifteenth century. It is no coincidence that Brunneleschi used existing works of architecture as the subjects of his perspective panels. The drawing system descends from architecture and relies upon it. Alberti, however, not only discourages its use as a tool of architectural inquiry, but also codifies a construction method (the visual pyramid) that obscures a full awareness of the architectural nature of the projective act. A plan and an elevation are embedded within the visual pyramid, but they are difficult to discern within his formula for the construction of a painting. Does Alberti intentionally obscure the presence of orthographic drawings in the visual pyramid, so as not to compromise his warning against the use of linear perspective in the architectural design process? According to Robin Evans, "… it is not perspective as such but rather the particular means of its construction that gives bias to its content."[17] Alberti certainly realizes that orthographic projection and linear perspective are two sides of the same coin, but perhaps his biases led him to separate them into distinct disciplines and to erase the evidence of their underlying connections. Alberti understands linear perspective as a frontal view onto a space that is detached from a viewer, and he understands architecture as something more than an object that is detached from its users. If he had had the benefit of a mathematical understanding of the drawing system, Alberti may have seen more possibilities for the use of linear perspective in the design process. The bias of this book is to privilege the analytical potential of linear perspective over its "mere" image-making capacity, and the bias relies on an understanding of the relationships that are hidden within the visual pyramid and underneath the gridded surfaces.

Piero's Points

Whereas Alberti's explanation of linear perspective is opaque, Piero della Francesca's explanation of it revels in transparency. Toward the end of his life, sometime in the 1480s, he publishes a treatise on perspective (*de Perspectiva*) that includes not only

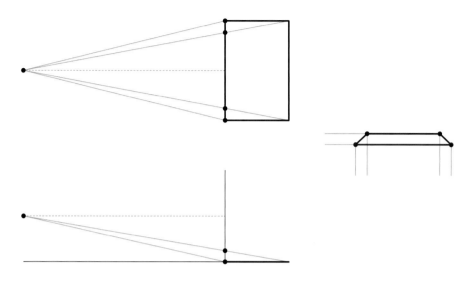

Figure 3.13: Author's interpretation of Piero's *coordinate method*

methods, but also explanations and proofs of the methods. Unlike some treatises on linear perspective, like Alberti's, which promote only one procedure that complements whatever objective the author has for the drawing system, Piero's treatise offers a variety of methods that illustrate the malleability of linear perspective—the fact that different procedures may lead to similar, if not exactly the same, results. One of his methods, which I will refer to as the *coordinate method*, involves the explicit use of a plan and an elevation (Figure 3.13). Piero projects lines in each of these orthographic views from a viewing point, through a measuring plane, and to the vertices of an object of projection. Each projection line in each view generates a coordinate at its point of intersection with the measuring plane. Each vertex of the object of projection is assigned one coordinate from the plan and one coordinate from the elevation. Piero then uses those coordinates to plot the vertices on a third drawing, which is considered to be the linear perspective. The final step, essentially, is to connect the dots in order to reveal the image of the object in linear perspective. The entire picture is determined without the use of any projective operations on the surface of the linear perspective itself. Projection occurs, but only within the plan and the elevation.

The value of this method, as Piero's examples of thrice-rotated cubes and human heads illustrate, is that it is a relatively simple way to construct linear perspectives of complex shapes. The word relatively is important here, as the constructions are complex (imagine drawing several plans and sections of a head). Still, the logic of these constructions is relatively straightforward. The virtuosity of Piero's work results as much from patience as from skill and knowledge. It is also notable that, unlike Alberti's visual pyramid method, the coordinate method locates points above the ground plane in the same manner as points on the ground plane. The tyranny of the floor has been lifted.

The abstraction of Piero's coordinate method is a stark departure from the literalness of some of the tiled floor methods. Piero, in fact, was ahead of his time, as the coordinate method demonstrates a fundamental property of linear perspective that figures prominently in treatises by mathematicians in the seventeenth century: every point in space has a corresponding image in a linear perspective that is also a point (the image of a point is a point).[18] Every point in space is connected to the viewing point through a viewing ray, and the point where the viewing ray intersects the measuring plane is the image of that point in a linear perspective. If the point in space is in front of the measuring plane, then the projection line is extended through the point until it meets the measuring plane. This is exactly the same logic as the visual pyramid, except for the fact that it emphasizes points instead of figures. An emphasis on points is typically a sign of a mathematical (or theoretical) approach to linear perspective, as opposed to a painterly (or practical) approach. Piero manages the blur the distinction, as he uses abstract points in order to create a literal image.

The construction method illustrated in Chapter 1 may be interpreted as a distant ancestor of Piero's coordinate method. According to its logic, the image of a point is the intersection of the images of three lines: an orthogonal line (x-axis), a horizontal line (y-axis), and a vertical line (z-axis). The only difference between this understanding of the image of a point and Piero's coordinate method is the venue of the projective procedures. Whereas the method illustrated in Chapter 1 locates the images of points in linear perspective through projective procedures directly in the linear perspective, Piero performs projective procedures in two separate drawings, which indicate the surface coordinates of points in a third drawing. In other words, whereas Piero draws in plan, elevation, and perspective separately, the method illustrated in Chapter 1 advocates drawing in plan, elevation, and perspective all at

the same time and in the same place. Piero's coordinate method, therefore, avoids the use of a specific rabatment, and the construction lines that inform the making of a drawing do not appear in that drawing. Because the inclusion of construction lines is critical to an analytical understanding of linear perspective, the cleanliness and pictorial literalness of Piero's coordinate method are incompatible with the objectives of this book; however, its analytical nature—the way in which it dissects the object of projection into a collection of points—is a vital source of inspiration.

Piero's coordinate method curiously does not involve any vanishing points, which is another major difference between it and the method illustrated in Chapter 1. The latter relies on an ability to locate an infinite number of vanishing points, so that the images of lines may be used to locate the images of points. Other methods in Piero's treatise employ vanishing points, but the coordinate method simply does not need any, and this raises an existential question: is a linear perspective without vanishing points truly a linear perspective? A similar question may be addressed to Alberti's visual pyramid: is a linear perspective that employs only a single vanishing point truly a linear perspective? The conclusions in Chapter 1 establish that the construction of a linear perspective requires at least two vanishing points because depth cannot be located through the use of only one vanishing point. Piero's coordinate method circumvents this rule through his use of two orthographic drawings outside of the linear perspective, and Alberti's visual pyramid method circumvents it through his use of one orthographic drawing outside of the linear perspective view (the side view of the relationship between the viewing point, the measuring plane, and the object of projection). The conclusions in Chapter 1, while valid, are not absolute. The intrinsic correspondence between orthographic drawing and linear perspective, as well as the multiplicity of possible entries into and navigation paths through the drawing system, render rules about linear perspective relative. It is no wonder that the drawing system has confused and captivated so many makers and thinkers over the course of its six-hundred-year history.

The Mathematics of a Point

The "missing" vanishing points in the coordinate method and the visual pyramid method are indicative of the fact that fifteenth- and sixteenth-century practitioners and theorists of linear perspective understood vanishing points (as well as the entire drawing system) differently than they do today, but not incorrectly. An empirical use

of a vanishing point may be mathematically correct even if a draftsperson does not understand the vanishing point mathematically. As Kirsti Andersen explains:

> Gradually the level of theoretical insight became more profound, and by the end of the sixteenth century the seeds for a complete understanding were scattered around in various writings. The time had grown ripe for the emergence of a general theory of perspective, and such a theory was indeed created by Guidobaldo del Monte. With his book *Perspectivae libri sex* (1600) he became ... the father of the mathematical theory of perspective. This accomplishment would have been unlikely, if not unthinkable, without the preceding fruitful development in Italy ... [Guidobaldo] was the first to realize the importance of considering the perspective images of sets of parallel lines and created the concept of a general vanishing point.[19]

Prior to 1600, linear perspective was primarily a sophisticated picture making practice that took advantage of geometric properties, but mathematical inquiry was generally not the aim of the practice. After 1600, although the application of the drawing system to picture making was maintained, linear perspective also became a topic of mathematics in its own right, and theorists developed proofs and theorems regarding its properties (such as the vanishing point). Most readers probably think of themselves more as practitioners than as theorists, but many of common practices and assumptions regarding the drawing system first appeared in the mathematical treatises of the seventeenth century: every set of parallel lines converges at a point; every linear perspective contains an infinite number of vanishing points; et cetera. Practitioners of linear perspective are more mathematically informed than they realize, but a more explicit mathematical awareness of the vanishing point is necessary in order to pursue a thoroughly analytical approach to linear perspective. In order to navigate the drawing system without any particular goal (such as the construction of a picture), it is necessary to understand the general conditions and properties that apply to any given point and to any given set of parallel lines. It is, therefore, important to look more closely at the moment when the vanishing point became a general concept as opposed to an operational device.

The term *vanishing point* first appeared in a mathematically oriented treatise by Brook Taylor in 1715, and I have been freely applying the term to any notion of a point of convergence for a set of parallel lines.[20] This type of point, in fact, has had many names throughout history (an absurd one will be discussed shortly). I will continue to use the term in a general manner, but it is important to note that *vanishing point* means different things to different people.

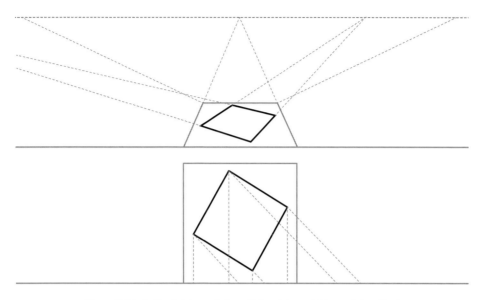

Figure 3.14: Author's interpretation of Vignola's vanishing point method

A drawing in a treatise by Vignola, from 1583, demonstrates an emerging mathematical understanding of vanishing points at the end of the sixteenth century (Figure 3.14). The drawing is a construction of the image of a square that is rotated at an arbitrary angle with respect to the measuring plane. Because no sides of the square are parallel, perpendicular, or diagonal with respect to the measuring plane, the drawing requires a more complex operation than the use of a central vanishing point and a diagonal/distant point. The horizon line of the drawing includes four vanishing points: the central vanishing point, both diagonal points, and the vanishing point for one of the sets of parallel lines in the square. Projection lines from the image of the square toward the horizon line imply a fifth vanishing point (for the other set of parallel lines), but the drawing is not large enough to allow these lines to meet on the horizon line (which they would do if they were extended).[21] Although the evidence within the drawing alone does not provide conclusive evidence regarding Vignola's method, I recognize this type of construction from my own experiments. To me, it appears that he uses the central vanishing point and the diagonal points to locate the image of the square and then uses the image of the square to locate the vanishing points of its two sets of converging lines. He, of course, no longer needs these vanishing points because the image of the square has already been drawn, so

he seems to be recognizing (or perhaps discovering) the fact that all sets of parallel lines converge to a point on the line that contains the points to which orthogonals and diagonals converge. Shortly after Vignola's experiment, Guidobaldo's treatise provides a clear demonstration and proof of the general behavior of vanishing points, and (as Andersen says) it is likely that he was able to do so because of empirical discoveries such as the one implied by Vignola's drawing.

Andersen credits Guidobaldo also with the first proof of the distance point method that had been in practice for some time before he wrote his treatise.[22] As I alluded to earlier, my empirical discovery of how the distance point operates was an important moment for me, as it was the first of many mysteries that led me to the drawing board in frustration and curiosity. When I first learned the method, my teacher referred to the point both as a diagonal point and, believe it or not, as a *magic point*. Its magic derives from the fact that it allows for the construction of perfect squares on the ground plane through the use of a diagonal line. There was some discussion regarding its location on the horizon line with respect to the central vanishing point, but only in terms of avoiding visual distortion. The plan condition of the isosceles right-angled triangle (viewing point, distance point, and intersection of the viewing ray and the measuring plane) was never discussed, so the role of the point in the drawing system remained opaque until I analyzed the properties of the distant point in plan and realized that the magic point was simply a vanishing point for diagonals. This is exactly the type of discovery that occurs around 1600 when practitioners and theorists begin to explore the drawing system for its own sake and to develop proofs of common practices. Architecture, as a result, lost its privileged position as the primary subject of linear perspective. Instead of floors and walls, lines and points emerge as the focus of construction processes. Before I was aware of this gradual historical transition, my teaching methods underwent a similar transition. At first, my emphasis on lines and points instead of architectural forms typically confused my students, especially since some of the lines and points in my constructions were not even part of the architectural subject of the drawing. They expected to draw clearly defined architectural surfaces in the most efficient way possible. They wanted magic points, and their questioning helped me both to realize and to articulate the merits of a deeper understanding of the geometric properties underlying linear perspective.

An awareness of the general behavior of vanishing points overcomes the limits imposed by many textbooks on linear perspective. It is common for students to learn

different methods for the construction of so-called one-point (or frontal) perspectives and so-called two-point (or oblique) perspectives. The former is generally understood as a method that does not require the use of a plan, as it collapses the two drawings used by Alberti in his visual pyramid method into a single view. The latter is generally understood as a method that does requires the use of a plan, as the projection of lines in plan from the viewing point to the measuring plane determine the location of the vanishing points. Several shortcut construction methods involve the projection of additional lines in plan from the viewing point to vertices of the object of projection, and it is easy to get lost in or confused by these lines if their mathematical properties are not understood.

William Ware's canonical treatise of 1882 contains the terms one-point and two-point, and the tone of the author's use of the terms does not imply that they are new, so I assume that their usage was common earlier in the nineteenth century.[23] Ware's treatise is interesting to note because, despite its embrace of the shortcut terms, it contains a high degree of mathematical complexity that fully illustrates a wide of range of conceptual (i.e., non-practical) issues relating to the drawing system. Many of the plates in the book read like mathematical proofs, and efficiency is not his goal. More recent textbooks, however, simply provide two (seemingly different) methods that correspond to frontal and oblique views, and they fail to provide any of the mathematical information necessary to understand that both methods derive from the same geometric properties. Whereas Ware sees linear perspective as a system of geometry that is worthy of architects' critical inquiry, most contemporary writers treat it as an operational device for picture making. Whereas Ware dedicates an entire volume to linear perspective, most writers incorporate linear perspective into a broader curriculum of drawing skills. Ware's treatise, however, is by no means a discourse on the analytical potential of the drawing system, as presentation-quality renderings are his ultimate goal. He typically refers to mathematical issues in direct relation to how they affect pictorial naturalism, and he seems to consider linear perspective as the culmination of the design process, not as a tool at the heart of it. Ware's treatise is a good example of a traditional dialogue between practice and theory. Like so many writers before and after him, he values picture making, but he also values the rigor that linear perspective demands of its users and does not try to ameliorate the complexity of the drawing system. His drawing plates, while too literal for the analytical purposes of this book, are exceptional examples of the technical craft that must underlie any serious inquiry in the nature of the drawing system.

While there are obvious similarities between the conventional two-point method and the construction method illustrated in Chapter 1, the latter relies on the assumption that, mathematically, every variation of every type of view obeys the same rules and is achievable through the same methods of construction. The objective of the method is conceptual comprehension, not efficiency. In addition to the dangers of shortcuts already mentioned, there are creative advantages to this comprehension. The slowing down of the construction process and the elimination of efficient shortcuts embeds a draftsperson within the spatial logic of the object of projection. As projection lines navigate from points on a measuring plane to points on a horizon line, and vice versa, the draftsperson performs a sort of spatial dance that is equally about the resulting drawing and the process of constructing it. Inefficient construction lines may evolve into analytical regulating lines that reveal previously unrecognized relationships within a project. Such "unseen" lines may even evolve into architectural design ideas. Once drawings may include the images of lines that do not exist within the object of projection, or ones that are not directly visible from a given viewing point, the analytical and interpretative potential of drawing expands exponentially. This potential relies on an ability to understand the general logic of how points in space relate to the images of those points in a linear perspective. This potential, therefore, is the gift of the mathematicians who, through their consideration of arbitrary lines and points, released linear perspective from its reliance on the depiction of architecture. Ironically, their non-architectural understanding of the drawing system allows architects and architecture students to wrest linear perspective from painting and to use it as a tool to investigate architectural issues unrelated to imagery.

Point-based linear perspectives also provide opportunities for theoretical drawing experiments. Now that mathematicians have proven every imaginable geometric property of linear perspective, contemporary architects and artists are free to navigate the drawing system for no other reason than to make drawings. Not every drawing construction needs to fulfill a precise analytical or design objective. Sometimes a drawing is just a drawing, and its usefulness lies primarily in its ability to expand a draftsperson's cognition of drawing. My awareness of this potential comes from theoretical drawings that I executed prior to my awareness of the mathematical history of linear perspective. I constructed these drawings in order to verify assumptions or to solve mysteries that arose during my learning process. As I constructed them, the inherent beauty of the language of linear perspective was impossible to ignore. The infinite scale of the digital drawing environment allowed me to explore the far

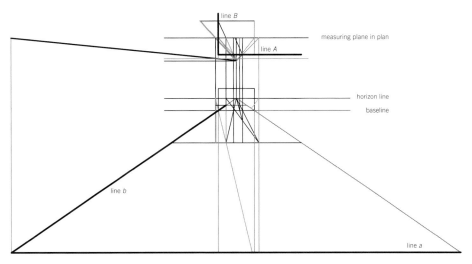

Figure 3.15: theoretical projective drawing—the limits of distortion

This drawing explores the perspectival distortion of the images of shapes that lie close to the viewing point in plan.

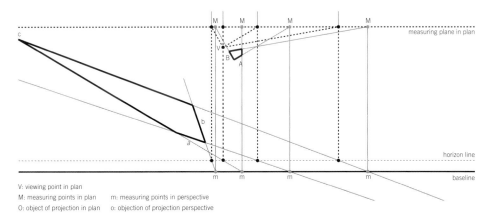

V: viewing point in plan
M: measuring points in plan m: measuring points in perspective
O: object of projection in plan o: objection of projection perspective

Figure 3.16: theoretical projective drawing—locating points behind the view point

This drawing assumes that the image of a point that lies behind the viewing point may be located, like any other point, through the location of the images of two lines that intersect it. Lines that describe an object of projection that lies behind the viewing point are extended until they reach the measuring plane; then, vanishing points that correspond to these lines are located according the same rules as all vanishing points. With a measuring point and a vanishing point for each line, it is possible to project them into the linear perspective in order to locate their points of intersection, which in theory will describe the object of projection.

reaches of the drawing system, locations of absurd distortion that would have been logistically difficult (if not impossible) to reach in an analog environment (Figure 3.15). I also applied my method to points behind the viewing point and discovered that they appear in the drawing, as if in front of the viewing point, in a double reflection (Figure 3.16). Points behind the viewing point are mirrored along two axes: the horizon line and a vertical line projected through the central vanishing point. While these sorts of drawings have no obvious relevance to architectural analysis and design, their graphic power potential to inform the processes of analysis and design are worthy of further investigation.

Scales

Shortly after mathematical proofs of linear perspective appeared at the beginning of the seventeenth century, some theorists devised methods of construction that eliminated conventional processes of projection. Gérard Desargues, for example, wrote a treatise on perspective called, *Example of one of the universal methods concerning the practice of perspective without using any third point, the distance point or any other kind [of vanishing point], which is outside the field of the picture* (1636). Later theorists referred to such methods as "Free Perspective," meaning that the construction process is free of normal (and presumably tedious) projective procedures. To compensate for the lack of vanishing points and projective operations, these methods involve the use of scales that calculate measurements of foreshortened width, depth, and height for a specific set of linear perspective parameters. Some scale methods even include an angle scale that locates the images of angled lines without any measurement or navigation. Scales are constructed outside of the drawing surface and then placed along the edges of the drawing. Artists locate given measurements on the scales, plot points according to those locations, and finally draw lines to connect the appropriate points. If any variable of the construction, such as the location of the viewing point, changes, an entirely new set of scales would be required in order to construct an accurate drawing. Scale methods are similar in spirit to Piero's coordinate method because they involve the plotting coordinates that have been determined in separate drawings onto a new picture surface, but they are far more complex than Piero's system. The process of drawing resembles data entry more than dancing, as mechanistic image-making replaces the serendipity of projective navigation.

Scale methods require a high degree of mathematical knowledge, as the "behind-the-scenes" construction of scales is a complex operation. At the same time, they eliminate mathematics from the actual practice of drawing. They recall, in this sense, the long tradition of drawing machines, which construct linear perspective images without the use of projection. In his treatise on painting, Alberti describes a linear perspective drawing machine as an easier alternative to his visual pyramid method.[24] It involves the use of a gridded veil through which the artist views the subject of the painting from a specific and constant point of view. The artist uses the grid on the veil as a mapping device to construct an image on a canvas, which has a corresponding grid. Lines that cross a certain quadrant in the gridded veil will pass through the corresponding quadrant on the canvas in the same manner. Drawing machines adhere to the same mathematical properties as linear perspective: the image of a point in space is a point on the measuring plane (in this case, the veil) through which a visual ray travels from the eye to the point in space. The precision of any given machine varies according to its details, but even the most elaborate ones have a higher margin of error than an accurately executed mathematical construction. The definitiveness of projection is sacrificed for the sake of a less tedious and/or opaque method. This sacrifice is especially useful for the depiction of complex geometries, such as the human body. A century after Alberti's description of the gridded veil, Albrecht Dürer illustrates a version of it, as well as other types of drawing machines. In each case, the subject of the drawing is a complex form, such as a woman situated in front of the veil in a manner that causes extreme foreshortening in the image. The depiction of architecture, as already discussed, is far more suitable to mathematical construction methods, and it is therefore less relevant to the drawing machine tradition.

Scale methods of linear perspective uphold both the precision and the orthogonal bias of mathematical constructions because they require the plotting of coordinates. They also, however, fulfill one of the primary goals of the drawing machine tradition: ease. Since the invention of linear perspective in the fifteenth century, treatises have sought to make the drawing system easy (or at least easier than previous treatises). Scale methods may be understood as the ultimate achievement of that objective, and also as a triumph of Modern science over traditional burdens of the artist. The elimination (or rather displacement) of the projective nature of linear perspective may be read as a progressive achievement. Soon after a fully mathematical understanding of linear perspective emerges in 1600 from empirical picture-based methods, scale methods free artists from the tedium that plagued so many of them for so many years. The

implication, contrary to the objectives of this book and aligned with the objectives of drawing machines, is that the act of construction is a mechanistic, as opposed to a creative, process—something to get through, not something to perpetuate.

Scale methods raise provocative questions, such as whether or not linear perspective drawings have an identifiable scale. The measuring plane in a linear perspective is always measureable, and its precise scale corresponds to the scale of the orthographic drawings in the rebatment. For example, if the scale of the plan in the rebatment is ¼" = 1', then the scale of the measuring plane in the perspective is also ¼" = 1'. The scale of a measuring plane may be considered as the scale of a linear perspective. Perspective drawings, for example, may be presented as direct projections of orthographic drawings and, therefore, as a function of the scale of the corresponding drawings. It is more common, however, to disregard the relevance of scale to linear perspective. After all, virtually all of the lines in a linear perspective (except those in the measuring plane) are foreshortened and cannot be measured to a scale. Linear perspectives are typically presented as isolated images without any acknowledgement of scale, and this approach weakens the analytical rigor of the design process. Scale is always a variable that may be more important in certain instances of drawing than in others, but it should never be disregarded altogether.

In the construction method illustrated in Chapter 1, the plan and the elevation are drawn in a digital environment at full scale (1:1), so the measuring plane in the linear perspective is also at full scale. The unlimited expanse of a digital drawing surface allows a draftsperson to forego the analog practice of drawing the plan and the elevation (and therefore the measuring plane) at a reduced scale. The printing of a digital linear perspective inevitably results in a scaling of the measuring plane, but the precise scale factor of the printed drawing may or may not be known. Scale is useful to consider because it is legible to well-trained architects, who are able to read certain scales in an intuitive manner and to evaluate design proposals based on this ability. At certain scales, certain spatial dimensions may or may not seem appropriate. Scale is also relevant to the amount of detail in a drawing; a large-scale drawing requires more detail than a small-scale drawing because it depicts only a small portion of a project. All of these variables are difficult to evaluate in a digital environment, and the ability to read scales intuitively is an endangered skill. The way that a draftsperson considers scale in linear perspective will depend on how well the relationship between linear perspective and orthographic drawing is understood as a presentation strategy.

Kirsti Andersen writes extensively on issues of scale in linear perspective, and her research reveals that the topic is largely ignored throughout history.[25] Leonardo considered the realism of a linear perspective to be a factor of the relationship between the location of the viewing point in the drawing construction and the location of the viewer in front of the final drawing (see Figure 0.1). The drawing in Leonardo's case is a full-scale depiction of an actual environment, not a scaled drawing of an environment, which allows him to avoid what Andersen refers to as "the problem of scaling."[26] The measuring plane in most linear perspectives is not full scale, which means that, even if viewers occupy the position of the viewing point in the drawing, the problem of scaling arises: the scaled distance between the viewing point and the measuring plane in the drawing construction is different from the actual distance between the eye of the viewer and the surface of the drawing. The viewer, therefore, does not see the environment depicted in the drawing at true human scale. Architects, who work with scaled drawings regularly, take this "problem" for granted, and most painters seem to ignore it. Andersen states:

> Only when an artist wants to make *an exact reproduction* of a *given scene* from a *given position* does the scaling become a real problem. In such cases it has presumably been seldom that the artist based his entire drawing on a geometrical construction. He could by eye or an instrument plot a few points on the screen and perform the rest of the construction from these points.[27]

Obviously, the problem of scaling is not, in fact, a problem in the context of an architectural design process, especially when analytical, as opposed to pictorial, drawings are the objective of the constructions. The goal of architectural drawing and diagramming is not to simulate the actual appearance of a built environment. Still, the fact that historical treatises ignore the problem of scaling is relevant to the context of architectural analysis. Andersen notes that, whereas mathematicians ignore the issue of scale discrepancies because their interests are theoretical not practical, painters discover empirical methods to mediate the problem when if and it is an issue for them.[28] Architectural analysis occupies a middle ground between theory and practice. While scale discrepancies are not a problem for architects and architecture students, it is essential for them to understand how scales operate in their work. For example, the scales of measuring planes in linear perspectives may be aligned with those of orthographic drawings in some instances and misaligned with them in other instances, always for strategic reasons. Even when such scales are misaligned, the scale factors should be managed with intent. Scales should not

differ from each other in random ways, but rather in precise and strategic ways. Scale is an invaluable analytical tool, and its power to affect both the design process and the presentation of a project is significant. Even when the scale of a measuring plane in a linear perspective is not legible in an obvious way, it may be an underlying factor that affects the reading of the drawing in unconscious ways.

The Double Life of Gérard Desargues

Whereas Desargues erases projection from the practice of picture making through his scale method of linear perspective, he concurrently celebrates projection as an immutable science through a series of theoretical explorations related to the drawing system. The diagram in Figure 1.39 is a rediscovery of one aspect of Desargues' extensive theoretical work on inverse and reciprocal relationships between the orthographic behavior of lines and the behavior of the images of those lines in linear perspective. Desargues investigates sets of lines that, orthographically, meet at a point (*pencils of lines*) and sets of lines that, orthographically, are parallel to each other (*sets of parallels*). In any given set of parallel lines, there is one line that passes through the viewing point, and Desargues calls this line an *eye line* (the method illustrated in Chapter 1 refers to this line as a viewing line).[29] The eye line in any given set of lines may be parallel to the measuring plane (case *i*), or it may intersect the measuring plane (case *ii*). The universal property, paraphrased by Andersen and illustrated in Figures 3.17.a–b, states that:

1. the images of a set of parallels are (*i*) a set of parallels, or (*ii*) a pencil of lines.
2. the images of a pencil of lines are (*i*) a set of parallels, or (*ii*) a pencil of lines.[30]

In other words, the perspectival projection of a set of orthographically parallel lines is either a set of parallel lines or a set of lines that meet at a single point. Inversely, the perspectival projection of a set of lines that meet at a single point is either a set of lines that meet at a single point or a set of parallel lines. Compared to Alberti's visual pyramid construction, Desargues' explanation exponentially furthers an understanding of the relationship between orthographic drawing and linear perspective. He identifies relationships that escape vision.

Desargues orchestrated another theoretical foray into the nature of projection that is now known as Desargues' Theorem (Figure 3.17.c). It considers a projective pyramid whose base is a triangle. All possible sections through that pyramid are

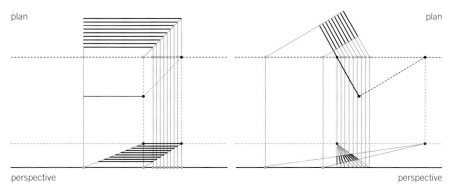

Figure 3.17.a: the images of a set of parallels are a set of parallels, or a pencil of lines.

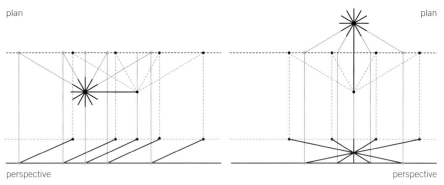

Figure 3.17.b: the images of a pencil of lines are a set of parallels, or a pencil of lines.

Figure 3.17.c: Desargues' Theorem

also triangles. Desargues discovered that lines extending from corresponding sides of triangluar sections within this projective pyramid, at any angle in reference to the base, meet at a common point. Furthermore, when lines are extended from all three sides of the triangular sections, the three resulting common points form a line. Desargues' Theorem, like his scale method, derives from the fully mathematical understanding of linear perspective that emerged around 1600, and it is perhaps the earliest demonstration of the potential of projection to escape the confines of the drawing system. Even more than Guidobaldo's interest in the general behavior of the images of lines and points, Desargues' Theorem disregards visual properties and treats projection as a isolated geometric discipline. His development of a non-projective method of linear perspective may be read as an attempt to dissociate representational drawing from what he saw as a new science of projection. In the context of analytical, as opposed to pictorial, drawing, Desargues is a key figure. Although he promotes a mechanistic type of linear perspective that is antithetical to an interest in exploratory constructions, he also initiates a practice of non-pictorial (and even non-representational) projection that lays bare the nature of projection, as well as its analytical potential.

The implications of Desargues' Theorem were largely disregarded until the end of the eighteenth century, when Gaspard Monge invented *descriptive geometry*. The discipline of descriptive geometry is a specific practice of orthographic drawing that depicts (or describes) a three-dimensional object through a limited number of two-dimensional views. These views follow the logic of orthographic plans and elevations, but they may differ from normative architectural drawings in important ways. For example, in descriptive geometry, a top view of an object may portray it as being transparent, not unlike a wireframe top view of a digital model. The point of such a description is to reveal geometric variations throughout the depth of the object in a single drawing, not to provide an orthographic "view" of the object. Whereas normative plans and elevations (both with and without section cuts) communicate only a single moment of the object, descriptive geometry drawings may collapse multiple spatial moments into a single drawing. The plan and elevation in the construction method illustrated in Chapter 1 are modest examples of descriptive geometry, as they include all of the lines that are necessary to describe the three-dimensional condition of the object of projection. Descriptive geometry is applied more often to complex objects, such as mechanical instruments and machines, than to architecture, but its logic has impacted all aspects of construction since its invention.[31]

Scholars have interpreted descriptive geometry as an ancestor of the theoretical objectives of Desargues, for it is a projective process that "verifies" a geometric reality.[32] Monge revived both an interest in geometry for the sake of geometry and an understanding of projective drawing as an analytical activity. Two of his immediate students, Jean-Nicolas-Louis Durand and Jean Poncelet, affected the nineteenth century in enormous and diametrically opposed manners, ones that reflect the duality in Desargues' own career. Durand's rational and mechanistic method of architectural composition and representation indicates an interest in the practical application of descriptive geometry, which is not unlike Desargues' practical scale method of linear perspective construction. Conversely, Poncelet's development of the discipline of *projective geometry* is, not unlike Desargues' theoretical inquiries into projection, an unusually poetic mode of rational thinking. Ironically, the descendent of descriptive geometry that seems less architecturally relevant (Poncelet) provides a more provocative model of spatial thinking.

Poncelet rediscovered the notion (first encountered by Desargues) that perspectival projections, like orthographic projections, follow absolute rules.[33] The discipline of projective geometry, broadly speaking, is the study of projective invariants, which are properties that apply to all possible sections within a single projective pyramid. A projective pyramid is mathematically identical to a visual pyramid, but its apex is not necessarily understood as an eye. Projective geometry is neither *perspectiva naturalis* nor *perspectiva artificialis*, but rather a geometric system like Euclidean geometry. Its purveyors scrutinize the mathematical nature of the projective pyramid and discover properties that are always true. Desargues' Theorem is the first example of a projective invariant, but many others have since been developed, such as the nature of the cross ratio. Consider a projective pyramid whose base is a single line that is divided by four points: A, B, C, and D. For any linear section through this projective pyramid, which creates points A', B', C', and D', the cross ratios of the two lines are equal: (A'C'/C'B')/(A'D'/D'B') = (AC/CB)/(AD/DB). Because this is true for any possible line through the projective pyramid, cross ratio is a projective invariant.

Desargues' investigation of pencils of lines and sets of parallels is also relevant to projective geometry. In projective geometry, his findings would be referred to as a *duality*, which is an essential component of the discipline and the root of much of its considerable elegance. Duality is rooted in the fact that projective geometry overrides the essential principle of parallelism in Euclidean geometry. Whereas parallel lines

never meet in a Euclidean spatial system, parallel lines always meet at a common point in projective geometry. Morris Kline describes duality as follows:

> The satisfying accomplishments of projective geometry were capped by the discovery of one of the most beautiful principles of all mathematics— the principle of duality. It is true in projective geometry, as in Euclidean geometry, that any two points determine one line, or as we prefer to put it, any two points lie on one line. But it is also true in projective geometry that any two lines determine, or lie on, one point.[34]

Projective duality allows the words *point* and *line* to be exchanged in any property without an error. If something is true about lines and points in projective geometry, then its inverse (or its *dual*) is also true. Kline discusses the dual of Desargues' Theorem as follows:

> The theorem says: "If we have two triangles such that *lines* joining corresponding vertices pass through one *point* O, then the pairs of corresponding sides of the two triangles join in three *points* lying on one straight *line*." Its dual reads: "If we have two triangles such that *points* which are the joins of corresponding sides lie on one *line* O, then the pairs of corresponding vertices of the two triangles are joined by three *lines* lying on one *point*." We see that the dual statement is really the converse of Desargues's theorem, that is, it is the result of interchanging his hypothesis with his conclusion.[35]

Kline further explains that the geometric proof of the dual of Desargues' Theorem proceeds in the same manner as the geometric proof of the original theorem, assuming that the proof of the dual interchanges lines and points. Other duals noted by Kline involve the ways in which lines and points define figures. For example, a *line* may be defined by a set of *points*, and a *point* may be defined by a set of *lines*. Likewise, while a figure may be defined by four *lines*, no three of which lie on the same *point*, a figure may be defined by four *points*, no three of which lie on the same *line*.

The beauty of projective geometry reinforces my sense that linear perspective is far more interesting as an analytical tool than as a pictorial practice. Alberti rejects linear perspective as an architectural design tool because it is non-Euclidean and therefore untrue to the nature of construction and proportion. Desargues and Poncelet suggest that perspectival projection provides a different version of truth in geometry. I propose that the properties of this truth may stimulate new modes of architectural thinking. In "Architectural Representation beyond Perspectivism," Alberto Pérez-Gómez and Louise Pelletier criticize the theoretical inquiries of Desargues and the

descriptive practices of Monge as overly rational modes of projection that deprive the architectural design process of a poetic dimension:

> The objectifying vision of technology denies the possibility of realizing in one drawing or artifact a symbolic intention that might eventually be present in the built work. The fact is that the process of making the building endows it with a dimension that cannot be reproduced through the picture or image of the built work. Reciprocally, architectural representations must be regarded as having the potential to embody fully an intended order, like any other work of art.[36]

Pérez-Gómez and Pelletier argue for a lyrical approach to architectural drawing that overrides the prescriptive biases of orthographic projection and linear perspective. They promote unconventional modes of representation, such as the paintings of Marcel Duchamp and the drawings of Giovanni Battista Piranesi, and urge architects to explore the "invisible" dimension of the built environment that escapes the prosaic nature of conventional drawing. Pérez-Gómez and Pelletier seem not to recognize the potential lyricism embedded within the conventions that they seek to circumvent. While their objective to reinvigorate drawing practices is critical to the future of architectural discourse, and while their artistic sources of inspiration deserve an architect's attention, their inability to appreciate the creative potential of normative drawing is troubling. Guidobaldo's demystification of the linear perspective construction process, Desargues' theoretical investigations, and the properties of projective geometry inspire acts of drawing that are no less poetic than those of Duchamp and Piranesi. Instead of displacing creative thinking to a revelatory activity outside of projective drawing, I defend the use of normative conventions, albeit at their absolute limits. The examples of theoretical drawings in this book (Figures 3.15–3.16 and 5.13–5.16), as well as the diagram in Figure 1.39, demonstrate only a small fraction of the poetic potential of projective drawing.

Perspectival Architecture

The historical relationship between linear perspective and the built environment is reciprocal, but unevenly so. Whereas the drawing system thrives (if not relies) on architectural subjects, the relevance of the drawing system to the design process is more variable. In the fifteenth century, linear perspective is an active participant in architectural discourse. Some of Alberti's contemporaries and immediate successors did not share his understanding of architecture as a non-pictorial practice. Instead, they practiced what may be called *perspectival architecture*. Because most architects

in the fifteenth and early sixteenth centuries were first and foremost painters, the origins of this approach to architecture lie in the discipline of painting, specifically in Alberti's painting treatise. The tiled floor in his purely verbal demonstration of linear perspective is not a specific work of architecture that is visible to the painter, but rather a common architectural typology that the painter creates and may interpret. The implication is that linear perspective, unlike a drawing machine, is a creative act, not a factual recording device. Although the drawing system promotes an empirical understanding of the world (i.e., we know what we see), it does so through a cognitive process that allows painters to invent what they see.

It is reasonable to assume that many architectural settings in Renaissance paintings are conceptions of the painters, not depictions of existing works. Piero's *The Flagellation of Christ* (1445) is a good example of an original architectural composition realized through the construction of a painting. The architecture in the painting is neither a neutral background, nor an explicit design proposal for a built environment. Some scholars consider architecture as a primary subject of the work, and it may be analyzed in various ways: built precedents that may have influenced Piero; the way in which architecture maps and regulates the narrative elements of the painting; and the extent to which the depicted architecture reinterprets conventional practices and thereby suggests new architectural ideas.[37] Piero, however, was not an architect. Given the prominence and complexity of the narrative scenes in the painting, it is difficult to conclude that the practice of architecture is a primary concern of the artist. The same may be said of the proto-projective paintings of Giotto, in which architecture is also a vehicle of storytelling. Although these depictions of built environments may be read as reflections of an architectural design culture, they do not appear to be explicit architectural discourses in themselves.

Three unattributed paintings from the mid-fifteenth century demonstrate a less ambiguous use of linear perspective as a speculation on architectural design. They depict ideal cities and, unlike *The Flagellation of Christ*, contain essentially no narrative content or dominant figures. Architecture is not the venue of a story, but rather the story itself. The properties of the visual pyramid method of linear perspective clearly motivate the formal qualities of the built environments depicted in these painting; their gridded ground planes, rigidly geometric buildings, and evenly regulated façades derive from the basic operations described in Alberti's treatise. They are drawn environments. Although not much is known about the purpose of

these paintings, they may belong as much to the history architectural theory as to the history of painting. Even if the rigorous symmetry of these urban visions is far more absolute than any realized projects of the time, the regularization of medieval fabrics during the fifteenth century did occur, as in Bramante's design for the Piazza Ducal in Vigevano (1470). Also, certain works of architecture from this period, such as Alberti's façade for Santa Maria Novella in Florence (1448–1470), exhibit the same approach to geometry and façade regulation. Colin Rowe even suggests that one of the ideal city paintings may have had a direct influence on a later building, Bramante's Tempietto of San Pietro in Montorio (1502).[38] He sees a clear affinity between that work and a circular building depicted in the painting that is now located in the Galleria Nazionale in Urbino (which Bramante likely knew well). Rowe also notes a striking similarity between Bramante's choir in Santa Maria del Popolo (c. 1506) and the architectural setting of Piero della Francesca's *Madonna and Child with Saints* (1472).[39]

There is, of course, a significant difference between the creation of a painterly architectural scene (regardless of whether or not it inspires or complements real architecture) and the use of linear perspective as an architectural design tool. In "The Rendering of the Interior in Architectural Drawings of the Renaissance," Wolfgang Lotz argues that linear perspective plays a systemic role in the architecture of Bramante—that the *ethos* of linear perspective is embedded within his design process. Bramante's architectural projects typically contain a privileged point of view, from which the primary intention of the work is most clearly understood and appreciated. Moreover, these privileged points of view lie outside of the architectural compositions and at considerable distances from them.[40] Viewers, therefore, encounter the intent of his architecture from a detached location, as if through a picture frame. The Tempietto, according to Lotz, is an architectural object in a courtyard whose deepest logic may be understood only from a point of view at the entrance to the courtyard, where a pictorial composition formed by the temple itself, its open portal, its altar, and its primary statue is evident.[41] Similarly, Bramante's choir in Santa Maria del Popolo is a space to be looked at, not occupied. It presents itself frontally as a composition of architectural elements.

An earlier and particularly fascinating work by Bramante is the simulated choir at Santa Maria presso San Satiro in Milan (c. 1482), and it may be a source of inspiration for his later choir. Bramante received a commission to renovate the church, and its

tight urban context limited his ability to construct a large choir behind the altar. Instead, he constructed a linear perspective of a choir, which operates as a spatial illusion (or *tromp l'oeil*). It is hard to imagine how Alberti would have reacted to the simulated choir in Milan. It demonstrates the effectiveness of his painterly method to simulate real space, but it somewhat undermines his notion that, in architecture, proportion and measure override visual effect. The illusion is perfect when the viewer is situated in a central position in front of the painting (aligned with the "prince of rays"), but the image looks distorted from other locations in the church. It may also undermine Alberti's understanding of painting as a window onto a detached world. Unlike most Renaissance paintings, the painting of the choir does not represent an isolated narrative world. Instead, it represents a space within the world of the viewer, albeit one that is somewhat separated from the public spaces of the church. In one sense, Bramante's mural shares an affinity with the ideal city paintings, whose only subject is architecture, but it is even more unique because of its literalness. It is not a speculation or reflection on architecture, but rather a surrogate for it.[42]

Arnaldo Bruschi addresses the painterly sensibility of Bramante's architecture in his analysis of the Belvedere Courtyard at the Vatican (1502–1510), which is informed by James Ackerman's research on the same project.[43] The Belvedere is a complex project that unifies many layers of history and orchestrates a complex composition of architectural forms. The courtyard itself and, in particular, the view of it from the Papal apartment is especially perspectival. Bruschi describes it as follows:

> Architecture has thus become predominantly an image to be looked at; it has been translated into painting … As Ackerman acutely points out, [Bramante] fixed the best viewing point of his gigantic "stage set" outside it altogether. He placed it exactly where the Pope, without leaving his apartment, could see the whole ensemble from the windows of the Stanze or the Borgia Apartments.[44]

In addition to his construction of a privileged point of view, Bramante distorts the measured reality of the Belvedere Courtyard, so that it seems even larger than its considerable size when perceived from the Papal apartment. Like a subtle funhouse, the courtyard tricks the eye. The floor of the upper courtyard gently slopes upwards as it recedes from the Papal apartment, similar to how a stage may slope upwards as it recedes from the audience. The cornice does not slope, so columns grow shorter as they recede from the privileged point of view; columns, therefore, do not obey the same proportions as each other. Bramante also doubles the number of columns in

each bay in the upper courtyard as compared to the lower courtyard, and the greater number of vertical elements in the upper courtyard creates the impression that it has more bays and thereby greater depth.[45] Bruschi further explains that, within the apartment, the three walls that do not overlook the courtyard contain elaborate murals, which reinforce the pictorial quality of the courtyard composition—the apartment is an environment that is enveloped in images.[46] Despite its considerable architectural attributes, the Belvedere Courtyard is an architecture of perspective, not measure.

Bramante's perspectival approach to architecture is unsurprising, given his background in painting as well as a general belief at the time that painting was superior to architecture.[47] Toward the end of his career, the influence of the drawing system on architecture began to wane. Lotz interprets the work of Raphael, both in architecture and in painting, as the beginning of a transition away from a pictorial understanding of architecture. He compares Bramante's choir in Santa Maria del Popolo to Raphael's Chigi Chapel (1509) in the same church.[48] The latter is a volumetric composition that, like the artist's painting *The School of Athens* (1506), invites the viewer into an enveloping space that escapes the limits of a single point of view. The chapel is visible from its exterior (i.e., from the aisle of the nave), but its essence lies within the space. The frontal detachment of the pure Albertian model of linear perspective has evolved into a notion of spatial occupation. Architecture and painting are still perspectival, but the threshold of the Albertian window frame has been breached. At the same time, Lotz argues, there was an evolutionary leap reflected in the ascension of Antonio da Sangallo the Younger as the chief architect of St. Peter's Basilica. Sangallo's background was in building, not painting, and he worked exclusively as an architect. The scale and complexity of St. Peter's required the analytical substructure of orthographic drawing more than the empirical immediacy of linear perspective. Its intention could not be reduced to an impression from a single point of view. Almost a century after Alberti wrote his treatise on architecture, the notion of an orthographically conceived and executed work of architecture came to fruition, and orthographic drawing began to establish itself as a fundamental component of the architectural design process.

Alberti's posthumous victory, however, was only partial. While the symbiotic relationship between painting and architecture that had thrived in the early Renaissance eventually ended, linear perspective evolved into a ubiquitous tool of the discipline.

In the mid-sixteenth century, Sebastiano Serlio wrote the first architectural treatise to include a section on linear perspective: "Book II: On Perspective," in *Tutte l'opere d'architettura et prospetiva* (1545). He justifies the inclusion of linear perspective in his treatise through his interpretation of Vitruvius' treatise on architecture from the ancient Roman era. In that book, Vitruvius uses the term *scenografia* to denote one of the essential tools of the architect, and Serlio interprets *scenografia* as meaning *perspective*.[49] In "Book II" of *Architettura*, the author demonstrates how to construct linear perspectives of various architectural components, both in the context of a building and as isolated elements. The text reads more like an instructional manual than a theoretical discourse, and Serlio explicitly states that his audience is architectural practitioners, not patrons or theologians.[50] Serlio is both progressive, in the sense that he is the first to address linear perspective as a legitimate topic in an architectural treatise, and reactionary, in the sense that he defends a pictorial approach to architecture that had begun to show its limitations:

> And so, as I said in the beginning, perspective is absolutely necessary for the architect. Or rather, perspective would be nothing without architecture and the architect nothing without perspective. To show that this is true, let us briefly consider the architects of our own century in which worthy architecture has begun to flourish. Bramante, the man who revived well-conceived architecture, was he not first a painter and highly skilled at perspective before he devoted himself to this art?[51]

Few architects pursue perspectival architecture in the manner of Bramante, but Serlio's reference to him is a sign of the assumed legitimacy of *looking at* architecture during the design process. Following Serlio, treatises on architecture generally include a section on linear perspective, and perspectival depictions of original architectural proposals have been common ever since.

By the beginning of the twentieth century, architecture becomes the sole proprietor of linear perspective. Cubist painters and their successors distanced themselves from the practice of linear perspective through their rejection of the illusionism of the picture frame, and mathematicians devised theories of complex geometries that no longer addressed (or even respected) the suppositions of projective geometry. Architects, meanwhile, developed the potential of the drawing system to address the new spatial conditions that emerged during the early Modern movement. A perspectival rendering of Le Corbusier's *La Ville Contemporaine* (1922), which was exhibited in the Pavilion de L'Esprit Nouveau (1925), may be read as a twentieth

century reinterpretation of the ideal city paintings from the fifteenth century.[52] Its aerial point of view communicates its vast scale, and its slightly off-center vantage point lends it a dynamic quality that suits the architect's love of speed and movement. Otherwise, it is strikingly similar to its Renaissance predecessors—a symmetrical vision of the urban realm that adheres to the orthogonal logic of linear perspective construction. Other perspectival drawings of the project reinforce the perspectival spirit of the ideal Modern metropolis, as do the urban visions of Ludwig Hilberseimer and other architects of the 1920s. The use of strict linear perspective in these visions announces the end of the vignette-driven picturesque tradition of urbanism, which was espoused by theorists such as Camillo Sitte. The city is no longer a container of perspectival moments, but rather a system of perspectival space.

Le Corbusier, however, complicates the matter (as he often does). In addition to the rigorous perspectival drawing of *La Ville Contemporaine*, he also constructs informal vignettes of the project that portray depth in a convincing but imprecise manner. In fact, in every stage of his long career, Le Corbusier constructs quick perspectival sketches to communicate his design thinking, regardless of the formal nature of the project under investigation. The extent to which the *ethos* of linear perspective informs his formal approach to architecture and urbanism varies from project to project (compare *La Ville Contemporaine* to *Plan Obus* for Algiers, and Ronchamp to the Unité d'Habitation), but his use of the perspectival sketch is constant. The origin of this method, no doubt, lies in his personal history of picturesque travel sketches. Long before he envisioned the perspectival architecture of *La Ville Contemporaine*, Le Corbusier studied and executed picturesque approaches to architecture and urbanism, and the perspectival vignette was a primary mode of communication. Later, when he adopted a more rigid approach to orthogonal geometry, his quick perspectival sketching simply adapted to the new formal bias of his work. From a young age, Le Corbusier trained himself to think through the construction of perspectival views, but not all of his work reads as a derivative of true linear perspective. In fact, Le Corbusier considers cinema, not linear perspective, to be the medium that best captures the spirit of Modern architecture.

Mies van der Rohe, on the other hand, conceives of architecture in perspective. His perspectival sketches of various projects (for example, the Barcelona Pavilion and the Hubbe House) reflect a consistent understanding of architecture as a composition of axial convergences and intersections. Although these sketches are

freehand constructions that lack the discipline of true linear perspective, they still communicate the underlying spatial parameters of the projects. Columns read as vertical anchors within a measured distribution of orthogonal planes that regulate both scale and hierarchy. Despite their lack of measured rigor, Mies' perspectival sketches embody the spirit of the drawing system no less than the ideal city paintings and the constructed urban visions of Le Corbusier and Hilberseimer. Far more than the informal sketches of Le Cobusier, Mies' sketches reveal the potential of freehand drawing to take advantage of the properties of linear perspective (horizon lines, vanishing points, et cetera). His perspectival sketches are both pictorial and analytical, as they communicate both an experiential impression of a space and a spatial philosophy.

Mies also constructs more precise linear perspectives, many of which are the most identifiable and characteristic drawings of his career. His evocative drawings of two proposed projects in Berlin from 1922, for example, are the definitive graphic images of those projects: a concrete office building and a glass skyscraper for Friedrichstrasse. Mies renders these drawings in ways that emphasize (or even exaggerate) their spatial intentions. The office building appears as an assembly of horizontal slabs that is controlled by a gridded structural system. It extends into the depth of the urban fabric seemingly without limits. The skyscraper appears as a soaring crystalline monument that is completely indifferent to the ground on which it sits. The carefully chosen point of view of the drawing accentuates the faceted geometry of the tower. Mies' frequent use of perspectival collages is another sign of the extent to which linear perspective pervades his thinking. These collages include photographs, drawings, and material textures, and they operate more analytically than pictorially. They resist the notion that architectural pictures are illusionistic and motivate viewers to interpret architectural intentions that are embedded in seemingly literal views. Like the analytical drawings, and unlike the poetic drawings promoted by Pérez-Gómez and Pelletier, these collages simultaneously adhere to the rules of architectural drawing and transcend their conventional limitations.

Throughout the twentieth century, architectural educators from William Ware to Francis Ching have sustained the relevance of linear perspective through the publication of construction methods, but conceptually productive uses of the drawing system (such as Mies') are rare. Most texts on the subject promote linear perspective as a literal form of drawing and as a presentation tool, so its potential as

a source of inspiration and discovery remains, for the most part, latent. Paul Rudolph and Lebbeus Woods are among the noteworthy exceptions to this tendency, as their idiosyncratic practices of linear perspective engage architectural ideas; however, such drawings require considerable effort, both to construct and to render, which makes them incompatible with an intent to incorporate linear perspective into the fluidity of the design process as a tool of speculation and inquiry. Even the more modest drawings promoted by Ware and Ching are too complex and intricate to be considered process drawings. A primary objective of this book is to provide what the existing architectural discourse on linear perspective lacks: a conceptual framework for the use of the drawing system as a tool of architectural thinking. The goal is to reconsider the meaning of *perspectival architecture* in terms of process. Formal biases arise in any design process, but descriptive and projective geometry suggest that complex geometries are as amenable to the properties of linear perspective as orthogonal ones. The evolution of perspectival architecture from Bramante to Mies indicates the stylistic elasticity of the drawing system.

The advent of digital modeling was a significant moment in the history of linear perspective because it dramatically reduced the time and effort that is necessary in order to construct perspectival views of architecture. In this sense, the aftermath of the digital revolution is an ideal opportunity to integrate linear perspective, and even projective geometry, into the design process. Unfortunately, like drawing machines and scale methods of linear perspective, digital modeling does not involve a construction method that captures the beauty and creativity of long-form modes of drawing. Furthermore, digital modeling reduces the resistance of drawing construction to such an extent that most students and practitioners do not understand how linear perspective operates. This ignorance precludes an analytical approach to linear perspective and promotes the use of presentation-style graphics throughout the design process. A principal in one of the largest architectural firms in the United States expresses his regrets on the matter this way: "We used to render buildings, but now we build renderings."[53] Contemporary firms often practice what may be called *rendered architecture*—works that derive from a pictorial approach to design, not unlike those by Bramante.

LTL (Lewis Tsurumaki Lewis) Architects is an example of a contemporary firm that somewhat mediates the perspectival problems that arise through the use of digital processes. First of all, the architects of the firm carefully negotiate the parameters

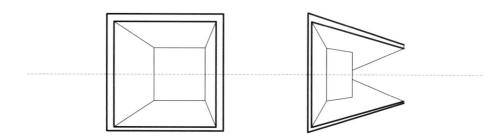

Figure 3.18: Two techniques for a sectional perspective

of the perspectival views that they extract from their digital models, so that decisions regarding the locations of vanishing points and viewing points are strategic. They treat linear perspective as a drawing tool, not merely as a picture-making tool. In addition, they create analog–digital hybrid drawings that challenge the apparent ease with which digital programs generate presentation graphics.[54] Perspectival views undergo numerous cycles of printing, hand rendering, scanning, and digital re-rendering. Digital modeling is a step within a broader process, not an immediate image generator. LTL's distinctive approach to perspectival rendering is an important transitional moment in the early digital era, as the processes of the firm are far more intelligent and analytical those of many contemporary firms.

The perspectival methods of LTL, however, are not above criticism. One of their common drawing types is a sectional perspective in which the section cut itself converges to a vanishing point. Although the conventional purpose of a section is to describe an orthographic condition, not a perspectival one, there is a long tradition of sectional perspectives that operate both orthogonally and perspectively. Paul Rudolph, for example, constructed many such drawings, in which a clearly delineated orthographic section acts as a base from which to project a linear perspective into the depth of the building. In LTL's drawings, the section also clearly appears as a cut, but it cannot be measured or scrutinized in the manner of an orthographic drawing (Figure 3.18). My objection to this technique is based on its pictorial bias, which underscores the dangers of the digital environment. Pictures of sections do not communicate the same information as true section drawings. In fact, they give the false impression that they may be evaluated in the manner of an orthogonal section. My point is not to suggest that these views are invalid, but rather that they should

not take the place of a true section. Many students have adopted the sectional perspective method popularized by LTL, and they typically fail to understand why these views do not qualify as true sections in their overall presentations. In digital modeling, orthographic views are becoming decorative elements, not vehicles of inquiry.

An Evolutionary Leap

A more aggressively analytical exploration of linear perspective may derive from a digital interrogation of projective drawing, not a creative use of digital modeling. The act of drawing lines (digital or analog) is an invaluable analytical and conceptual tool that cannot be replaced by modeling. I propose that designers and researchers (at least temporarily) resist the apparent evolutionary leap represented by digital modeling and instead leap into new approaches to traditional drawing practices, ones which may (or may not) soon be left behind. The point is not to step backward, but rather to move forward with a new appreciation of historical methods. Eventually, designers and researchers may have to embrace digital modeling or other modes of working that challenge the relevance of traditional drawing, but an interest in projective drawing will never be irrelevant.

The work of Preston Scott Cohen on projective geometry is an obvious point of departure. In *Contested Symmetries and Other Predicaments in Architecture*, the author employs a variety of projective operations in order to provoke analytical inquiries and design processes, and his extraordinarily rich drawings prove the impotence of Pérez-Gómez and Pelletier's argument. My approach to projective drawing as a form of analysis differs from Cohen's in that, whereas Cohen takes advantage of computer modeling to further his investigations, I limit myself to two-dimensional digital line drawing.[55] A purely line-based medium presents certain obstructions that, to me, seem appropriate to the linear basis of projective geometry. One of my primary interests is the aforementioned sense of line drawing as a form of dance. My approach to design also somewhat differs from that of Cohen. Whereas his projective investigations seem to lead directly (albeit arbitrarily) to design proposals,[56] I remain open to less literal translations between projective properties and design decisions as well. My theoretical approach to projective design drawing is rooted more in the process (or act) of projection than in the results of it.

The Extents (and Limits) of Architecture–CInema

The camera prowls around the room. This is how the eye works at the end of the twentieth century, after a hundred years of training. The camera slides through the doorway and feels its way like a blind man along the surface of the clutter: a von Sternberg shot, a *Citizen Kane* shot. The mind would like to move with that sensuous calm, to be the mechanical invulnerable eye passing disembodied through space, magnifying and illuminating at will, forcing the world to reveal itself. The surfaces flatten themselves into pictures as it goes by. The field of vision wants to be filled. The eye hungers for compositions and camera movements, for chases and crashes, for sudden sprawling boom-shot vistas ... It was when your world blacked out and the other radiant world imposed itself that you understood the word "awe." ... If God was anywhere, He was across town working wide-screen miracles.

Geoffrey O'Brien, *The Phantom Empire* (1993)

Photography, compared to linear perspective, is relatively free of geometric biases. The indexical nature of the medium allows it to capture complex geometries, such as human figures, as easily as regular geometries, such as buildings. Architectural subjects therefore do not facilitate the mechanical procedures of the medium as they do the projective procedures of linear perspective. Not surprisingly, theoretical and practical exchanges between architecture and photography have never been as vital or as consequential as those between architecture and linear perspective. Architectural subjects play an important role in the history of photography, as the works of Paul Strand and Bernd and Hilla Becher demonstrate, and many photographs of buildings are iconic architectural images, such as those of Le Corbusier's early villas, but photography has never been widely understood as a tool of architectural analysis and design Likewise, and regrettably, it has never been an integral part of the education of an architect. Unlike linear perspective, it never became a graphic standard. Although the location of a camera lens with respect to a building may be understood as an orthographic relationship somewhat similar to the location of a viewing point in a linear perspective construction, most photographers do not understand their medium as a tool to survey orthographic relationships. In many ways, the photographic camera is the apotheosis of the automated drawing machine and the antithesis of the *costruzione legittima*, as it facilitates the production of pictures and does not require any knowledge of (or interest in) basic geometry or mathematics.

Movies, of course, are motion photographs (or temporal photographs), and they too allow image-makers to compose pictorial shots in an intuitive manner and, thereby, to disregard the orthographic underpinnings of perspectival images. Cinema may encourage an even greater degree of automatism because every second of a movie contains at least twenty-four individual photographs. As the number of images increases, the compositional integrity of any single image becomes less critical. At the same time, the multiplication of images creates an illusion of the passage of time, and the spatio-temporal nature of the cinematic image is the primary reason that cinema is far more widely recognized than photography as a historically significant (and perhaps ongoing) mode of architectural and urban discourse. The architects who first recognized the theoretical and practical potential of cinema did not understand the medium as a derivative of either photography or linear perspective. Instead, they recognized movies as a spatio-temporal experience that encroaches upon the territory of architecture in an unprecedented manner. This chapter investigates the historical significance of cinema to architecture and urbanism, as well as the importance of architectural subject matter in cinema. Much of the established discourse on architecture and cinema is pictorially, as opposed to analytically, inclined, but all of it is still relevant to a broader investigation into how cinematic imagery may operate as a mode of architectural projection.

What is Architecture–Cinema?

Any inquiry into the relationship between architecture and cinema faces the problem of the overuse and/or misuse, of terms like *cinematic architecture* and *architectural cinema*. These imprecise terms mean different things to different people, and even the meaning of *cinema* is elusive in the contemporary landscape of moving imagery. One of the primary objectives of this chapter is to classify various approaches to the relationship between architecture and cinema under different terms in order to establish a more complete and specific understanding of the landscape of the discourse. I will refer to the discourse as a whole as architecture–cinema, an alphabetically ordered compound noun that resists attributing one of the two disciplines as the qualifier of the other. The relationship between architecture and cinema has been considered extensively enough to deserve an umbrella term, and architecture–cinema is both neutral and comprehensive. This chapter discusses three types of architecture–cinema. The first is the assumption that architecture and cinema are reciprocal types of spatio-temporal experience. It will be referred to as *Architecture–Cinema I: Reciprocity*. The second is the depiction of imaginary built environments in movies through either set design or computer-generated imagery. It will be referred to as *Architecture–Cinema II: Imagined Indexes*. The third is the use of cinema to document, either pictorially or analytically, specific built environments. It will be referred to as *Architecture–Cinema III: Spatio-temporal Surveys*. While some of the movies discussed in this chapter are analytical (architectural movies), others are pictorial (movies about architecture). Chapter 6 addresses the matter of analytical cinema more explicitly, as it posits a fourth type, *Architecture–Cinema IV: Indeterminate Projections*, which reconsiders how the reciprocity between architecture and cinema may directly engage practice and research.

All four approaches to architecture–cinema first appear in the 1920s, which is the most prolific decade in the history of the discourse. Cinema in the 1920s is comparable to linear perspective in the fifteenth and sixteenth centuries. It infiltrated the culture of architecture and revolutionized how the built environment is perceived through imagery. The first three approaches to architecture–cinema have been continually reinterpreted since the 1920s, in both inventive and simplistic ways. The fourth type, however, has remained a latent aspect of the discourse. Hints of its influence have reappeared in the work of moviemakers who are unaffiliated with architecture–cinema, and my goal is to appropriate their works into the discourse, so that they may inspire a new understanding of the reciprocity.

Architecture–Cinema I: Reciprocity

Space and Time

The relationship between architecture and cinema is somewhat analogous to the reciprocity between orthographic drawing and linear perspective. As discussed in Chapters 1 and 3, despite considerable differences in appearance, both drawing types belong to the same geometric system, and each type is embedded in the other. Architecture and cinema may also be understood as belonging to a single geometric system: spatio-temporality. In "The Work of Art in the Age of Mechanical Reproduction," immediately after he argues that cinema, unlike painting, is perceived in state of distraction, Walter Benjamin notes that, "Architecture has always represented the prototype of a work of art the reception of which is consummated by a collectivity in a state of distraction."[1] Architecture and cinema are alike because occupants absorb built environments, just as viewers absorb movies; likewise, occupants are not absorbed by built environments, just as viewers are not absorbed by movies. Buildings, like movies, are engaged through habit, not attention. At the same time, it is impossible to equate buildings and movies, just as it is impossible to equate orthographic drawings and linear perspectives. The relationship in both cases is one of reciprocity, not equality: *architecture is primarily a spatial construction in which time is embedded, and cinema is primarily a temporal construction in which space is embedded*. Buildings may appear indifferent to time, and movies may appear indifferent to space, but space and time are inseparable, which is why architecture and cinema historically overlap in so many ways. Each discipline looks to the other in order to engage its embedded dimension of spatio-temporality. Architecture enlivens the spatial dimension of cinema, and cinema enlivens the temporal dimension of architecture.

Benjamin is the patron saint of architecture–cinema. It is difficult to find an essay or book on the topic that does not refer to his remarks on distracted perception and habit, and it is important to understand the malleability of his argument. Interpretations of the spatio-temporal reciprocity between architecture and cinema generally fall into one of three categories, all of which are traceable to Benjamin. The first is that architecture and cinema inform each other. The second is that cinema may replicate the spatio-temporal experience of a built environment exactly. The third is that cinema is a model of spatio-temporality to which architecture should aspire. It is critical to note that all of these positions assume that both architecture and cinema are public experiences, as opposed to individual ones. Benjamin's notion of the reciprocity between architectural and cinematic perception is contingent upon the collective nature of distracted perception. In *A Small History of Photography*, he says that, "cinema provides

material for collective, simultaneous perception, just as architecture has always done."[2] According to this logic, individuals have little control over spatio-temporal experiences, as both buildings and movies unfold in an inevitable manner. While this logic may be questionable, it underlies much of the historical discourse on the reciprocity between architecture and cinema.

Sequential and Serial Spaces

Sergei Eisenstein, who was mentioned in Chapter 2 in reference to his theories on shot adjacencies, begins his 1935 essay "Montage and Architecture" with a discussion on the notion of path. He distinguishes between a cinematic path and an architectural path.[3] The former involves an immobile subject and a mobile space depicted on a cinematic screen, and the latter involves a mobile subject and an immobile space in the real world. In other words, montage and architecture are not only similar, but also reciprocal: in architecture, the subject moves through space; in cinema, the space moves through the subject. The objective of Eisenstein's essay is to establish the architectural roots of cinematic experience:

> Painting has remained incapable of fixing the total representation of a phenomenon in its full visual multidimensionality. (There have been numberless attempts to do this). Only the film camera has solved the problem of doing this on a flat surface, but its undoubted ancestor in this capability is — architecture. The Greeks have left us the most perfect examples of shot design, change of shot, and shot length (that is, the duration of a particular impression) … The Acropolis of Athens has an equal right to be called the perfect example of one of the most ancient films.[4]

Eisenstein includes an extensive quotation from Auguste Choisy's nineteenth-century analysis of the Acropolis in Athens. Choisy emphasizes the importance of procession through the site, in particular the path that leads to and through the monuments. He understands the path as a carefully calibrated sequence of movement that includes privileged viewing positions. Visitors, he says, move through the site and assemble a collection of impressions that are significant both in their own right and in relation to each other. Eisenstein interprets the individual impressions as shots and the relationship (or juxtaposition) between them as cinematic montage, and he understands architecture as the epitome of the two most important operations of cinema: the construction of individual spatio-temporal moments and the composition of a hierarchy of spatio-temporal adjacencies.

Eisenstein was trained as an architect, so his knowledge of Choisy's analysis is unsurprising; however, his extensive reference to it in his essay may have been inspired by Le Corbusier's earlier and less precise reference to it in *Toward an Architecture* (1923).[5] Eisenstein and Le

Corbusier interacted with each other in the 1920s, and they admired each other's work. The objective of Le Corbusier's reference to Chosiy's analysis is to promote the importance both of movement and of asymmetrical geometries to architectural and urban environments. The path on the Acropolis for him is an *architectural promenade* that embodies the energy of Modernity. In other venues, such as the movie about his work that will be discussed later in this chapter, Le Corbusier acknowledges that cinema too embodies that energy, but he never claims that the Acropolis is a work of proto-cinema, and he does not insist that his work is cinematic.[6] He understands both architecture and cinema as arts of sequential movement and spatial juxtaposition, but he resists the temptation to force architecture and cinema into an unhappy marriage. Even Eisenstein, who makes a more literal connection between architecture and cinema than Le Corbusier, considers cinema as an independent discipline that abides by its own set of principles. He refers to the evidence of montage sensibilities in the Acropolis and other pre-Modern works of architecture in order to argue for the cultural relevance of his art, not to suggest that cinema should simply emulate architecture.

The choreography of the Acropolis is an exceptional type of architectural experience. Like a movie, it is a strictly sequential composition of spatio-temporal moments. In most cases, architecture is a serial composition of adjacent spaces that may be experienced in any order depending on the whims of an occupant. One may argue that even unplanned sequences involve movement and spatial juxtaposition, but Le Corbusier does not address that nuance when he applies the example of the Acropolis to his work in 1920s. Instead, he simply inserts a miniature interpretation of what he calls an architectural promenade. In many of his villas, the promenade cuts through the house in a dramatic way and terminates on the roof terraces. In Villa Savoye (1928), for example, a ramp ascends from the ground level and weaves in between the interior and the exterior of the house until it terminates on the roof in front of an open picture window that frames the landscape. The finitude of such a procession (i.e., the fact that it has a clear beginning and a clear ending) may be interpreted as a cinematic sequence, but the precedent for it is actually another work of architecture, not a movie. Later in his career, Le Corbusier constructed compositions of movement and spatial juxtaposition that are more serial than sequential and therefore less easily likened to a movie. The Carpenter Center for the Visual Arts (1962), for example, has an architectural promenade that operates as a multi-directional axis, not a one-way path. It is an exterior ramp that cuts through the center of the building and connects two streets that lie on either side of it. The apex of the ramp is not a terminus, but rather a hub that provides two thresholds into the building. Occupants may use the ramp as an entrance into the building, as an exit from the building, or as a transitional space between different parts of the building. The promenade in The Carpenter Center is a

less literal translation of the path through the Acropolis than the promenade in Villa Savoye, and it demonstrates the maturity of an architect who devoted his career to the investigation of movement and spatial juxtaposition in architecture. To call it a work of cinematic architecture is to belittle its significance as a work of architecture.

Total Cinema

Eisenstein's approach to cinema is highly analytical. His movies mediate their depictions of reality for the sake of an effect and take liberties with spatial and temporal continuities. They therefore cannot be understood as illusions of actual spatio-temporal experiences. After World War II, several moviemakers began to question to extent to which movies may (and should) suppress the artifice of the medium. The Neorealism movement in Italy sought a purely pictorial approach to the medium, which will be discussed later in this chapter in reference to the cinematic documentation of urban built environments. The most historically significant theorist of realism in cinema is the French film critic André Bazin. In the 1950s, Bazin co-founded the influential journal *Cahiers du Cinéma* and helped to inspire the emergence of the French New Wave movement. He argued that, "The [movie] screen is not a frame like that of a picture ... The world of the screen and our world cannot be juxtaposed."[7] Whereas frames are strict boundaries between a viewer and a picture, movie screens are permeable thresholds that, like human fields of vision, may shift over time. Bazin advocated the use of long shots and disparaged the use of blatant editing methods, so that viewers could enter into the world of the screen more easily and navigate it on their own terms. He appreciated montage as a founding principle of cinema, but he found it to be overly deterministic. Whereas montage tells a single story that is prescribed by the moviemaker, realism (like life) allows for multiple interpretations.

One of Bazin's most provocative ideas is that cinema has not yet been invented. This is a startlingly different position from that of Eisenstein, who sees the birth of cinema in ancient architecture. In his essay "The Myth of Total Cinema," Bazin writes:

> The guiding myth, then, inspiring the invention of cinema, is the accomplishment of that which dominated in a more or less vague fashion all of the techniques of the mechanical reproduction of reality in the nineteenth century, from photography to the phonograph, namely an integral realism, a recreation of the world in its own image, an image unburdened by the freedom of interpretation of the artist or the irreversibility of time ... If the origins of an art reveal something of its nature, then one may legitimately consider the silent and the sound film as stages of a technical development that little by little made a reality out of the original "myth." It is understandable from this point of view that it would be absurd to take the silent film as a state of primal perfection which has gradually been forsaken by the realism of sound and color ... The real primitives of

the cinema, existing only in the imaginations of a few men of the nineteenth century, are in complete imitation of nature. Every new development added to the cinema must, paradoxically, take it nearer and nearer to its origins. In short, cinema has not yet been invented![8]

Total cinema, in effect, is architecture. It is not a sequential type of architecture that is prescribed for us, like the path through the Acropolis, but rather a serial type of architecture through which occupants navigate themselves. The role of the moviemaker, or "architect," in total cinema is unclear. If a movie is completely unmediated by the interpretation of an artist, as Bazin suggests, then how is it made? The *auteur* theory of cinema, which Bazin supported to a limited degree, suggests a way to reconcile this apparent conflict.[9] According to the theory, although many assistants and technicians may be required to make a movie, its overall quality may be attributed to one person, its auteur (or director). Cinema, then, is the epitome of both objectivity and subjectivity. A work of total cinema seems absolutely real and inevitable, and viewers enter its depicted world unequivocally; however, it is also an absolute vision of a single artist. The correlation between the auteur and the architect should be clear. Although the construction of a work of architecture requires an enormous team of professionals, it too is often attributed to a single visionary. Architecture, then, is also the epitome of both objectivity and subjectivity. A building is absolutely real and inevitable, and occupants enter its world unequivocally; however, it is also an absolute vision of a single artist. Even if the myth of the heroic creator in cinema and architecture is dispelled (as it should be), the duality of objectivity and subjectivity remains. Individual creators make decisions that affect movies and built environments, but then viewers and occupants navigate them in their own way.

Bazin's protégés in the New Wave movement made several movies that are beautiful hybrids of realism and artistry. A scene in *Le Mépris* (*Contempt*, Jean-Luc Godard, 1963) is particularly interesting for its epic depiction of an ordinary apartment. The scene follows a rambling conversation between two characters, played by Brigitte Bardot and Michel Piccoli. Most of the shots in the scene are long tracking shots, and camera movements are fluid. The scene unfolds, more or less, in real time, and cuts between shots are inconspicuous and temporally continuous in relation to each other. The aspect ratio of the screen is wide, and the shots have a deep depth of field that renders both the foreground and the background in focus. Viewers therefore have more space through which to navigate. All of these methods contribute to the quest for objective realism in cinema. The composition of the shots and the hierarchy of the shots within the scene, however, are meticulously crafted by a true master of the medium. Godard takes advantage of the layout of the apartment (as well as various door and window openings in the apartment) in order to construct a richly layered spatio-temporal experience. As

the camera glides through the apartment, characters appear and disappear behind walls and doors, which act as secondary frames within the primary frame of the movie screen. Although the movement of the characters with respect to the camera may not be strictly choreographed, the parameters of the scene somewhat regulate the possibilities. The director, therefore, does not micromanage the experience of the environment, but he provides a relatively controlled vision for viewers to interpret. The camera assumes a voyeuristic position within the apartment, not a purely objective or detached one. Godard also dresses the apartment in primary colors, which reappear throughout the movie and heighten the sense of artistic mediation. Despite the realist tendencies of the movie, viewers are well aware of its artifice.

The movies of Frederick Wiseman demonstrate a similar balance between objectivity and subjectivity. Their documentary, as opposed to narrative, subject matter gives them an even greater sense of veracity. Wiseman was trained as a lawyer in the 1950s, and many of his movies address matters of public policy: *High School* (1967), *Public Housing* (1997), *State Legislator* (2006). Even his less apparently serious movies, such as *Model* (1980) and *The Store* (1983), examine their subjects with an anthropological eye that reveals the nature of social interaction and cultural meaning. His style may be referred to as fly-on-the-wall documentary because the subjects in the movies rarely (if ever) seem aware of the camera. They conduct their business in what seems to be an unaffected manner. Most of Wiseman's shots are long and unmediated, and this method seems to allow him to "disappear" somewhat during the shooting process. An early shot in *Public Housing* is emblematic of his approach. It depicts one side of a telephone conversation between a housing official and a social worker; viewers see and hear the housing official during an uninterrupted and unmediated seven-minute shot, but they do not hear the other side of the conversation. Somehow, and this is the mysterious power of Wiseman's work, the shot is fascinating. To watch one of his movies is simply to inhabit a spatio-temporal environment. The apparent immediacy, however, is a fiction. Wiseman, in fact, refers to his movies as "reality fictions," and he has a discernible artistic style that he applies to all of his subjects.[10] For example, he balances shots like the one just described in *Public Housing* with montages of establishing shots that give a broader view of the environment under investigation. The montage sequences, which are nowhere near as abrupt as the ones in Soviet cinema, provide a (sometimes welcome) recess from the raw indexicality of the other shots. Changes in rhythm allow Wiseman to craft a hierarchy of spatio-temporal fragments that tell the story of the environment in a particular (and subjective) way. Despite its artistry, or perhaps because of it, Wiseman's work approaches the notion of total cinema. Whereas montages orient viewers in the given environment, long shots operate as almost pure indexes of space and time, assuming of course that time may be captured indexically.

The extent to which the duration of a cinematic shot qualifies as an index of time is debatable. One may argue that every movie frame is an index of a fraction of a second, and that a one second movie is an index of one second of real time. One may counter-argue that several fractions of the second (the ones that occur between the frames) are missing, so the movie cannot be considered a true (or full) index of the second. At stake in such a debate is the nature of the cinematic image: is it a physical trace of a real moment in time, or is it a simulation of the passage of time in a more general sense? Likewise, is it a moment of linear time or a moment of cyclical time? A related quandary addresses duration from the perspective of the viewer: is the duration of a movie a pictorial temporality that displaces (or erases) a moment of real time, or is it an analytical temporality that engages (or enhances) a moment of real time? Although these philosophical questions probably do not occupy the minds of most moviemakers, they are interesting to consider from the perspective of architectural projection. Architectural moviemakers may consider the temporal dimension of the imagery in a number of analytical ways.

Derivative Architecture

A wave of Post-Modern architecture beginning in the 1970s returns the discourse on the reciprocity between architecture and cinema to Eisenstein's theory of montage, albeit with a significant shift. Whereas Eisenstein considered architecture as the basis of montage, Post-Modern architects consider montage as the basis of a new approach to architecture. Bernard Tschumi, for example, uses cinema as a model of spatio-temporal experience that is uniquely relevant to the condition of the Post-Modern built environment: "Film analogies [to architecture] are convenient, since the world of cinema was the first to introduce discontinuity—a segmented world in which each fragment maintains its own independence, thereby permitting a multiplicity of combinations."[11] For Tschumi, architecture is a vehicle of disjunction. It must reject synthesis and celebrate dissociation; it must challenge the relationship between use and form; and it must trigger transformations that question the readability of built form. Path and sequence are dominant themes in Tschumi's work. For *The Manhattan Transcripts* (1976–1981), he constructed a thirty-two-foot-long drawing that cannot be understood from a single perspective and is supposed to be read by a mobile viewer. It promotes "walking while viewing"[12] in an attempt to overcome the limitations of static modes of architectural projection. The overall objective of the project is to depict transitory relationships between space, movement, and events, not absolute formal conditions. Many of the drawings in the project read more like movie storyboards than conventional architectural graphics.

Tschumi's architectural and urban theories are among the most provocative and influential ideas to affect design and research in the past several decades. If his reading of cinema contributed to the development of these theories, then architecture owes cinema a debt of gratitude for its role in his thinking. It is important, however, to scrutinize Tschumi's specific references to cinema, as they are sometimes misleading. Parc de la Villette (1982–1998) continues the themes of *The Manhattan Transcripts*, and it is Tschumi's most formidable and problematic foray into the reciprocity between architecture and cinema. The park is a hugely successful project, but it typically fails to substantiate its architect's cinematic rhetoric. Tschumi's argument on the influence of montage on the project is particularly unconvincing:

> No semantic intention governs the transformation of La Villette; they result from the application of a device or formula. While this may superficially resemble a variation of the surrealist "exquisite corpse," we have seen earlier that the relation between form and meaning is never one between signifier and signified. Architectural relations are never semantic, syntactic, or formal, in the sense of formal logic. Instead, a better analogy to these montage and mixing techniques might be found in Dziga Vertov's or Sergei Eisenstein's work in the cinema … To the notion of composition, which implies a reading of urbanism on the basis of the *plan*, The La Villette project substitutes an idea comparable to montage (which presupposes autonomous parts or fragments).[13]

Tschumi's reference to Soviet montage is imprecise. Vertov and Eisenstein understood montage, despite its spatial juxtapositions and temporal discontinuities, as an art of intentional composition and formal synthesis. Tschumi understands it as a way to escape compositional intention and synthetic formalism. Like many architects of his generation, Tschumi attempts to distance himself from the responsibility of architectural composition and to justify his work as the product of a theoretical, as opposed to a formal, operation. Tschumi envisions La Villette as a system of collisions between points, lines, and planes that generate formal events beyond the control of the architect and the expectations of the parkgoer. The rhetoric is fascinating, but it does reflect to aims of Soviet montage. Perhaps Tschumi is interpreting a more dissociative and authorless potential within the historical precedent of Soviet montage; however, the park is hardly the embodiment of a dissociative approach to montage either. Like all works of architecture, it is static, enduring, and continuous, and it lacks the abruptness that the architect seeks to harness. The park, however, is a beautifully composed, well programmed, and thriving urban landscape. Whatever "device" Tschumi used to design the park, it worked, but it did not produce an example of "cinematic architecture."[14]

The signature reference to the reciprocity between architecture and cinema in La Villette is its so-called cinematic promenade, which is a linear walkway that slices through the park in a sinuous manner. In plan, it reads as a winding picturesque garden path or (perhaps) as a

piece of film that has been removed from its reel. A sequence of gardens lines the path, and Tschumi employed the services of a different designer for each garden in order to heighten the sense of discontinuity between them. Each garden has a unique formal and conceptual identity and is envisioned as a scene or a shot within the sequence of a cinematic montage. Again, it must be said that the design is both compelling and successful, but it is cinematic only in a literal and uninteresting manner. The experience of the path is nothing like that of a movie, and it cannot be compared even to the orchestrated spatio-temporal experience found on the Acropolis.[15] The path is an imposition on the gardens, not an integral part of them. At times, the path skirts the perimeter of a garden and merely provides a view of it, and occupants may chose whether or not to enter the garden. Even when the path cuts through the core of a garden, it feels more like a fragment of the extended path than like a unique spatial moment affiliated with the particular garden. One's experience of the promenade is controllable and predictable, not inevitable and overwhelming. The fact that Tschumi refers to the path as a cinematic, as opposed to an architectural, promenade is significant. Between the 1920s and the 1970s, architecture–cinema evolved into an entirely different discipline. In the hands of most Post-Modernist architects, cinema is a literal model, not a vital collaborator. The most dubious assumption behind much of the cinematic architecture that has emerged since the 1970s is that cinema is somehow more visceral and more engaging than corporeality. The use of cinema, as in Tschumi's case, sometimes leads to provocative built work, but the recent rhetoric of architecture–cinematic tends to narrow the potential of the reciprocity.

Several academic programs provide an antidote to such reductive notions of cinematic architecture. Between 1983 and 2008, Pascal Schöning led an ongoing investigation into the potential of cinema to engage architectural design at the Architectural Association in London. The work from the program, which has been exhibited and published widely, mostly refrains from the this-will-kill-that rhetoric that informs Tschumi's work.[16] Instead, the work concentrates on precise and subtle formal maneuvers. Similarly, since its founding in 2002, the Delft School of Design has promoted the use of cinema, in particular video, as a form of urban mapping, and it has established rigorous strategies as part of a larger vision of the relevance of cinema to architecture.[17] This book promotes an approach to the use of cinema as a mode of architectural projection that differs from these and other academic precedents of architecture–cinema.

Architecture–Cinema II: Imagined Indexes

Cinema and Aesthetics

Set design is as old as cinema itself. As soon as the technology to capture the world in a naked state of spatio-temporal realism had been invented, moviemakers began to create imaginary worlds to place in the front of the camera. In most cases, early movie sets are simple backdrops or three-walled rooms that present an image of an architectural space to the camera, not unlike how a theatrical stage set presents itself to an audience. Actual spaces were difficult to use as locations because of certain technical requirements, such as natural light and the placement of equipment during shooting. The imaginary spaces in early movies are mostly non-descript rooms that provide a setting for the actions of the characters, as opposed to spaces that have a specific architectural character. In rare instances of early cinema, depicted environments actively contribute to the identity of a movie, as in the science fiction films of George Méliès. His stylized visions of scientific laboratories and lunar landscapes are the ancestors of the sets that interest architects, but they are missing two key criteria. First, they are generally more graphic than spatial (more two-dimensional than three-dimensional) and thereby more like painted theater backdrops (or paintings) than works of architecture.[18] Images of space on a stage take little advantage of the spatio-temporality of architecture–cinema. Second, Méliès and his peers were in no way affiliated with (or necessarily even acquainted with) the dominant aesthetic theories of their era. Their imaginary spaces were created for a commercial industry, not an artistic discourse. Cinema did not emerge as a self-conscious aesthetic discipline until after World War I, which is when Architecture–Cinema II begins.

Spatio-temporal Fantasies

The earliest aesthetic tradition of set design is German Expressionism, which is a broad and difficult to define movement that includes painting, sculpture, theater, dance, cinema, and architecture. In many ways, cinema did not complement the goals of the Expressionists, who rejected photographic realism and were ambivalent toward Modernity. Although the movement did not abandon figuration or reject Modernity altogether, it did adopt pre-Modern forms of art and ways of life as sources of inspiration. The Expressionists, however, did not understand cinema as the epitome of objective truth and newness. Instead, they realized and exploited the potential of the medium to distort and defamiliarize reality. Their movies are illusions of abstractions, not illusions of reality. One of the founding works of Expressionist cinema is *The Cabinet of Dr. Caligari* (Robert Weine, 1920). Its sets depict a sinuous built environment that,

as the end of the movie reveals, is the vision of a delusional patient in a mental institution. Oblique axes and canted walls distort the scale of the depicted environments and instill a sense of imbalance. The sets, designed by Hermann Warm, Walter Reimann, and Walter Röhrig, are not mere images of environments, but actual three-dimensional spaces through which characters move. Although still somewhat frontally oriented, like a theater set, they are clearly designed for the camera, not the stage. One scene, for example, depicts a group of citizens chasing a suspected murderer through a street in the city, and the set accommodates two camera locations that depict the street from significantly different perspectives. The street is not perceived as a detached image of a space, but rather as an enveloping environment. The viewer is able to occupy the street like one of the characters. Although the sets in the film are rendered with two-dimensional graphics that derive from the painterly traditions of theatrical sets, such as black lines that accentuate spatial imbalances, the shooting and editing methods of the movie create a sense of spatio-temporal continuity that is specific to cinema. To an unprecedented degree, the world of the screen has become an alternate world in which to engage an aesthetic discourse.

As Expressionist cinema progressed throughout the 1920s, moviemakers created increasingly sophisticated illusionary worlds through well-practiced techniques of set composition, lighting design, and editing. The culmination of the movement is *Metropolis* (Fritz Lang, 1927). It is difficult to overstate the accomplishments of *Metropolis*, especially in regard to its sets, designed by Otto Hunte, Erich Kettelhut, and Karl Vollbrecht. The movie depicts three distinct worlds that co-inhabit a single city: the first is the glittering Modern environment of the business owners; the second is the furious mechanical environment that generates the wealth of the city; the third is the vernacular underground environment of the workers. The imagery of American skylines undoubtedly influence the ziggurat vision of the city of Metropolis, which is far more vertically oriented than any European city at the time (and arguably even now). Other references for specific environments in the movie include works of infrastructure, industrial factories, and medieval fabrics. None of the depicted spaces in the movie, however, bears any resemblance to a real environment. The objective is not to faithfully recreate the qualities of an existing environment, but rather to create anew an imaginary and allegorical world that resonates with multiple references. The city of Metropolis is far more realistic than the fantastic setting of *Dr. Caligari*, but it is still a mythic setting that allows the moviemakers to create a comprehensive theoretical discourse on the nature the city.

Throughout *Metropolis*, spatial conditions operate as story devices in ways that would be impossible without the use of sets. One of the primary themes of the movie that is reinforced

by its sets is the vertical segregation of the city. Workers, for example, go to work in elevators that move vertically, not on trains that move horizontally. Spatial hierarchy in the city occurs in section, not plan. The horizon, in fact, is almost never visible in the movie, except from the pleasure gardens on the top of the city. The ground plane is similarly disregarded, as most of the spaces depicted in the movie lie either high above or far below the ground, or perhaps so deeply embedded into the fabric of the city that the location of the ground is irrelevant. One of the few depictions of the ground is a shot that depicts the house of the inventor Rotwang. The house sits directly on the desolate and deserted floor of the city, as if it is a lone and stubborn reminder of a former idea of a city. Whereas the ground is a site of engagement in the traditional city, it is a forgotten wasteland in the city of Metropolis. The ground regains significance in the finale of the movie, when it provides the setting for the reconciliation between the lofty rulers and the subterranean workers.

The great irony of *Metropolis* is that, despite its reputation as one of the most architecturally significant movies in the history of cinema, it is not an especially interesting cinematic depiction of spatio-temporality. In this sense, it is somewhat of a red herring in architecture–cinema. It is a compelling story about architecture and urbanism, and its vignettes of architectural and urban imagery are spectacular, but it rarely takes advantage of shooting and editing methods to depict a built environment in an especially cinematic manner. The sets, perhaps, do not complement (or even allow) such methods. Many of them provide totalizing images that may be understood only from a detached perspective. They fill the frame perfectly, not unlike how a theatrical set fills a proscenium frame, or how a painting fills a picture frame. Although they have significant spatial depth, they are strictly frontal, and the viewer is more often looking at space than being enveloped by it. The same may be said of *Dr. Caligari*, which also has frontally oriented sets, but the separation between the viewer and the depicted environment is more extreme in *Metropolis*. In *Dr. Caligari*, shot compositions are typically asymmetrical, and characters move through the frame in ways that often activate the implied space beyond the edges of the frame. Each shot has the sense of being a moment in a spatio-temporal continuum. In *Metropolis*, shot compositions are more often symmetrical and internally cohesive, and the edges of the frame are less frequently engaged. The relatively holistic nature of the shots in *Metropolis* renders them as freestanding vignettes arranged into a succession.

One exception to the compositional autonomy of the shots in *Metropolis* is a shift-change scene in which workers take elevators either to or from the factories of the city. Although the scene includes a strictly frontal and detached view of the tunnel that leads to the elevator, it also includes two oblique views from opposite directions within the tunnel that give a thoroughly

cinematic and non-theatrical perspective of the space. Furthermore, one of the shots is a relative close-up of the workers, and one is a relative distant shot of them, so the viewer occupies the space of the scene in a more complex and engrossing manner than many of the other depicted spaces in the movie. Lang and his team, therefore, clearly understand the potential of the medium to depict space in different ways, and they chose to privilege detached and singular perspectives instead of internal and multiple ones. The point of this analysis is not to question the significance of *Metropolis* to architecture–cinema, but rather to clarify that significance. It is important to distinguish between the content of a given movie and its formal attributes. Movies that depict fascinating spatio-temporal environments may not be interesting examples of architectural projection in cinema, and interesting depictions of spatio-temporal environments may sometimes appear in movies that do seem to engage the built environment as a subject.

One such movie is *The Passion of Joan of Arc* (1928, Carl Theodor Dreyer), which is one of the most compelling depictions of an imaginary built environment in the cinema of the 1920s. Its set is a fully three-dimensional environment that may be shot from multiple directions. It therefore does not suggest precise camera locations as strongly as the sets in *Metropolis*. Parts of the set, in fact, never appear in the movie.[19] *The Passion of Joan of Arc* is not widely discussed as a significant work of architecture–cinema, possibly because its medieval setting does not overtly address the discourse on Modernity that pervades other movies of the era; however, the movie fully demonstrates the Modernity of the cinematic image. It is best known for its inventive and extensive use of extreme close-ups on characters' faces, which recall medieval icon paintings in which figures are situated against abstract backdrops, not in clear architectural settings. The association between the icon tradition and the moving portraits in the movie is loose, not literal. The movie does not imitate the richly colored icons, which would be impossible in black-and-white, but rather references them. Moving facial expressions provide the "color" in the shots. The same type of association exists between depictions of architecture in medieval painting and depictions of architecture in the movie. The set, designed by Hermann Warm and Jean Hugo, references (but does not mimic) the distortions in scale and perspective that are typical in medieval depictions of architectural settings. The walls of the sets, however, are stark white, and shadows provide the rendering that typical occurs through color and pattern in the paintings. These abstractions of medieval references are fully aligned with both the motives and methods of the Expressionists, but the austerity of the imagery also references the aesthetic of Modernism. The world of the screen is an enigmatic hybrid of Modern and pre-Modern sensibilities.

Dreyer and his team heighten the depiction of the village through their integration of cameras into the sets. In one instance, trenches are built into the floor of a set, so that a camera may be placed below the floor level in order to capture awkward and disquieting spatial relationships between characters and their environments.[20] Unlike conventional frontal views, these shots activate the space in between the characters and the sets. In another instance, a camera is integrated into the roof of the monument gateway into the village. The camera's position on the roof is stationary, but it is able to rotate between overhead plan-like views and frontal elevation-like views. Dryer uses this camera location in order to capture two dynamic shots of movement along a pathway that runs through the gateway. During the course of the first shot, the camera rotates in order to follow the movement of soldiers who are protecting the gate. It begins as an overhead view of the soldiers' walking toward the gate, and it follows their movement until the shot becomes a frontal view of the gate. During the course of the second shot, the camera rotates in the opposite direction in order to follow the movement of villagers who are storming into the village. It begins as an overhead view of the villager's passing through the gate, and it follows their movement until the shot becomes a frontal, albeit upside-down, view of the pathway into the city. This final position of the camera is upside-down because the camera is mounted into the set in the same manner for both shots. Dryer could have remounted the camera for the second shot, so that both shots ended on a right-side-up frontal view, but the upside-down orientation complements the madness of the movie's finale. Furthermore, spatial awkwardness is a recurring theme in the movie, and Dryer's editing style reinforces it. The movie contains a variety of spatial-temporal textures, such as long close-up shots, in which space is reduced to a surface, and rapid editing cuts between discontinuous spatial locations, which fragment the spatial continuum of the setting.[21] The fluctuating rhythms of the spatio-temporal depiction in *The Passion of Joan of Arc* are completely unlike the even rhythms of the successive vignettes in *Metropolis*. Far more than its more architecturally celebrated predecessor, Dryer's movie exploits the potential of set design, shooting, and editing to displace its viewer into an entirely new, and fully cinematic, type of spatio-temporal environment.

Spatio-temporal Realities

The set designs of the 1920s do not always depict environments as fantastic as the ones depicted in Expressionist sets. In the *strassenfilm* (street-film) genre, which thrived in Germany as a parallel to Expressionism, sets depict the Modern metropolis in a relatively documentary fashion. The main character in a *strassenfilm* is typically a victim either of the temptations of the street or of a social injustice brought upon by Modernity. The characters' downfalls unfold in the everyday environments of the city, such as shops, housing tenements, alleyways,

and street corners. It is not difficult for cinephiles to recognize the artifice of the sets in a *strassenfilm*, but they are derivatives of places that every moviegoer would recognize as real. Like the set in *The Passion of Joan of Arc*, many *strassenfilm* sets are fully three-dimensional environments, albeit to a lesser extent. The hotel in *The Last Laugh* (F.W. Murnau, 1924), for example, does not have a top story or a roof because that portion of the building never appears in the frame. Despite their everyday appearance, these sets are meticulously composed and subjected to effects that may seem more appropriate to Expressionist movies. In *The Last Laugh*, the set of a seemingly ordinary tenement courtyard is activated through lighting effects and shot compositions that would have been difficult, if not impossible, to achieve in a real space. In the opening scene of *The Street* (Karl Grune, 1923), a man lies on his back in an ordinary apartment and watches abstract shadows that are cast onto the ceiling by the movements of the street below his window. The hypnotic imagery, which is as stunning as the imagery in *Dr. Caligari*, eventually draws him to the window, at which point the movie cuts to an Expressionistic montage of bustling street views superimposed over the faces of harlots and clowns. The *strassenfilm* genre fully embraces the capacity of shooting and editing to create visual intensity and abstraction, but it applies that capacity to depictions of ordinary, as opposed to extraordinary, environments.

After the 1920s, imagined everyday environments in the movies become somewhat less spectacular. The *film noir* genre is highly indebted both to Expressionism and to the *strassenfilm* genre, but it hardly aspires to the same effects. In film noir, light and shadow play upon generic urban environments in an atmospheric, as opposed to a fantastic, manner. *M* (Fritz Lang, 1931) is a proto-noir movie that is particularly interesting to compare to Lang's *Metropolis*. The plot of *M* follows a child murderer who is brought to justice by a band of petty criminals who have been inconvenienced by the increased police presence that arose in response to his crimes. In one sense, Lang must have considered this crime drama, which takes place in non-descript settings, as a relatively modest undertaking in comparison to his earlier epic, which was one of the most elaborate productions in the history of cinema; however, *M* presented him with creative challenges that were absent in *Metropolis*. It was Lang's first sound film, and its sets, designed by Edgar Ulmer, are three-dimensional environments that, like the sets in *The Passion of Joan of Arc* and many *strassenfilms*, may be viewed from multiple locations. Unlike the architectural and urban icons of *Metropolis*, the imaginary built environment of *M* gave Lang more opportunity to consider the city as a complex spatio-temporal condition.

One of Lang's interests in *M* is the mapping of the city. Both the police and the underworld use forms of cartography in their attempt to capture the murderer. Whereas the police use a

compass to survey and to divide the city into ideal geometric sections, the criminals use a more vernacular system of mapping that assigns specific portions of streets to specific watchmen. Architectural drawings also appear in the movie. When the murderer is cornered in an office building, the criminals use an electrical plan of the security system to understand the spatial order of the building, and the police use an architectural plan to locate the exact position of a triggered alarm in the building. An orthographic logic also infiltrates some of Lang's shot compositions. On several occasions, he shoots spaces from above in a plan-like manner, as when the police are searching backyards for evidence.[22] In the climactic trial scene, he surveys the room with a horizontal pan that flattens and elongates the space in the manner of an architectural elevation. In other scenes, the perspectivalism of the cinematic image is exploited, as when a mother looks down a stairwell, which appears as an endless abyss, in hopes of seeing her child, who has been killed. *M* depicts space both analytically and pictorially. The city is both an object to investigate and an environment through to navigate.

A shooting strategy that occurs throughout *M* and only rarely in *Metropolis* is the use of multiple camera positions, many of which face each other, to shoot one space. The shooting of spatio-temporally continuous shots is complex, as it involves repositioning all of the equipment and actors. The benefit, of course, is a greater sense of spatial relationships. Lang's use of multiple shots to depict the exterior of the office building in which the murderer hides constitutes a virtual case study of how to shoot an architectural subject. The first shot is an overhead view of the building's street condition, which is followed by a tracking shot that follows the murderer as he enters the courtyard of the building and weaves through its column grid. From that point, Lang constructs a series of frontal and oblique views, both from within the courtyard looking out onto the street and from the street looking into the courtyard. Each of these shots takes advantage, in one way or another, of the column grid as a framing device, and the alternating perspective is reflective of how the building acts as a barrier between the murderer and his pursuers. To complement the intense depiction of the ground level, Lang provides a tracking shot of the upper levels, which operates as a sort of elevational survey of the building.

Lang's use of sound in *M* is another sign of his acute sense of cinematic spatio-temporality. Most of the sound in the movie is diegetic, but much of it derives from the sources that do not appear in the shot in which it is heard. Off-screen sounds often identify various spatial relationships between the characters, as when the desperate call of a mother is heard over a series of shots of places where her missing child may be. The places are empty, and the increasingly faint volume of the mother's voice foretells that she will never see her child again. Similarly, as the criminals look for the murderer in the office building, various sounds from

behind walls and closed doors allow both the pursuers and the pursued to chart each other's location. Just before the criminals finally locate the murderer, Lang reveals the murderer's face reacting to the increasingly loud sound of their fury as they approach. These uses of sound may seem elementary to today's moviegoers, but they were radically more advanced than the conventions of the time. Like Lang's use of maps and sets in the movie, his handling of sound reveals a spatio-temporal artist of the highest order, which is why *M* deserves a place along *Metropolis* in the canon of architecture-cinema.

Spatio-temporal Manifestos

The cinematic depictions of imaginary built environments so far discussed have addressed architectural and urban issues in only an indirect manner. Movies like *Metropolis* and *M*, as well as their many descendants like *Blade Runner* (Ridley Scott, 1981) and *Taxi Driver* (Martin Scorsese, 1975), present aesthetic visions of the built environment, but not prescriptions for it. Robert Mallet-Stevens, a French architect and set designer who was an important figure in the design world throughout the 1920s, understood set design as an extension of the design professions. He is perhaps the Bramante of architecture–cinema, as his accomplishments include significant works of both visual art and built space. Mallet-Stevens is a complex figure, and his engagement with matters of architecture–cinema is extensive. The use of one of his villas as the setting of a Surrealist movie by Man Ray will be discussed later in this chapter. First, it is important to examine how his own work in the movies resonates with his architectural and urban projects.

Mallet-Stevens' general theory of architecture-cinema is that set design and architectural design are both mutually exclusive and mutually beneficial. On the one hand, actual built environments are in no way compatible with cinematic sets. The camera, after all, sees differently than an embodied observer. At the same time, cinematic depictions of Modern design may promote the principles of the Modern movement to a broader public, and they may also promote the identification of the medium with Modernity. As a member of one of the earliest and most influential avant-garde cinema organizations, *Le Club des Amis du Septième Art* (Friends of the Seventh Art), Mallet-Stevens rallied against the use of generic architectural settings in movies, particularly French movies. His sets for *L'Inhumaine* (Marcel L'Herbier, 1924) demonstrate his commitment to redefining the potential of cinematic imagery to engage Modernity. His visions for the houses of the two main characters in the movie, the singer and the engineer, are unlike anything that appear either in the conventional movies or in the innovative German movies of the same era. They are neither realities nor fantasies. Instead,

they are architectural provocations that promote the reduced geometries that were beginning to appear on the European landscape in the works of Le Corbusier, Adolf Loos, and other early Modern architects. The sets, however, are far more than architectural propaganda, as they contribute to the narrative objectives of the movie. Each house evokes the character that lives behind it. The souring verticality of the engineer's house is not only phallic, but also representative of his accomplishments, aspirations, and ideals. The entrance into the house, by contrast, is compressed and has a mechanistic quality, like a small valve on the side of a large machine. The singer's house, by contrast, sprawls in the horizontal dimension and fully opens itself to visitors.

One of the fascinating aspects of *L'Inhumaine* from an architecture–cinema perspective is that Mallet-Stevens is not the designer of the interiors of the houses. The engineer's laboratory is the work of Fernand Léger, and the spaces within the singer's house are the work of Alberto Calvacanti. Both interiors are far more decorative and densely articulated than the exteriors. The laboratory is a chaotic environment of fractured geometric shapes that recalls the aesthetic of Léger's Dada-inspired movie *Ballet Mécanique* (Fernand Léger and Dudley Murphy, 1924). The singer's entertainment room, meanwhile, is a composition of richly patterned surfaces and sharply angled forms that has the spirit, if not the exact style, of a densely layered Art Nouveau interior. The incongruence between the interiors and exteriors is also spatial, as the geometries of the interior volumes are incompatible with the volumetric disposition of the exteriors. One may interpret these disparities as inconsistencies, but it is important to question whether formal cohesion was even an objective of *L'Inhumaine*. The use of several designers is a clear sign that L'Herbier intended to create a sort of essay on the role of design in cinema.[23] Other liberties include the use of both a full-scale set and a small architectural model of the engineer's house, as well as the use of real locations, such as the Théâtre des Champs-Élysées.

Although Mallet-Stevens rejected the notion that set designs should influence architectural designs in a direct manner, it is interesting to speculate upon the extent to which his work as a set designer may have infiltrated his architectural projects. A comparison to his Parisian colleague Le Corbusier is inevitable, as both were at the forefront of Modern architecture in the 1920s, and both understood cinema as a relevant but peripheral discipline. Of the two, Le Corbusier more successfully immunized himself against the influence of cinematic imagery, perhaps because he never worked as a set designer. Two side-by-side houses on Rue Denfert-Rochereau in Paris, one by each architect, provide an unusually convenient comparison of the two architects' sensibilities. Whereas the façade of Villa Collinet (Mallet-Stevens, 1925) is a simplistic composition of clear visual symbols, the façade of Villa Cook (Le Corbusier, 1926)

is an enigmatic composition of mass, void, and line. The stairwell in Villa Collinet, for example, is located in the front of the house, and its massing creates a vertical tower (not unlike the tower of the engineer's house in *L'Inhumaine*) that announces the function of the space is a straightforward manner. Likewise, a protruding horizontal slab clearly articulates the location of the front door of the house (again like the engineer's house). The stairwell in Villa Cook, by contrast, is located in the center of the volume of the house, so that the façade of the house is free to evolve into a collection of architectural components that create a Modern discourse on light, structure, and geometry. Likewise, the entrance to the house is discreetly embedded within a dark void underneath the primary mass of the house, and the façade of the house reads less like a front than an edge of a complex volume. Whereas Villa Collinet presents us with a Modern-looking face, Villa Cook embodies a more fully developed Modern doctrine.

Mallet-Stevens' most impressive built project, the Rue Mallet-Stevens (1927) in Paris, is far more satisfying as a work of Modern architecture, but it is still somewhat indebted to the visual biases of set design. The project consists of six buildings on a single street that include dwellings, studios, and galleries. One the one hand, the street has a rich and irregular distribution of single-height and double-height spaces throughout its entire length, and varying entrance conditions along the street provide a heterogeneous texture. At the time of its construction, it was a progressive, albeit not unprecedented, spatial condition. On the other hand, similar to the façade of Villa Collinet, the façades of the project contain vertical bands of fenestration that communicate the locations of stairwell volumes in a literal manner that weakens the sophistication of the overall composition. In addition, the project is littered with Art Deco details, such as stylized window mullions and sculptural lighting fixtures and stairwell bannisters. Despite his ability to participate in the Modern discourse on spatial composition that characterizes the most significant works of architecture in the 1920s, Mallet-Stevens could never seem to resist dressing his architecture with decorative accessories.

Given that this book investigate various intersections between linear perspective and cinema, it is interesting to note that Mallet-Stevens developed an ideal city treatise, called *La Cité Moderne* (1922), that consists entirely of perspectival vignettes of individual buildings, such as a town hall, a public market, a bathhouse, a museum, et cetera. There is almost no evidence in the vignettes of an urban context, as each one is a pictorial image of an isolated building from a single position. Most of the views are oblique, as opposed to frontal, so they are more three-dimensional than many of the movie sets of the time. Still, it is difficult not to interpret them as another sign of a scenographic, as opposed to a spatial, sensibility in the work of Mallet-Stevens. His alter ego, Le Corbusier, was developing urban plans at the same time,

informed by plans and sections and regulated more by the relationships between architectural components than by the pictorial identity of the components themselves. Like Bramante, Mallet-Stevens seems to have understood architecture and urban planning as a primarily visual composition, and he is therefore relevant to this discussion primarily as a model of an approach to architectural projection to avoid.

Spatio-temporal Criticism

Set design may also operate as a mode of architectural criticism. *Play Time* (Jacques Tati, 1967) is a masterpiece of architectural criticism. The minimal plot of the movie, which has almost no dialogue, chronicles a day in the life of a man, M. Hulot, who navigates, with varying degrees of success, the Modern environments of a new section of Paris. The set for the movie is one of the most elaborate and comprehensive sets in the history of cinema. It includes six primary architectural settings, as well as a vast urban context that includes roads and multiple skyscrapers, some of which are partially built at full scale, and some of which are built at a reduced scale and positioned in order to appear full scale in false perspectival depth. The sets and the cameras in *Play Time*, as in *The Passion of Joan of Arc*, are a single mechanism, and Tati manages the environment with extreme skill and intention. In various ways, cameras, characters, and elements of the sets interact in order to activate the image.

The dominant material in the set is glass, which creates disorienting reflections and eliminates the distinction between the public and the private realms of the city. In one scene, a street acts as a sort of cinema, as Hulot watches the private lives of families through screen-like windows. In several shots, glass doors swing open in order to reflect iconic images of old Paris in the distance and to remind viewers of the city that is being threatened by the production of steel and glass architecture. The formal monotony of Modern architecture is another subject of Tati's criticism, as is the shoddiness of its construction. In one scene, the camera, which represents Hulot's point-of-view, is placed on an ascending escalator. As the camera slowly rises above a maze of office cubicles, Hulot understands the space for the first time. The message is clear: Modern architecture makes sense only from a detached perspective. These critical depictions of Modern architecture, however, are strangely attractive. Although Tati may regret the modernization of his city, he seems to appreciate, or at least to recognize, the formal beauty of a Modern built environment.

An alternative to comprehensive set design is the defamiliarization of existing built environments. This method of set dressing, as opposed to construction, has economic advantages, but it also

has aesthetic potential. *Blade Runner*, for example, takes place both in imaginary settings and in existing works of architecture in Los Angeles, such as Union Station, the Bradbury Building, and the Ennis-Brown House. The objective is not simply to save money through the use of an existing location, but rather to subtly weave the iconic architectural history of a city into a futuristic vision of it.

Digital Spatio-temporalities

Computer-generated imagery has revolutionized the art of set design. Purely digital built environments are non-indexical, and they escape the limits of physics effortlessly and absolutely. At the same time, digital set design typically addresses the same principles as traditional set design. *Inception* (Christopher Nolan, 2010), for example, combines many of the themes so far addressed. Like *Dr. Caligari*, it depicts a distorted built environment in order to simulate a dream state. Like *The Street*, it applies special effects to everyday environments in order to make them seem imaginary. Like *Play Time*, it includes references to recognizable monuments in order to relate to the real world of the viewer. Digital sets may depict either actual or imagined built environments, and they may do so to varying degrees of abstraction.

The use of fly-through sequences by design professionals to simulate the experience of architectural and urban project proposals is a sort of digital set design, one that depicts environments that may, one day, be real. When the ability to create such sequences emerged in the 1990s, they were hailed as an unprecedented design tool that harnessed the temporal dimension of the built environment; however, their promise is somewhat unfulfilled. Considering the ease with which they may be created on virtually any type of architectural software, fly-through sequences are surprisingly rare in academic and professional environments. More often than not, they are used as presentation tools, not design tools. Clients, after all, typically prefer to understand the pictorial, as opposed to the analytical, implications of their pending projects. Designers, perhaps, simply do not realize the analytical potential of time-based depictions of built environment. One of the objectives of this book is to reconsider the relevance of the time-based technology that generates fly-through sequences. Once the ways in which cinematic imagery may operate in an analytical manner are understood, the technology of the fly-through sequence may be reconsider as a more engaging mode of architectural projection.

Architecture–Cinema III: Spatio-temporal Surveys

The Movement of the City

Specific references to architecture are conspicuously absent from the early years of cinema (1895–1920). There is no motion picture equivalent to the drawings of tiled floors and simple geometric volumes that appear throughout both the prehistory and the early development of linear perspective. The primary subject matter of early cinema is movement itself, and architecture operates primarily as a setting for movement, not as a subject itself. The city and works of infrastructure, on the other hand, play prominent roles in the early years of the medium, especially during the first decade. The city may not have provided early moviemakers with a technical advantage over other subjects, in the way that tiled floors provided a technical advantage to early perspectivists, but it did provide them with invaluable content. Both of the premiere moviemaking enterprises of the time, Thomas Edison and The Lumière Brothers, dedicated many reels of film to the urban fabric. Edison's catalog includes bustling harbors filmed from moving boats and city panoramas filmed from atop bridge towers. The Lumière Brothers' catalog includes trains filmed in motion and cityscapes filmed from streetcars. Markets, parades, and other nodes of urban vitality also figure prominently in the era.

Edison and the Lumière Brothers shot the movement of the city in multiple ways, and the catalogs of both companies are somewhat interchangeable in terms of subject and style. There is, however, a subtle distinction between their general approaches. The Lumière Brothers understood cinema as a visual art that, no matter its subject matter, should follow established rules of pictorial composition. Most of their city films are carefully composed stationary shots. Even shots taken from moving trains are remarkably smooth and meticulously framed. Edison, on the other hand, was more likely to allow his camera to respond to its subjects in a spontaneous way. His movies, in general, entail more camera movements (subtle handheld movements as well as dramatic pans) than those by the Lumière Brothers. There is a coarseness to some of his city films that (perhaps unconsciously) complements the vitality of the city. Whereas the city films by the Lumière Brothers feel somewhat staged, the city films by Edison feel engaged in the flux of the city. All early moviemakers staged some of their allegedly spontaneous subjects, but the Lumière Brothers seem to have practiced an ethic of staging more thoroughly than Edison. Their first film, *Workers Leaving the Factory* (1895), captures a staged instance of a daily occurrence. A real scene of the same subject could have been filmed, but the producers clearly wanted to manage the rhythm and the density of the workers within the film frame. Edison's *Ghetto Fish Market* (1903), meanwhile, is a meandering depiction of urban life during

which the camera appears to react to its subject. The extensive catalogs of Edison and the Lumière Brothers contain multiple exceptions to the tendencies posited here, but a general distinction between the practices of these pioneers is nonetheless evident. They understood the moving image differently.

City Symphonies

The city films by Edison and the Lumière Brothers are the origin of a genre of cinema that continues to this day. The city has never ceased to fascinate moviemakers, and both the reactive tendencies of Edison and the premeditated strategies of the Lumière Brothers recur throughout the history of cinema in more elaborate forms. The apotheosis of the genre, which I refer to as the *city movie*, occurs in the 1920s, when the first so-called *city symphony* movies were made. City symphonies tell the story of a single city through moving images and sometimes sound. The earliest examples are silent, and they are referred to as symphonies because of their overall structures, which consist of acts or movements, and their rhythmic styles of editing. Every shot is carefully composed, and every editing decision is carefully considered in order to capture the pulse and the wonder of the Modern metropolis. City symphonies may have a narrative structure, such as "a day in the life of the city from morning to night," but they typically do not have fictional narratives imposed upon them. Certain shots may be staged, but usually in ways that conceal the artifice. In this sense, the city symphony may be interpreted as a more sophisticated version of a Lumiére Brothers' city movie; however, Edison's approach to the city movie is not incompatible with the type. In fact, the two most paradigmatic city symphonies of the 1920s reflect the contrast between the compositional aesthetic of the Lumière Brothers and the reactive aesthetic of Thomas Edison. *Berlin: Symphony of a Great City* (Walter Ruttmann, 1927) adheres more to the former, and *Man with a Movie Camera* (Dziga Vertov, 1929) adheres more to the latter, and both movies are highly mediated cinematic visions of urban life in the 1920s that satisfy most of the parameters of the city symphony type.

Whereas Ruttmann uses cinema to explore the city, Vertov uses the city to explore cinema. The differences appear in the opening scenes of the movies (not to mention in their titles). *Berlin* opens on a shot of lightly rippling water, and the subtle movement of nature quickly dissolves into a rhythmic superimposition of Modernist graphic imagery. Eventually, the composition of moving lines and patterns transforms into a sequence of a train barreling toward the capital city in the early morning. The sequence alternates rapidly between shots of the train and shots from the train, as blurring images of electrical wires, train tracks, and iron bridges communicate the energy of the age. *Man with a Movie Camera* opens on a shot of a cameraman, who appears

to ascend a giant camera as if it were a mountain. Like many of the shots in the movie, it is a trick shot (in this case, a split screen) that directly refers to the moviemaking process. The cameraman descends the giant camera after he takes a shot. He then travels to and enters a movie theater, where he prepares for a screening of his footage. Moviegoers enter the theater; musicians begin to play a score (unheard by viewers because the movie is silent); and the movie begins. Vertov's use of the movie-within-the-movie device accentuates his interest in the medium itself. Throughout its duration, the movie depicts the cameraman climbing walls and mounting his camera in various urban locations. He is an occupying army-of-one that invades the urban fabric with his camera, and *Man with a Movie Camera* is a document of the occupation. Although much of *Berlin* is highly mediated and by no means illusionistic, Ruttmann does not show literal evidence of the moviemaking process in the same manner. His cameraman is more voyeuristic.

Man with a Movie Camera is unlike *Berlin* and many of the classic city symphonies in two additional and important ways. First, it combines footage from more than one city and is therefore not a portrait of a single and specific urban environment. Second, its compositional structure is relatively loose. *Berlin* is organized as a true symphony with clearly defined "acts" and tightly managed themes. *Man with a Movie Camera* is organized as a series of "reels," so the structure refers to cinema itself, not to music. Like *Berlin*, Vertov's movie-within-a-movie begins at dawn and ends at night, but Vertov's day is more episodic and less systematized than the one composed by Ruttmann. Not surprisingly, Ruttmann shoots the city in a more classical manner than Vertov, and at times he is imaginative. He fully exploits the nature of the cinematic medium, but he also abides by certain conventions of image composition, such as framing a building façade as a true elevation. Vertov rarely affords his architectural subjects such respect. Instead, he experiments with sharply oblique angles, mirrored superimpositions, and other inventive methods of composition. Vertov's stated goal is to develop a visual language that is absolutely unique to cinema and unburdened by conventions of the other arts.[24] *Man with a Movie Camera* is considerably more analytical than *Berlin* because it constantly reminds us of its artifice and agenda. Both movies, however, are more analytical than pictorial, as neither induces a completely immersive condition of viewing. *Berlin* includes several pictorial scenes, but the structure of the movie and the regular recurrence of spectacular shots prevent us from falling into a deep mode of pictorial perception.

City symphonies investigate urban built environment and force viewers to interpret the meaning of the city, and variations within the genre, such as the two examples discussed here, raise a profound question: is the city primarily a built environment or a social environment? More

specifically, are cinematic depictions of the city primarily documents of a formal condition or vehicles of social change? Ruttmann treats the people of the city mostly, albeit not entirely, as anonymous elements of texture and pattern within the great urban machine. Vertov, on the other hand, grants his human subjects personality and humanity, and he recognizes the social fabric more overtly than Ruttmann. Some of his subjects even become leading characters in short scenes. Both movies address social concerns and the human condition of the city, but *Man with a Movie Camera* does so in the revolutionary spirit of Russia in the 1920s. *Berlin*, meanwhile, is more reflective of the bourgeoisie culture of Berlin in the 1920s, and its references to the underprivileged are less engaged than those in *Man with a Movie Camera*.

The capacity of cinema to engage the social dimension of the city is by no means limited to analytical approaches. The Italian Neorealism movement of the late 1940s and early 1950s produced pictorial city movies that address the physical and social devastation of Italian cities in the wake of World War II. Prior to the War, most Italian movies were produced at Cinecittà, a large movie studio founded by Benito Mussolini that accommodated elaborate sets and specialized in lavish epics. The Neorealist movies were shockingly real in comparison. The opening scene of the *The Bicycle Thief* (Vittorio de Sica, 1948) depicts an anonymous housing settlement on the outskirts of Rome, far from the iconic monuments of the city. Living conditions are poor, and employment opportunities are scarce. Throughout the course of the movie, the main character traverses the city, first as a newly employed worker and then in a desperate search for a stolen bicycle that is a condition of his employment. Most of the shots depict spaces that might be the subject of a shot in a city symphony, but the realism of the moviemaking and the social narrative situate the urban environments in an entirely different context. Even when the movie depicts recognizable areas of the city, they are not celebrated as formal wonders. In this sense, *The Bicycle Thief* is the inverse of *Berlin*. The social condition of the city is the primary concern, and images of the built environment are the supporting materials of the discourse.

Building Movies

In the history of cinema, movies devoted to specific buildings begin to appear in the middle of the 1920s, at around the same time as the first city symphonies. There is not, however, a prehistory of the building movie genre that is comparable to that of the city movie genre in the early years of the medium. While there were theoretical musings on a potential relationship between cinema and a new type of architectural space in the early decades of the medium,[25] the architecture of the early twentieth century did not inspire moviemakers to address it as a

primary subject. The rise of Modern domestic architecture in the 1920s was a changing point. The Modern houses that began to appear in both the bourgeois and the avant-garde circles of Europe were by no means as dynamic and as vital as the city, but they did catch the attention of moviemakers. Furthermore, cinema caught the attention of Modern architects and their promoters. It is no wonder that the designers of houses would welcome, or even seek out, an association between their work and a progressive mode of imagery.[26] Sigfried Giedion, one of the greatest promoters of Modern architecture, famously wrote in 1928 that, "Still photography does not capture [Modern buildings] clearly. One would have to accompany the eye as it moves: only film can make the new architecture intelligible."[27] Three movies from the 1920s demonstrate a range of approaches to the building movie in the first era of the architecture–cinema: *Neues Wohnen: Haus Gropius, Dessau* (*New Housing: The Gropius House, Dessau*, Richard Paulick, 1926), *Les Mystères du Château de Dé* (*The Mysteries of the Chateau of the Dice*, Man Ray, 1929), and *Architectures d'aujourd'hui* (*Architecture Today*, Pierre Chenal, 1930). The extent to which these movies substantiate Giedion's vision of cinematic imagery as a form of architectural projection varies.

The Gropius House (Walter Gropius, 1925) served as the director's house for the Bauhaus in Dessau. The movie that depicts it was part of a series of films that were produced in Germany in order to promote Modern living and contemporary building practices.[28] This particular example largely ignores the spatial qualities of the house and instead revels in the Modern gadgetry that occupies it: automatic washing mechanisms, industrially produced household objects, convertible furniture pieces, modular storage units, et cetera. Stop-action editing methods depict various objects in different states of operation and mobility, but Giedion's notion of movement through space is absent from the depiction. The movie, for example, depicts sliding doors moving without the aid of a human hand, but it does not depict the human body traversing through the spaces of the house. The imagery appeals to the general public, not to designers. More specifically, it speaks to women who run households. The characters in the movie are Frau Gropius and her female friends, who visit the house for an afternoon of chatting and marveling at domestic conveniences. The failure of the movie to address significant spatial issues of Modern architecture is surprising and disappointing given its context. It reflects neither the progressive design culture of the Bauhaus, which included inventive approaches to photography, nor the increasingly influential culture of analytical cinema as promoted by Ruttmann, Vertov, and others. Its intentions lay elsewhere, and it is a missed opportunity. The movie celebrates the potential of cinema to depict the dynamism of household objects, but not the dynamism of the hierarchical relationships within the house itself. It operates more as a product brochure than as a work of architectural projection.

One shot in the movie stands out among the imagery of household products as an expression of the spatio-temporal condition of Modern architecture. The shot, which depicts a small room that protrudes from the main volume of the house, captures an ambiguous relationship between the interior and exterior conditions of the house (and thereby a primary formal trope of Modernism). The camera is located outside of the house, and it points through the volume, which hovers over the garden of the house and is glazed on three sides. Frau Gropius is seen inside the space, and she greets her friends through an open window as they pass the room on their way to the entrance of the house. As her friends turn the exterior corner of the volume, she walks beside them on the interior corner of the volume. She is physically separated from her friends, but the transparency of the space and their coordinated movements unite them. A slight camera movement at the end of the shot follows their movement and accentuates the fluidity of the relationship. Unfortunately, most of the rest of the shots in *Neues Wohnen* and most of its editing strategies depict the spatial condition of the house in an unimaginative way that fails to take advantage of its spatial richness.

Les Mystères du Château de Dé is a relatively convincing demonstration of Giedion's claim regarding the relevance of cinema to Modern architecture, as it depicts both the formal and the experiential attributes of its architectural subject. The setting of the movie is Villa Noailles (Robert Mallet-Stevens, 1928), which sits atop a hill in a small village in southeastern France. Charles and Marie-Laure de Noailles, who commissioned the house, were patrons of the Modern art scene in Paris. The Surrealist artist Man Ray, who knew the owners and benefitted from their patronage, requested to use their house as the setting for a movie because he believed that it was perfectly suited to the medium of cinema. He deploys the house as the venue of a Surrealist narrative and creates both pictorial scenes, which take viewers through the house in a literal manner, and analytical scenes, which isolate and abstract certain qualities of the house for the purpose of closer examination. He also uses pans and tracking shots to catalog the geometric conditions of the house's elevations and gardens. Villa Noailles provides him with several moments of visual interest: impressive Art Deco interiors, moving walls, an indoor swimming pool, and large windows and terraces that integrate natural light into the volumes of the house. Light, in fact, is one of Man Ray's primary interests the house. In an inter-title in the movie, he refers to the reflections generated by the swimming pool as "piscinéma" (*piscine* is the French word for pool), and he shoots the reflections in various ways, both with and without human figures. Man Ray regularly integrates human occupation into the depiction of the house through his characters, who are dressed in striped costumes that accentuate tectonic and lighting patterns evident throughout the house. The actions of the characters are often abstract and absurd (in order to complement the narrative), but the

inclusion of moving figures greatly heightens a viewer's understanding of the house. Unlike the characters in *Neues Wohnen*, which mostly just look at things, the characters in *Les Mystères du Château de Dé* participate in the space.

Historically, Villa Noailles (similar to Mallet-Stevens' Villa Collinet) is only a modest achievement of Modern architecture. Its simple volumes and large apertures recall the industrial roots of Modern architecture, but its interior reflects well-established decorative trends of the 1920s more than the emerging new sense of spatial composition. Although a relatively progressive house for its era, it lacks the spatial ingenuity of the Gropius House and the villas of Le Corbusier that appear in *Architectures d'aujourd'hui*. Man Ray, of course, was attracted to the house not because of its Modern spatial significance, but rather because of its capacity to generate Modernist imagery, and Mallet-Stevens provided him with plenty of visual fodder. Man Ray appreciated the house for how it complemented his imagination, not as a subject of an investigation in itself. *Les Mystères du Château de Dé*, therefore, does not entirely realize Giedion's vision of cinematic imagery as a mode of architectural communication. Although Man Ray's methods are thorough and meticulous, his subject matter is somewhat compromised, and his objective is only quasi-architectural.

Architectures d'aujourd'hui is the final film of a trilogy of architecture–cinema movies by Pierre Chenal. The two other films, *Bâtir* (1930) and *Trois Chantiers* (1930), address issues of construction and infrastructure in the Modern era.[29] The primary subject of *Architectures d'aujourd'hui* is the architecture of Le Corbusier, who collaborated with Chenal on the movie, and who is seen throughout the movie in various capacities: diagramming architectural and urban ideas; walking through houses; and literally directing the movement of the camera. Unlike the other two building movies so far discussed, *Architectures d'aujourd'hui* does not depict a single building, but rather a series of villas by Le Corbusier that promote a general new vision of architectural space. In this sense, it engages the discipline of architecture in a more direct manner and is a truer demonstration of Giedion's vision. Human movement through the space is a primary theme of the movie. Le Corbusier and other characters are seen climbing staircases and ramps that lead to roof terraces, where specifically designed architectural sequences terminate. Other scenes depict spatial sequences through multidirectional pans that trace how a person is supposed to move through the various houses. Like their peers, Chenal and Le Corbusier also depict discrete architectural moments. One shot is especially revealing of an interest in the human condition of Modernity. It depicts a ribbon window that is covered by horizontal louvers. As the louvers open slightly, the shot reveals a man on a terrace, but his face is obscured by one of the lines of the open louvers. The shot captures Modern conditions

of voyeurism, anonymity, and tenuous privacy. The final shot of *Architectures d'aujourd'hui* depicts one of the cruciform skyscrapers in Le Corbusier's Plan Voisin for Paris (1925). The tower glistens in reflective light, and this image gives an entirely different impression than the well-known photographs of the physical model of the project, in which opaque blocks represent the towers. In all of these cases, cinema allows the architect to depict his work in a manner that best communicates his intentions.

Given his comprehensive understanding of cinema as a mode of architectural projection, it is curious that Le Corbusier did not continue to engage it throughout his career. If cinema is in fact the perfect way to depict Modern architecture, why did it not become a staple of his portfolio? More specifically, why did Le Corbusier and others not experiment in any significant way with how to incorporate moving images into the architectural design process? Le Corbusier communicated with several moviemakers during the 1940s, 1950s, and 1960s, but the exchanges reveal a relative lack of interest on the part of the architect.[30] The initial wave of building movies inspired by the emergence of Modern architecture in the 1920s passed without causing significant changes to conventional uses of architectural projection within the profession. Andres Janser, a leading scholar of architecture–cinema, has noted that economic and logistical issues are partially responsible for the failure of cinema to replace photography as a form of visual dissemination, and the same concerns must have also hampered its ability to infiltrate the design process.[31] The recent democratization of cinema allows amateur moviemakers to overcome these obstacles and, in the venue of architecture, to reconsider the potential of cinema to operate as a mode of architectural promotion.

Construction Symphonies

Another recurring type of building movie that first emerges in the 1920s investigates the construction process of architecture.[32] I refer to these movies as *construction symphonies* because they have many of the same attributes as city symphonies. First of all, their subjects are well suited to cinematic depictions. Like cities, construction sites are inherently about change and movement, and their stories cannot be told through still imagery as effectively as through moving imagery. Second, construction symphonies generally have a clear analytical structure that is unconcerned with pictorial illusionism. In most cases, they begin with the start of a construction process and end with the completion of a building. Third, construction symphonies generally do not include narrative devices other than the story of the construction itself. Construction symphonies, however, vary dramatically. Three examples demonstrate the persistent fascination with this type of architectural documentation, as well as different ways to

interpret it: *Zett Haus* (Carlo Hubacher and Rudolf Steiger, 1933); *Skyscraper* (Shirley Clarke and Willard Van Dyke, 1959); and *Work in Progress* (José Luis Guerín, 2001).

Zett Haus is a Modern residential and commercial building that was constructed in Zurich, Switzerland, between 1930 and 1932. It includes a rooftop swimming pool and a large cinema, which at the time of the opening of the building had a retractable roof. In 1930, the plans for the building, which included state-of-the art mechanical and window systems, must have seemed almost like a fantasy. It is no surprise, therefore, that the entire process was captured on film. The first part of the movie depicts the demolition process in extensive detail. In an early shot, a graphic "X" is superimposed over the existing building on the site, and subsequent shots depict various scales of destruction, from large portions of the building tumbling into debris piles to individual bricks being removed one-by-one by hand. Instead of skipping over the erasure of the old fabric, the movie dwells on it as a source of pride. After the depiction of the demolition, the movie chronicles the pouring of the concrete structural system in an equally detailed manner. In order to better explain the process, the moviemakers use motion-graphic architectural drawings. In one shot, animated white lines move over a section drawing in a way that traces the sequence of the concrete pours. The same section drawing reappears throughout the movie to further explain whatever process is about to be depicted through the movie's indexical imagery. In another shot, a perspectival cut-away section is superimposed onto a view of the completed building. These and other relationships between indexical and non-indexical graphics demonstrate an intention to education the viewer. *Zett Haus* is not a pictorial depiction of the construction process, but rather an explicitly instructive one. The final scenes of the movie show the building in use. One scene depicts the cinema and its roof in various conditions, including an animated shot with graphic superimpositions that simulates the effect of an open-roof screening under the stars. In other scenes, children play in the rooftop pool, and cheerful workers and customers inhabit the ground floor commercial spaces. In a way that Giedion probably admired, Modern architecture is depicted as a vibrant engine of activity and as a savoir of the city.

Skyscraper chronicles the construction of 666 Fifth Avenue in New York City in a much more methodical manner. Each phase of construction is given a relatively equal treatment, and no image of the completed building is shown until the construction process is completed. The tone of the movie is more light-hearted and less ideological than *Zett Haus*. Unlike its predecessor, *Skyscraper* is a sound film, and it uses music and a non-diegetic voiceover to portray the construction workers as the everyday heroes of the project and as contributors to the growth of a great American city. There is a social message in this portrayal, but the movie

also communicates that the building will be a corporate skyscraper in the economic capital of the world. It is difficult, therefore, to interpret it as a celebration of a comprehensive new vision of urban living, which is what *Zett Haus* portrays. *Skyscraper* does not include any graphic imagery, but its indexical depictions of the construction processes are nonetheless detailed enough to be instructive. The humorous commentary of its narrator, however, maintains a lyrical, as opposed to a didactic, quality. Furthermore, its stunning black-and-white imagery is more poetic than documentary in nature. Clarke and Van Dyke humanize and demystify architecture, but they see it primarily as a beautiful formal object, as opposed to a social force. The final shots of the movie depict the splendor of the building in its urban setting. What is striking about both *Skyscraper* and *Zett Haus* is the relative absence of the architects. Passing references are made to design intentions, but the perspective of the designer seems irrelevant to the objectives of these movies.

José Luis Guerín isolates his construction symphony from the culture of design in a far more extreme manner. *Work in Progress* chronicles the three-year construction process of an apartment building in a rapidly gentrifying section of Barcelona, and the formal nature of the building is completely absent from the movie. Guerin, in fact, never depicts the new building in a way that allows viewers to understand what it looks like. During the first half of the movie, his cameras are located in the areas surrounding the construction site, and they document images of demolition and embryonic construction that are difficult to relate to each other. Once the construction site begins to resemble a building, Guerin moves his cameras into the new structure and points them toward the areas surrounding the site.[33] The real subject of the movie is the human population that is affected by the construction process: construction workers, displaced residents, and remaining residents faced with a changing neighboring and eventual eviction. Guerin shows us human faces, not architectural façades. His primary interest is the effect of time on his characters, and he sees space merely as a container of temporal change.[34] In this sense, he harkens back to the early years of cinema, before architecture became a self-conscious subject of the medium. Like Edison and the Lumiére Brothers, Guerin sees wonder in the flux of generic environments. Instead of concentrating on formal attributes, Guerin investigates the effect of formal changes on the social fabric of the city.[35] Like Ruttman and Vertov, he sees the built environment as an authorless form that contains a way of life.

Work in Progress suggests that Giedion and others may have underestimated the potential of the building movie genre to engage the discipline of architecture. The most compelling and moving scene in *Work in Progress* depicts a series of apartment interiors that are adjacent

to and visible from the new building. In each apartment, a television screen plays the same program, which is the "movie of the night" on the local over-the-air station. Earlier in the movie, it becomes clear that these nightly movies on television play an important social role in the neighborhood. They are the only form of entertainment that most residents can afford to consume, and they are a common topic of conversation in cafes and on the street. Guerin edits a montage of the movie as it plays on screens of various sizes and in rooms of various types. In some apartments, the movie plays in the background and is apparently ignored by the occupants of the space; in other apartments, a solitary viewer watches it intently; in other apartments, no one is visible at all, but the television still plays. All of the shots into these apartments are stationary shots, and their compositions are layered by a secession of frames-within-frames: the window frames in the new building through which the camera looks; wires and hanging laundry on the balconies of the older buildings; the window frames of the apartments in which the televisions play; door frames, curtains, or other obstructions within the apartments; and finally the television screens themselves. Throughout *Work in Progress*, Guerin layers his images with vernacular frames that represent the neighborhood's varying degrees of self-regulated privacy and community. The public and private realms of the neighborhood bleed in between conventional borders. As the construction process concludes, however, the sterile walls of the new structure entomb the cameras in an environment of sameness, and the rich layering of the old neighborhood vanishes. Guerin's montage concludes on the final frame of the "movie of the night," which reads, "fin." Indeed, something has ended.

in situ

Gordon Matta-Clark was trained as an architect and became one of the most prolific and influential artists of the 1970s. One of his most iconic works is *Splitting* (1974), in which he cuts through the body and foundation of a condemned suburban house so that it splits open. Matta-Clark documents this and other works of a similar nature on eight-millimeter films. The artist's work is temporal, and therefore relevant to cinema, in two ways, as it is both performative and ephemeral; the act of making it cannot be separated from the results of the processes, and the results are typically demolished shortly after their completion. In some instances, sculptural fragments are rescued from the demolition processes and exhibited as museum artifacts of the works, but the movies are the true remnants of the works. A curious aspect of Matta-Clark's filmic documents is their indifference to conventional notions of craft, especially compared to the rescued sculptural fragments, which, despite their roughness and evidence of destruction, are presented as rarefied objects. The movies are far less precious and display only a passing interest in careful shot composition and strategic editing methods. They are not,

however, poorly made. *Splitting* contains moment of haunting beauty, such as close-up shots of sunlight hitting debris fragments in midair, and the camera work reflects an attentive and instinctual eye. *Bingo/Ninths* (1974) and *Conical Intersect* (1975) are similarly raw indexes of architectural events that, in addition to being documents, have a vibrant aesthetic that captures the spirit of the work far more convincingly than an isolated sculptural fragment. The roughness of the moving imagery engages the fleetingness of the initial work.

To contemporary or untrained eyes, Matta-Clark's movies, as well as many examples of analytical and early cinema, may appear to be poorly crafted. Craft, however, is relative, not absolute. It is less a function of laboriousness and skill than of intention and technology. Just as a rough sketch is sometimes more valuable than a tediously executed drawing, a seemingly casual shot is sometimes more evocative than a carefully orchestrated scene. The latter requires a different type of craft than the former, but both may be either well crafted or poorly crafted. Matta-Clark's movies are well crafted not because they are neat and tidy, but rather because they are reckless in a specific (and analytical) way. One may argue that rough craft is more analytical than pictorial because it calls attention to the artifice of a movie, and that seamless craft is more pictorial than analytical because it allows viewers to fall into the illusion of the screen more effortlessly, but (as always) it is important not to oversimplify the matter. While it may be easy to disrupt the illusionism of a cinematic image through carelessness, it is far more difficult to craft a cinematic image with an analytical agenda. Amateurs must not allow the ease and economy of digital moviemaking to relieve them of a responsibility to craft. Their objective should be to execute a level and type of craft that complements their analytical intentions and their tools. When I first began to make videos, I tried to replicate the look of high-end film production, and the results were disastrous. My pans and zooms, for example, were awkward because my tripod was not heavy enough to stabilize the camera and to achieve the smoothness that such shots require. Eventually, I developed an analytical aesthetic that was more compatible with my objectives and my equipment, and all amateurs should do the same.

Matta-Clark made movies of various types of performances as well, many of which address provocative issues related to spatial perception (*Chinatown Voyeur*, 1971; *Automation House*, 1972) and urban experience (*Clockshower*, 1973; *Paris Underground*, 1977). *City Slivers* (1976) is especially relevant to issues of architectural projection. In this film, the image is divided into vertical strips of varying widths that reveal cropped glimpses of urban environments in New York City. Most of the slivers are extremely narrow. At times, only a single sliver is apparent against a black background; at other times, multiple slivers fill the entire frame. In a digital environment, the image would be constructed through the use of pillarboxing and shot

layering. Matta-Clark achieved the effect through masking the lens during the shooting process and reshooting the same film several times. When projected onto the side of a building, which is how the movie was supposed to be exhibited, *City Slivers* integrates itself into the rhythmic fragmentation of the city. Even when exhibited in a screening room, the movie captures the tension of urban perception through its limitation of the view, as well as the beauty of the city's color, texture, and movement.

The video installations of Anna von Gwinner, who works both as an architect and as an artist, expand the potential of architecture–cinema in a manner that complements the work of Matta-Clark (especially *City Slivers*). All of von Gwinner's installations involve moving images of what she calls "characters" (water, smoke, balls, trampolinists, ice skaters, chandeliers) in order to define and/or distort the limits of a physical space in which the images are projected. Her movies, therefore, do not depict space, but rather activate it. In *Trampolinist I* (2001), a screen hangs under a dome in a church and depicts a jumper in midflight. Viewers see neither the trampoline nor the apex of the trampolinist's jump. Instead, they see his entering and exiting the frame. The scale of the figure within the space of the installation and the timing of his ascension and descension imply that the trampoline lies on the floor of the church and that he ascends into the height of the dome. In *Inflight* (2009), the screen hangs in an abandoned factory and depicts colored balls flying through the air. Off screen, the balls hit walls, bounce, and return to the screen. Viewers, however, never see balls hitting a surface; instead, they hear them. The timing of sounds of the bounces and the speeds of the images of the balls flying into and out of the image are calibrated so that the balls seem to be hitting the actual walls in the space. In *Minus 8* (2009), the screen is placed in a shop window, and viewers do not enter the space of projection (which is a common theme in von Gwinner's work). The image depicts the silhouettes of two ice skaters in a way that conceals the spatial context of the ice rink in which they skate. As the skaters traverse the unseen rink, the images of their silhouettes grow larger and smaller in a fluid motion, and expectations regarding scale and proximity are challenged. Larger images typically imply closer proximity, but in the case of shadows, the inverse is true, as larger images are generated when figures are closer to the light source and thereby further away from the screen. Although there is a sense of illusionism in all of von Gwinner's work, the element of illusion does not displace viewers into a different world. Instead, it encourages viewers to scrutinize the nature of a physical environment. In this sense, it perhaps epitomizes the objective of this book more than any example so far discussed.

Part III—Indeterminate Projections

Architectural Drawings

In architecture the trouble has been that a superior paradigm derived either from mathematics, the natural sciences, the human sciences, painting, or literature has always been ready at hand ... We beg our theories from these more highly developed regions only to find architecture annexed to them as a satellite subject. Why is it not possible to derive a theory of architecture from a consideration of architecture? Not architecture alone but architecture amongst other things. If we take the trouble to discriminate between things, it is not just to keep them apart but to see more easily how they relate to one another. Architecture can be made distinct but it is not autonomous ... A crucial source of intelligence for such a theory would therefore be the numerous transactions between architecture and other topics, for instance geometry.

Robin Evans, *The Projective Cast*

This chapter interrogates the relevance of projective drawing to architectural analysis and design. The reciprocity between orthographic drawing and linear perspective is a primary focus. An important issue to address is the extent to which the location of the viewing point affects the analytical nature of a drawing. Orthographic drawings are derived from abstract viewing points that are infinitely far away from an object of projection; they are therefore understood to be analytical. Linear perspectives are derived from literal viewing points that are within the spatial environment of an object of projection; they are therefore understood to be pictorial. While this distinction, which is the basis of Alberti's argument on the difference between painterly and architectural drawing, is undeniable, I argue that the location of the viewing point may not be as consequential as it seems (Figure 5.1). Orthographic viewing points may communicate literal aspects of an object of projection that ameliorate the inherent abstraction of the view, such as wall thicknesses and window details. Meanwhile, perspectival viewing points may communicate abstract aspects of an object of projection that ameliorate the inherent literalness of the view, such as spatial relationships that escape the conventions of human vision. The relationship between the viewing point and the objection of projection is a variable that does not necessary compromise (and may in fact complement) an analytical intent. The objective is to treat orthographic and perspectival drawing as reciprocal modes of analytical projection. In both types of projection, the literalness of the depiction of the object of projection is a variable that may be exploited for analytical purposes.

The first step is to heighten the analytical nature of the orthographic views that will be used as the building blocks of a linear perspective construction. Normative plans and elevations may not provide a helpful starting point for the construction of an analytical linear perspective because they may contain too many literal details. *Orthographic diagrams*, as opposed to orthographic drawings, are the ideal building blocks of a perspectival drawing. Orthographic diagrams are simplified and distilled versions of orthographic drawings. They maintain the scale and proportion of the object of projection, but they have no responsibility to communicate the type of codified information found in orthographic drawings. They are strategically narrow as opposed to dutifully comprehensive. The level and type of detail depends on the role of the diagram in an overall analysis. Orthographic diagrams may (and should) subvert the graphic conventions of orthographic drawings, such as line weight, line color, line type, and the literalness of lines. Whereas orthographic drawing typically describe walls as double lines, orthographic diagrams may describe them as single lines, triple lines, or even abstract combinations of lines that communicate an analytical reading of the wall, such as implied transparencies or ambiguous adjacencies. Orthographic diagrams may even omit certain walls from the description of a space altogether.

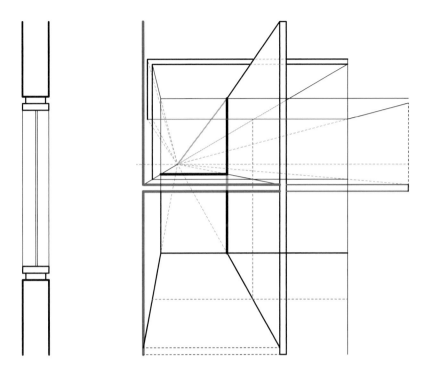

Figure 5.1: literal (plan) and abstract (perspective) projections

If the orthographic views that underlie a perspectival construction already convey a precise analytical idea, then the resulting linear perspectives will automatically communicate the same analytical intent. Conversely, if the orthographic views that underlie a perspectival construction are overly literal, then the resulting linear perspectives will likely convey the same literalness. In such cases, the next step would be to manipulate the literal views in order to make them more analytical, but the use of orthographic diagrams eliminates the need for this step. It is better simply to instill the entire construction process with an analytical basis. The relationship between the viewing point and the object of projection is still an open matter, but at least the views will be derived from an abstract condition. Two questions to keep in mind once the construction of an analytical linear perspective begins are:

What visible aspects of the object of projection should be removed, so that they are not seen?
What invisible aspects of the object of projection should be added, so that they are seen?

For example, lines that represent certain components of an object of projection may be removed or made transparent for the sake of a more focused and distilled depiction of it.

Conversely, regulating lines that do not represent any component of an object of projection may be inserted into an orthographic diagram of it for the sake of identifying or accentuating certain spatial relationships. The construction lines within a rebatment may also contribute to an analytical reading of the object of projection. The presentation of a linear perspective may in fact include the orthographic views that underlie its construction. Although presentation drawings probably should not include every construction line, certain ones may call attention to important spatial conditions. All lines, whether they correspond to literal components of an object of projection or to a regulating or construction line, may be rendered abstractly in order to heighten the analysis.

It is important to note that certain analytical themes are more amenable to linear perspective than others. Massing conditions and structural girds, for example, are typically better communicated through orthographic or axonometric projections because they address measured, as opposed to experiential, aspects of a design. Axial relationships and threshold/enclosure conditions, on the other hand, are well suited to the logic of linear perspective. It is impossible to make strict rules regarding themes that are better suited to certain types of projection, as contingencies and exceptions always exists. It is important to question the extent to which the objective of a drawing might benefit from a perspectival view. The premise of this book is that linear perspectives are never immediate, embodied, and experiential views of an architectural space; however, their viewing points do, in fact, occupy the same spatial environment as the object of projection, and their usefulness is relatively limited to issues of occupation and spatial perception, albeit with a heightened sense of abstraction and an aversion to literalness. The following examples are meant to communicate the need to balance the realism and the abstraction of the drawing system.

Precedent Projections

The first step is to interrogate a historical precedent. The use of a precedent, as opposed to an original design, allows for the exploration of basic graphic methods without the burden of a design objective. Once the power of analytical projections are understood, their potential relevance to design process will make more sense. The precedent, which will be revisited in Chapter 6 through cinema, is The Mellon Center for British Art (Louis Kahn, 1974) in New Haven, Connecticut. The first step is to construct a series of analytical orthographic diagrams, which will serve as the building blocks of perspectival projections (Figure 5.2).

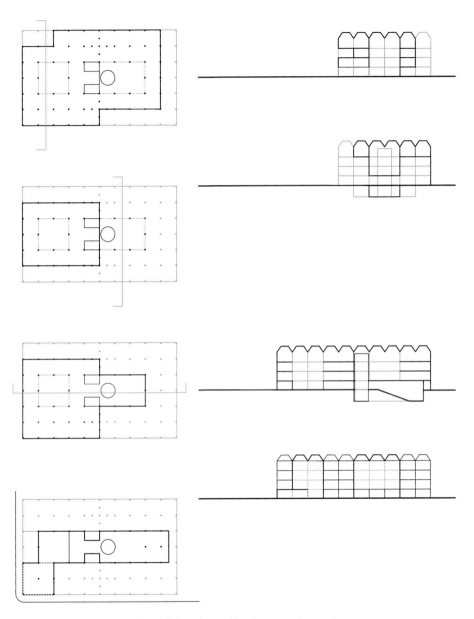

Figure 5.2: orthographic diagrams—base set

These "base" orthographic diagrams describe the precedent in a distilled manner. The geometries of the building are simplified, and the rendering of the lines clarifies its essential hierarchies, including the distinction public and private spaces.

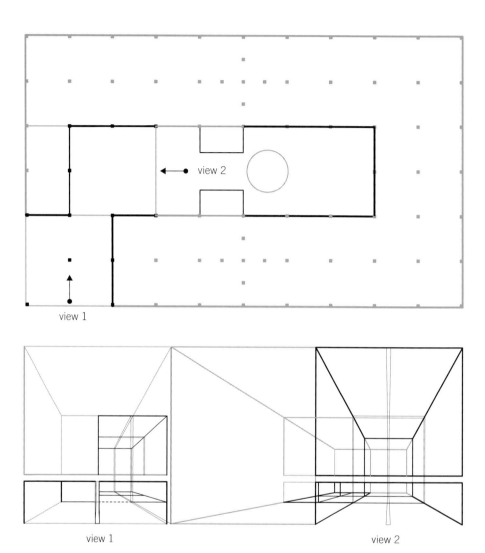

Figure 5.3: threshold analysis

The threshold into the building occurs through a dark recess on the corner. The rest of the base of the ground level is occupied by vibrant shops, and the museum somewhat disappears in the city. The low recess is square in plan, as is the high adjacent entry foyer. The entry foyer is a four-level high space that is lit by skylights, so it is the spatial inverse of the recess on the corner. The two squares overlay but do not align with each other, and the misalignment complements the dramatic shift that occurs in scale and light. These diagrams communicate the awkward adjacencies that belie the relatively straightforward grid that regulates the building.

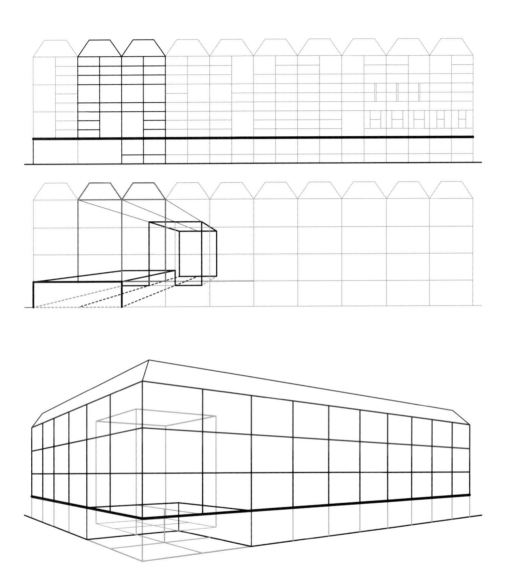

Figure 5.4: façade/threshold analysis

The "compression and release" tension between the interior and exterior entry spaces is legible on the façade of the building, albeit subtly. The strong distinction between the commercial base of the building and its upper levels somewhat ameliorates the power of the exterior entry void, and the upper portion of the façade communicates difference only in an ambiguous manner.

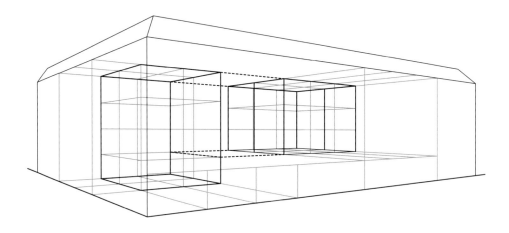

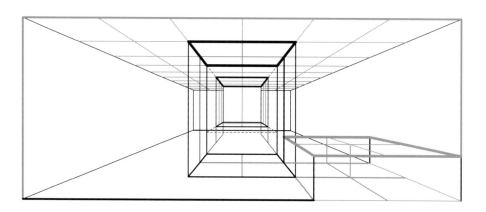

Figure 5.5: interior geometry analysis

Inside, there are two primary open spaces that are lit from above. One is the four-level entry foyer that is adjacent to the voided corner, and the other is the three-level court that contains a cylindrical stair volume. The relationship between these volumes is a critical aspect of the hierarchy of the building. A façade analysis further reveals the complexity behind the simple square-gridded volume of the building.

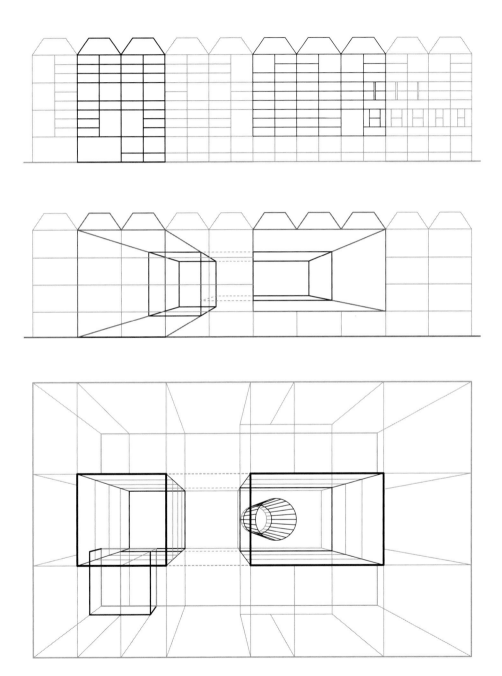

Figure 5.6: interior geometry analysis

Design Projections

The design process is becoming increasingly dependent upon digital modeling, and perspectival views of models are a dominant mode of both evaluation and presentation. Students often rely too heavily on such views and forego the use orthographic drawings (or, worse, they generate orthographic views directly from a model and present them in a perfunctory manner without ever having engaged them during the process). A knowledge of the reciprocity between orthographic drawing and linear perspective (and of the analytical potential of linear perspective) makes it clear that the problem is not the use of perspectival views, but rather the pictorial emphasis that is typically placed on such views. Figures 5.7–5.12 present a hypothetical design project almost entirely through perspectival views in order to demonstrate that an analytical use of such views may communicate the type of information that is commonly communicated through orthographic drawing. This modest example illustrates the fallacy that perspective communicates visual information. These perspectival drawings convey the deeper intentions of the designer.

Figure 5.7: site of design project

The project is a house on an imaginary site in a low-rise dense urban fabric. The volume of the house will fill the footprint of the site and match the volume of the adjacent buildings. It also has a basement level.

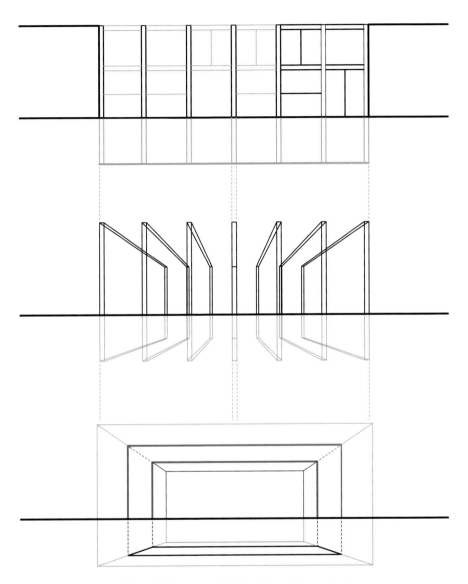

Figure 5.8: basic spatial logic of the design project

From the street, the house appears to be organized into six discreet volumes that are perpendicular to the grain of the street; however, an unseen organizing principle is a series of three volumes that are parallel to the grain of the street, and the hierarchy of the house is regulated by the interaction between these two systems. In the above views, the street level (as opposed to eye-level) serves as the horizon line in order to emphasize the datum line of the ground, which is a third ordering principle.

Figure 5.9: public/private

Figure 5.10: central court

Contrary to the implications of the façade, the three volumes that are parallel to the grain of the street regulate the hierarchy of the house in a more consequential manner than the six volumes that are perpendicular to the grain of the street. The parallel volumes articulate a distinction between public and private spaces within the house. The back volume is primarily, but not entirely, private, and the front volume is entirely public. The central volume consists primarily of a void that brings light into the enclosed site and provides circulation between the front and back volumes.

Figure 5.11: entry/circulation

Figure 5.12: relative opacity of perpendicular walls

All of the depictions of the project in Figures 5.9–5.12 are exactly the same view. The differences lie in how the views are rendered and, therefore, in the information that they communicate. None of the depictions is an experiential view. The viewing point is understood as an extension of the architecture, not as a human eye. The horizon line matches the geometry of the building, not the eye level of an observer. Like the views in Figure 5.8, these views are frontal and therefore include a purely orthographic elevation, which complements the orthogonal nature of the project. If the project were located on a corner site, oblique views would have been strategic as well.

A less straightforward way to incorporate an analytical use of projection into the design process is to draw theoretically and/or unintentionally in a digital drawing environment. Sometimes a drawing is just a drawing that stimulates thought, as opposed to a representation of something specific, and digital drawing environments exponentially expand the conceptual horizons of projective line drawing. Contrary to common assumption, CAD is not an awkward transitional practice between analog and digital paradigms of design, but rather an evolutionary leap in drawing that is somewhat analogous to the mathematical discoveries of Guidobaldo. The infinite surface area of the digital drawing environment allows for projective operations that would be impossible to achieve through traditional drawing means, and the computational logic of computer-aided drafting reorients how designers and artists may proceed through the process of drawing. Unfortunately, the rapid development of advanced forms of computation (such as scripting and building information modeling) has inhibited the exploration of the implications of digital line drawing. CAD deserves a Desarguesian moment in which its full potential is laid bare. Free of the biases regarding its practicality, the digital drawing

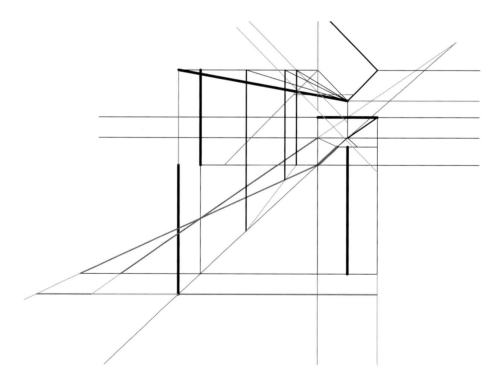

Figure 5.13: exploratory projection—intersecting a cube

environment may be understood as a creative abyss in which the behavior of points, lines, and surfaces may be interrogated, negotiated, and potentially reconceived. A mathematical awareness of linear perspective and projective geometry frees projection from its reference to an object. Drawings of spatial ideas that escape the limits of vision may, perversely, achieve Alberti's ideal of architectural drawing as a non-pictorial practice. While the logic of CAD or the ideas of Desargues may not survive the ongoing revolution in architectural discourse, those who believe in the future of drawing should heed the lessons of these historical precedents. Digital projective drawing heightens an awareness of spatial order and trains designers' eyes to look beyond representational immediacy. It is a raw form of geometric inquiry that may inform ways to navigate future digital platforms with more agility, intention, and control. One may translate the lines of exploratory drawings into literal architectural designs, but translation is not necessarily the goal. The construction of perspectival projections is a form of cognitive dance. The following pages include a variety of approaches to thinking-while-drawing. Some are translated into design proposals, but others are simply indeterminate projections.

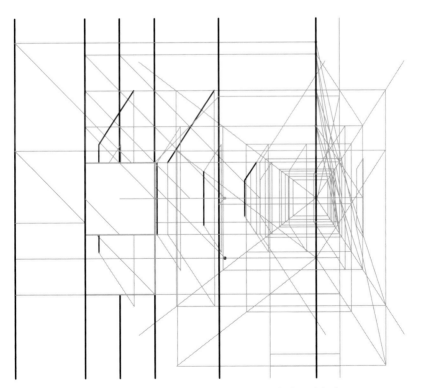

Figure 5.14: exploratory projection—perspectival modularity

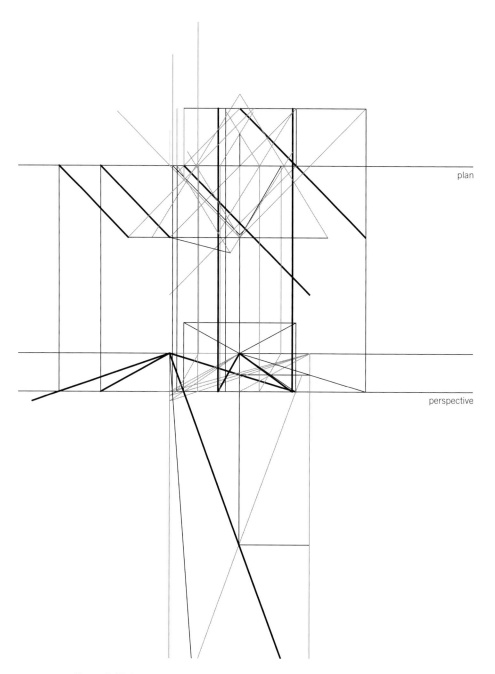

plan

perspective

Figure 5.15: "useless" inquiry into the general behavior of the images of lines

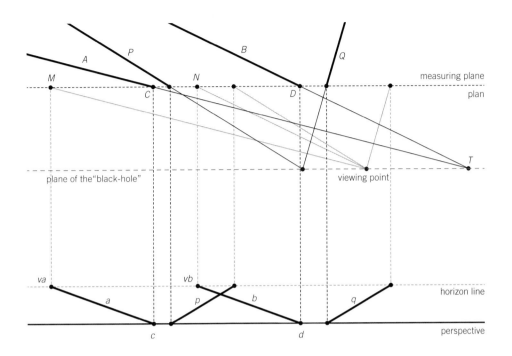

Figure 5.16: the "black hole" of linear perspective

Figure 3.16 (in Chapter 3) demonstrates that, counter to the logic that linear perspective simulates human perception, it is possible to locate the images of points that lie behind the viewing point. There are, however, points whose images cannot be located: points that have the same *y*-value as the viewing point. These points lie on a unique plane in the drawing system that I call the "black hole" of linear perspective.

I discovered the black hole by accident while studying the orthographic behavior of lines that are parallel to each other in linear perspective. First, given an arbitrary set of parameters for the horizon line and viewing point, I drew two lines that are parallel to each other in linear perspective (*a* and *b*). Second, I projected lines from the vanishing points (*va* and *vb*) and measuring points in the perspective (*c* and *d*) onto the measuring plane in plan. The resulting measuring points (*M*, *N*, *C*, and *D*) allowed me to construct the viewing rays that would have generated the vanishing points. I know that lines *A* and *B* pass through *M* and *N* respectively and are parallel in plan to the viewing rays that correspond to *va* and *vb* respectively. The intersection of *A* and *B* occurs at point *T*, which has the same *y*-value as the viewing point. Because the images of *A* and *B* (*a* and *b*) do not intersect each other in linear perspective, the image of the point *T* cannot be located. In a sense, point *t* does not exist, as it lies within the black hole of perspective. I repeated the process for lines *p* and *q* in order to see if, as Desargues' suggests, there is an invariant pattern. Indeed there is. In both cases, lines whose images are parallel to each in perspective (*A* and *B*; *P* and *Q*) intersect each other in plan at a point that cannot be located in linear perspective.

Architectural Movies

The avant-garde film is not solely for the entertainment of the masses. It is at the same time more egotistical and more altruistic. Egotistical because it is the personal expression of a pure idea; altruistic in its exclusive endeavors for the development of the medium. The real avant-garde film possesses the fundamental trait of containing under a sometimes-opaque surface the germ of inventions that will lead the film on its way to its future form. The avant-garde is born of both the criticism of the present and the anticipation of the future.

Germaine Dulac, "Avant-garde Cinema"

In the introduction to this book, I proposed a distinction between *architectural movies* (analogous to analytical drawing) and *movies about architecture* (analogous to pictorial drawing). In Chapter 2, I reinterpreted that distinction through Walter Benjamin's analysis of moviegoing as one between *analytical cinema*, which is primarily interrogative despite moments of realism, and *pictorial cinema*, which is primarily illusionary despite moments of abstraction.[1] I also noted that the line between analytical and pictorial cinema is somewhat vague, and the movies discussed in Chapter 4 illustrate that ambiguity. *Metropolis* is a movie about architecture (and thereby pictorial), and *M* is an architectural movie (and thereby analytical); however, *Metropolis* is more often associated with the analytical tradition of cinema because of its Expressionist (or avant-garde) methods, and *M* is more often associated with the pictorial tradition of a cinema because it belongs to a narrative crime genre. Thus, whereas *Metropolis* adheres to a general notion of analytical cinema because of its association with an avant-garde movement, *M* adheres to a specifically architectural notion of analytical cinema because of its approach to the depiction of spatio-temporality. Likewise, *Neues Wohnen: Haus Gropius, Dessau* is a movie about architecture, and *Architectures d'aujourd'hui* is an architectural movie. Whereas *Architectures d'aujourd'hui* engages in an analytical discourse on Modern architecture through the nature of its individual shots and its organizational strategies, *Neues Wohnen* is an advertisement for Modern living in general that does not exploit the role of architecture in the emerging culture; however, the latter employs editing techniques (such as stop-motion photography) that are more commonly associated with analytical cinema, and the former employs less mediated editing techniques that are more commonly associated with pictorial cinema. *Les Mystères du Château de Dé*, meanwhile, is an example of Surrealist cinema that exhibits many of the identifiable tropes of analytical cinema: abstract lighting, discontinuous editing, disorienting shot composition, et cetera. It does not, however, engage architectural issues explicitly. Its relevance to a discussion on architectural movies, therefore, is limited to its cataloging of discrete analytical methods. *Berlin: Symphony of a Great City* and *Man with a Movie Camera* are less ambiguous, as both are landmarks of analytical cinema that are explicit examples of architectural movies (or, perhaps, urban movies). *The Bicycle Thief*, by contrast, is ambiguously pictorial, as it inspires, to borrow Benjamin's term, an absent-minded examination of the built fabric and thereby a level of analysis.

The goal of this chapter is to distill a new and pure notion of the architectural movie that is relatively free of the inherent ambiguities of analytical cinema in general. The movies examined in this chapter are unambiguous examples of the analytical tradition, and they have a greater imbalance between analytical and pictorial moments than any of the movies discussed in Chapter 4. They are not purely abstract, but all of them employ shooting and editing methods

that question the limits of the illusionism of the cinematic image. In turn, they further an understanding of how movies may operate more like drawings and diagrams and how the construction of motion pictures may contribute to processes of design and research. The ultimate goal is to define the parameters of a new approach to architecture–cinema that I refer to as *Architecture–Cinema IV: Indeterminate Projections*. The projections are indeterminate because they operate not only as modes of communication, but also as tools of inquiry. Although some of the movies discussed may be either exhibited as supporting documents of an architectural proposal or disseminated as supporting materials of an architectural research project, others may never be seen by anyone other than their creators, like speculative drawings and diagrams that remain buried within a sketchbook. In all cases, the process cannot be separated from the product. Unlike architects and researchers who worked prior to the digital revolution, contemporary makers and thinkers have virtually unlimited access to the cinematic medium, both logistically and economically. Traditional obstacles to the incorporation of cinema into practices of design and research no longer exist, and it is time to consider a new frontier for architecture–cinema.

The Origins of the Approach

Like the three approaches to architecture–cinema discussed in Chapter 4, the notion of indeterminate projections in cinema is rooted in the rich architecture-cinema culture of the 1920s. In his essay, "'Only Film Can Make The New Architecture Intelligible': Hans Richter's *Die neue Wohnung* and the Early Documentary Film on Modern Architecture," Andres Janser classifies five types of movies on architecture that emerged on the 1920s, "according to the way they were commissioned."[2] His reason for this approach is to emphasize the influence of the commission on form, content, and dissemination.[3] The five types are: 1) films for interest groups, which is further defined as including both films for architecture interest groups and films for cinema interest groups; 2) films for the clients of a building, which is further defined as including both films for institutional clients and films for individual clients; 3) films for industries related to building and manufacturing; 4) newsreels about architectural projects; 5) various independent productions, such as home movies, documents made by architectural offices, and short movies intended as supporting programs in commercial cinemas.[4] *Neues Wohnen* is an example of the first type; *Les Mystères du Château de Dé* is an example of the second type; *Architectures d'aujourd'hui* is an example of the third variation of the fifth type. Janser's classification is indicative of a broad range of attitudes regarding the relevance of cinema to architecture in the 1920s, as well as the extent to which architecture–cinema, even in its early years, extended well beyond mainstream genres and venues.

Janser's use of the word "documentary" as an umbrella term for his categories raises an interesting question: are works of documentary cinema necessarily works of analytical cinema? On the one hand, movies that document a built environment, an event, or a person's life may disrupt a viewer's pictorial mode of perception to a significant degree. The narrator and musical score in *Skyscraper*, for example, prevent a viewer from slipping too deeply into the world of the screen. The depiction of the building is instead viewed from a certain, and perhaps analytical, distance. On the other hand, documentaries may also collapse the barrier between the world of the screen and the world of the viewer, as *Public Housing* and *Work in Progress* do. Still, even when a documentary movie heightens the absent-mindedness of the examination, the instructional nature of the genre persists. All of the movies that fall under Janser's five categories display a certain degree of architectural analysis; however, the film that interests Janser most, Richter's *Die neue Wohnung* (*New Living*, 1930) has an analytical sensibility that deserves special note. Richter employs analytical methods of shooting, editing, and hierarchical composition in *New Living* that question many of the assumptions of architecture–cinema that have so far been encountered, and the movie is the primary precedent that informs the proposed new approach to the use of cinema as a mode of architectural inquiry.

Janser has written extensively on *New Living*, both in the aforementioned essay and in the book, co-written with Arthur Rüegg, *Hans Richter, New Living: Architecture. Film. Space.*[5] The movie was commissioned by the Swiss Werkbund (SWB) for the occasion of an exhibition on Swiss housing and furniture. The SWB understood cinema as a mode of communication that would reach the public in a more immediate manner than a standard exhibition display, especially in the context of a large exhibition hall with other standard displays. The assumptions were that tired visitors would welcome a comfortable seat and that the message of the SWB would seep effortlessly into their minds.[6] Whereas the first assumption reflects an understanding of the medium as a passive, or pictorial, experience, the second assumption reflects a faith in the potential of the medium to activate the public's awareness of important issues. *New Living* is, in fact, an aggressively analytical movie. Richter's moviemaking methods evolved throughout the 1920s through a wide range of work in the medium. His work includes purely abstract (non-indexical) movies, Surrealist narratives, and commercials.[7] All of Richter's prior experiences inform his innovative approach to the documentation of architecture in *New Living*.

New Living is essentially a cinematic essay that compares and contrasts traditional and Modern ways of life. The message of the film is clear: the darkness and clutter of traditional living must be replaced by the light and clarity of Modern living. Comparative vignettes of household settings, such as the kitchen and the living room, offer unambiguous visions of both the problem and the

solution. Architecture and furniture are given equal emphasis. Victorian interiors are mocked, and (similar to the depiction of the Gropius House in *Neues Wohnen*) adjustable built-ins and moveable appliances are celebrated through stop-motion photography. Richter also addresses industrialization through a series of highly analytical montages that chronicle the evolution of various industries, such as agriculture and transportation. In each case, Richter juxtaposes a still image of a traditional industry and a motion image of the corresponding contemporary industry: a shot of a mechanical reaper replaces a woodcut depiction of a human reaper; a shot of a steamship replaces an image of a model of a sailing ship, et cetera. The transitions between the two images include a glimpse of the sprocket holes of a film frame, which reminds viewers not only that they are watching a film, but also that cinema is part of the new age. Richter follows the image of the steamship with one of the most powerful shots in the entire movie: a superimposition of a shot of a flying airplane over a shot of a moving car. At first, they appear to be heading for a collision, but they effortless glide past each other, as if engaging in a dance of technological peers. Despite the original idea of the SWB to lull exhibition visitors into a state of comfort and passive reception, *New Living* demands attentive, as opposed to passive, reading, and it challenges, but does not overturn, Benjamin's notions of distracted perception and shock effects in cinema. The examiner in this case is not so absentminded.

Richter's depiction of Modern architecture, as Janser notes, is an unusual example of architecture–cinema.[8] Instead of providing comprehensive depictions of identifiable buildings, Richter composes montages of spatio-temporal fragments from various buildings, which remain somewhat authorless or, in Janser's words, "typical."[9] The point is to communicate general ideas (or ideals) about the nature of the Modern built environment, not to celebrate the accomplishments of a given architect or a specific project. Although some canonical works of Modern rchitecture are recognizable in the movie, most scenes are organized by themes, such as fenestration, thresholds, verandas, et cetera. In one sequence, titled "Wenig Mauerwerk," Richter pans the elevation of a house in a manner that obscures the identity of the building, emphasizes qualities of transparency and reflection, and depicts moveable components of the elevation in action. Janser compares Richter's fragmentary approach to the depiction of architecture to Chenal and Le Corbusier's comprehensive approach in *Architectures d'aujourd'hui*. He notes that Chenal and Le Corbusier depict specific and complete spatial sequences through identifiable houses in a manner that is somewhat indebted to traditional notions pictorial perspective (or realism) and symbolism. Richter, on the other hand, seeks to evoke "intellectual associations" between anonymous spaces in a manner that calls attention to the inherent abstraction of the medium. In this reading, *Architectures d'aujourd'hui* is pictorial and *New Living* is analytical, which contradicts my previous reading of *Architectures*

d'aujourd'hui as an architectural movie, as opposed to a movie about architecture; however, as should be clear by now, designations of analytical and pictorial invariably overlap and contradict each other depending on the lens through which the designation is read. *New Living* undoubtedly achieves the greatest imbalance between analytical and pictorial moments among the movies we have discussed so far.

Cinema as Drawing and Diagram

New Living accumulates the analytical cinema practices of the 1920s and redistributes them in the service of an architectural mission. Its rejection of spatio-temporal continuity and embrace of analysis suggest an alternative to the three notions of architecture–cinema that are discussed in Chapter 4. Unlike those notions, Richter's example has not been reinterpreted in serious ways within the disciplines of architectural design and/or research. His position on the far end of the analytical-pictorial scale of cinematic imagery has not been adopted by others who have similar or adjacent interests. At the end of his career, Richter noted a miss opportunity in the 1920s that may have made a difference in this respect. Kazimir Malevich, a Russian Suprematist artist who admired Richter's films, wrote a screenplay for a movie that would have addressed a new concept of the unity of space and time.[10] Malevich believed that cinema, more than painting, could achieve his vision.[11] Like Suprematist painting, and like Richter's series of abstract films that he began in 1921, the movie would have been a non-indexical animation of geometry. Richter rebuffed Malevich's overtures because he was busy with other work, and he later regretted that decision because he believed that it hindered the development of abstract cinema.[12] If Malevich and Richter had achieved a collaborative cinematic depiction of a new understanding of architectural space, the development of architecture–cinema throughout the twentieth century may have been significantly more weighted toward analytical and abstract methods. Although the non-indexical abstraction of geometric animations is somewhat different than the indexical abstraction of *New Living*, the Malevich–Richter project could have inspired multiple interpretations of the relevance of cinematic abstraction to the development and depiction of architectural ideas.

The fact that Richter created both indexical and non-indexical movies suggests that the same mentality may be applied to both types of cinema. *Rhythmus 21* (Hans Richter, 1921) is one of the non-indexical movies that inspired Malevich to contact Richter regarding his idea for a space-time cinematic project. The three-minute film is an animation of black, white, and gray rectilinear shapes, which appear, disappear, move, and change size in various ways. At first, Richter blurs the figure–ground relationship of the image: black shapes appear to be in front

of white shapes; then white shapes appear to be in front of black shapes. Several sequences, however, consist of discrete figures on a clear background. The geometric compositions in the movie are reminiscent of the graphic sensibilities of the early Modern movement, and the relationships between shapes are more important than the integrity of any given one. As Richter states, his interest is rhythm:

> I went on to take parts of the rectangular screen and move these *parts* together or against each other. These rectangles are not *forms*, they are parts of movement. The definition of Form refers to one's perception of the formal quality of a single object, or several single objects; but, when you repeat this same form over and over again and in different positions, then the relationship between the positions becomes the thing to be perceived not the single or individual form. One doesn't see the form or object anymore but rather the *relationship*. In this way you see a kind of rhythm.[13]

Although Richter is not concerned with architecture in an explicit manner, his words perfectly explain the nature of architectural experience: buildings are not objects that are perceived from a single detached perspective, but rather environments that provide shifting perceptions of various formal relationships. It is easy to imagine *Rhythmus 21* as a motion diagram of an architectural space, both of spatial sequences and of conditions of spatial simultaneity, seriality, adjacency, and organization. Certain sequences suggest an orthographic understanding of the image, as shapes relate to each other in ways that imply varying plan and elevation conditions. Others give a sense of perspectival depth, as shapes seem to vanish to or emerge from the depth of the image. Over the course of the movie, Richter's image appears both flat and volumetric. Despite its abstraction, *Rhythmus 21* appears to have influenced Richter's approach to *New Living*, which emphasizes associations between shots and resists literal (or straightforward) depictions of space. Malevich apparently understood these multiple spatial inferences as the seeds of a more explicitly architectural use of the medium.

The potential of cinema to operate as a form of architectural drawing or diagramming never materialized. As mentioned in Chapter 4, Janser identifies logistical and economic reasons for the inability of cinema to affect the architectural profession in a more significant and direct manner than the movies that were made during the 1920s and 1930s. He also notes that, "… the two media [architecture and cinema] have their own respective logic and inner structure. In the long run the differences remained stronger than the similarities."[14] The notions of drawing and diagramming, however, have the ability to overcome the differences between architecture and cinema. As Alberti preaches, architectural projections should not be literal depictions of architecture, but rather documents that reveal underlying conditions. Diagrams are even further removed than orthographic drawings from the impressionistic reality of a work

of architecture, as they involve more intense processes of distillation and extraction that defy comprehensiveness and immediacy. What if moviemaking is considered as a form of spatio-temporal drawing and diagramming, instead of as a vehicle of spatio-temporal illusionism?

The Precedents

Although the spirit of architectural abstraction in both *Rhythmus 21* and *New Living* did not infiltrate the multiple strains of architecture-cinema that recurred throughout the twentieth century, it did not altogether vanish. Many examples of so-called *experimental cinema*, such as Bill Morrison's *Outerborough* (which was discussed in the introduction), interrogate the pictorial disposition of cinematic imagery through depictions of the built environment. Movies by artists like Morrison often distill aspects of spatio-temporal significance that elude more intentional approaches to architecture–cinema: the spatio-temporality of movement, sound, and light; relationships between linear and cyclical time; the impact of duration on perception and materiality; et cetera. Some analytical moviemakers approach the built environment in ways that are unburdened by the legacies of Walter Benjamin, Sergei Eisenstein, Le Corbusier, and Jacque Tati. They may not understand their work as the basis of a new approach to architectural projection based on orthographic drawing and diagramming, but they nonetheless provide a wealth of imagery that has the potential to redefine the limits of architecture-cinema. In this chapter, I will briefly discuss three moviemakers whose work may act as a catalyst to a new approach to architectural projection: Michael Snow, Ernie Gehr, and Warren Sonbert. This work provides a clearer sense of the nature of analytical cinema (free of qualifications and contingencies), as well as its potential to engage architectural and urban subjects. All three of these moviemakers create indexical works of analytical cinema, and they generally resist the use of special effects and image manipulation during the editing process. They address space and time in a relatively raw manner, and the analytical nature of their movies derives mostly from shot compositions and strategies regarding shot adjacency. It is these methods that will figure prominently in the indeterminate projections illustrated later in this chapter.

Michael Snow constructs films with a tectonic sense of composition. Separate shots combine to form a sort of structural system in each of his films, and even individual shots typically consist of a modular "unit," such as a recurring camera movement. In *Wavelength* (1967), the structuring principle is a forty-five minute simulated zoom that depicts the space of a New York City loft. The film begins on a wide shot of the loft and ends on an extreme close-up of a photograph of ocean waves that hangs on the far wall of the loft. As the film ends, the photograph fills the frame, and the loft (which is unyieldingly present for much of the film)

disappears. The simulated zoom is both continuous and discontinuous. Spatial continuity is achieved through the fact that each frame of the film depicts the loft in a manner that logically follows its preceding frame, as if the entire film were a single shot. At the same time, the zoom consists of multiple shots that were shot out of sequence. The temporally discontinuous depictions of the loft expose it in different lighting conditions and through different image filters. The scene freely shifts between day and night in a disjunctive montage of varying types of visibility and varying degrees of activity (both within the loft and outside its windows). In the current age of digital video, which allows single shots to last much longer than the forty-five minute duration of *Wavelength*, it is easy to forget that shot length was once a limitation of the medium. Snow demonstrates both a respect for and a disregard of those limitations. The implied spatial continuity of the film suggests that he could have created a thoroughly convincing illusion of continuity that was beyond the capacity of his media; however, the exploitation of the temporal discontinuity of the shots reveals that he rejects the legitimacy of such false continuity.

In addition to its discourse on continuity, *Wavelength* is a critical meditation on duration and the dialogue between expectation and fulfillment (or lack thereof). As it mediates between a constant (the journey through space) and a set of variables (temporal dislocations), viewers are forced to endure the projection of the loft in a manner that differs from a conventional relationship to architectural imagery. Like a work of actual architecture, the loft does not entertain viewers or allow them to escape it (unless they walk away). Viewers of the film occupy the loft in the true sense of the word, not as an illusion. At the same time, the mediation of the editing renders the loft as a coded environment. The architecture is both relentlessly opaque and alive with meaning. Human scale and compositional proportion are a particular focus. The proportions of the room change as the film progresses, and occasional superimpositions of earlier moments in the film remind viewers of the variability of scale in the built environment. Certain short segments of the film reappear later as superimpositions, so that two scales are evident at once for an extended period of time. Scales overlap and compete with each other. The ultimate change of scale occurs at the conclusion, when the viewers enter the ocean, the spatial inverse of architecture.

Two movies by Ernie Gehr represent another approach to structural moviemaking. In *Serene Velocity* (1970), Gehr investigates the scale and proportion of an institutional hallway. Gehr places his camera in the center of the width of a hallway. The resulting shots are symmetrical depictions of the length of half of the hallway, not unlike a frontal perspectival view of a hallway. Every shot in the movie is taken from the same location, but Gehr varies the focal length of the

lens, which affects both the apparent proportions of the space and the extents of the space that fall within the limits of the frame. Regularly spaced doorways, lights, ceiling and floor tiles, and other elements within the hallway act as horizontal and vertical units of spatial measurement, which allow viewers to analyze proportional differences between the various views. The temporality of the movie is not illusionistic, but rather metrical, as the various images follow each other in rapid secession (often, but not always, in a back-and-forth rhythm between two different settings of the lens). Although the frontal perspectival views of the hallway somewhat recall a classic Albertian linear perspective with a clear central vanishing point, *Serene Velocity* is by no means a pictorial depiction of a space. Instead, it is an analytical study of geometry, distance, and proportion. In this sense, it reflects the spirit of Richter's *Rhythmus 21*. As Gehr states, the image refers to itself:

> In representational films sometimes the image affirms its own presence as image, graphic entity, but most often it serves as vehicle to a photo-recorded event. Traditional and established avant garde film teaches film to be an image, a representing. But film is a real thing and as a real thing it is not imitation. It does not reflect on life, it embodies the life of the mind. It is not a vehicle for ideas or portrayals of emotion outside of its own existence as emoted idea. Film is a variable intensity of light, an internal balance of time, a movement within a given space.[15]

The point is not to create a simulation of perception, but rather to analyze the nature of perception. The same is true in *Side/Walk/Shuttle* (1991), in which Gehr composes an astoundingly diverse series of shots of San Francisco from within a single glass elevator. Each shot depicts a single ride in the elevator (either up or down), and the camera is placed in a different position for each shot. Each shot, again like Richter's *Rhythmus 21*, is an animated geometric composition that is both abstract and suggestive of a spatial condition. The relative distances of surfaces in the frame create distortions of both scale and speed, and the varying orientations of the camera render streets as elevations, elevations as horizontal surfaces, and skies as infinite voids. The simplicity of the method and the richness and diversity of the imagery is a lesson in the limitations of normative vision. Gehr's abstract approach to cinema reveals embedded spatial conditions that typically escape attention. In turn, he expands a viewer's consciousness of how to perceive the spatial environments that they encounter.

Warren Sonbert's films are deceptively simple and appear to lack the type of meticulous construction that characterizes the work of Snow and Gehr. In fact, Sonbert simply follows a different set of construction principles, and his films are far less casual than they appear. In *Carriage Trade* (1972), he assembles a montage of short shots (between two and ten seconds, but predominantly around five seconds). All of his shots are captured with a handheld camera

and feel like fleeting moments or fragments uncomfortably extracted from a continuum. There is a sense that Sonbert begins shooting when he sees something worth capturing; none of the shots feel orchestrated or composed in any manner. The contents of the shots include backyard gatherings, depictions of everyday life in non-Western locations, depictions of infrastructures in various states of use and abandon, spectacles, and unadulterated nature. Long before notions of the global village arose after the end of the Cold War, Sonbert's editing style captures a sense of global simultaneity and correspondence. Dislocation is a complementary theme in his work. The rapidity of his editing denies a viewer's desire to remain in a shot and to inhabit its depicted environment. At the same time, this film is not disconcerting or seizure-inspiring in the manner of certain approaches to music-video and action-film editing. Sonbert's handling of rhythm and his keen selection and organization of shots render dislocation as a phenomenon of simultaneity, not disruption. His fragmentations are fluid, not curt. The resulting montage is a sharp departure from a historical model that it may appear to reference: the associative montage of Soviet cinema in the 1920s. Sonbert resists literal associations and instead promotes a looser set of relationships between different scales of human activity, different typologies of space, and different levels of mediation between natural forces and human endeavors. The potential to apply this approach to depictions of the contemporary city is immense: like a city, Sonbert's films are discontinuous and are layered with simultaneous but unrelated subjects.

Indeterminate Projections

The next and final step is to reconsider the methods and intentions of Matta-Clark, Richter, Snow, Gehr, Sonbert, and other analytical moviemakers. Although the movies of these artists do not aspire to be explicit acts of architectural projection, they do suggest ways in which cinema may operate as a time-based mode of architectural drawing and diagramming. What if architects, urban planners, and scholars of the built environment were to deploy similarly analytical methods of cinematic projection for the sake of better understanding the implications of their work? What if they diagrammed cinematically? The following pages describe six movies that serve as an opening argument on the topic. The first three are analytical investigatations of specific existing built environments that aim to elucidate certain spatial and temporal qualities of those environments; the second three are analytical speculations that question the relevance of cinema to the design process. These latter examples combine images and sounds captured in multiple places and during various times in order to question general design principles and to stimulate architectural investigation.

6.1.a

Movie 6.1: threshold

Movie 6.1 revisits the precedent explored in Chapter 5 through drawing, the Mellon Center for British Art. Its objective is to interrogate the entry sequence from the street, through the dark corner recess, and into the sky-lit entrance foyer. In each shot, the camera is integrated into the geometric logic of the architecture. Each shot adjacency, likewise, emphasizes proportion and spatial order over experiential impressions.

The opening shot (6.1a) depicts the façade of the building as an abstract landscape against a bright sky. Its inversion of the horizontal and vertical axes establishes a sense of decontextualization that reflects the way in which the entry sequence removes museum-goers from the city. Shots 6.1b–6.1.d explore the threshold between the street and the corner recess in a manner that is typical of the analytical (and methodical) approach of the movie. The first two shots (6.1.b–6.1.c) in this sequence depict the two sides of the corner condition in a rigorously coordinated manner, and the third shot (6.1.d) is a superimpositions of the first two shots that accentuates the awkward symmetry of the corner condition and challenges the alleged clarity between the darkness of the void and the brightness of the city. Shot 6.1.e similarly distorts the experiential quality of the corner recess through a superimpositions of two carefully calibrated views of it (one looking into it and one looking out from it).

6.1.b

6.1.e

6.1.c

6.1.f

6.1.d

6.1.g

The movie depicts the interior court from various perspectives that emphasize geometry and proportion (e.g., shots 6.1.f and 6.1.g). The geometries of adjacent shots align with each other, which (along with further superimpositions) suggest unexpected reciprocities between elevational and perspectival views

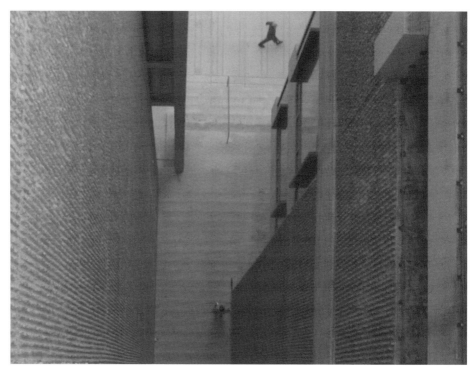

6.2.a

Movie 6.2: vertical passage

Movie 6.2 explores the powerful vertical hierarchy of the Art and Architecture Building (now Rudolph Hall) at Yale University (Paul Rudolph, 1963). The opening shot depicts the entrance stair from above in a quasi plan view. A soaring void above the stair allows for this shot to occur. As the movie progresses, shots reveal different perspectives of this powerful negative space. In every case, the camera is orientated either directly up or directly down, so as to emphasize the subject of verticality. Shots of an interior stairwell that lies adjacent to the void (such as Shot 6.2.c) act a metering device throughout the length of the movie, albeit an erratic one. Like the sectional condition of the building, the rhythm of the stair is irregular, and the abrupt pacing of the movie reflects the lack of geometric regularity that informs Movie 6.1.

Throughout the movie, the camera descends the interior stair, and the depiction of the exterior void complements the descent (The overhead shots of the void gradually zoom-in on the exterior stair) The final overhead shot of the void (6.2.f) is a close-up of the exterior stair that barely resembles the wide overhead shots of the void (such as 6.2.c) that appear earlier in the movie. The final shot of the void depicts it from below (6.2.g), and this shot points toward the location of the camera in the first shot. A sun flare creates a sudden contrast that accentuates the darkness of the void.

6.2.b

6.2.e

6.2.c

6.2.f

6.2.d

6.2.g

As in Movie 6.1, the entirety of the building is never depicted—the objective is to communicate an abstract sectional condition, not a comprehensive or experiential understanding of a particular building. Geometric proportions and rhythms take precedence over embodied experience.

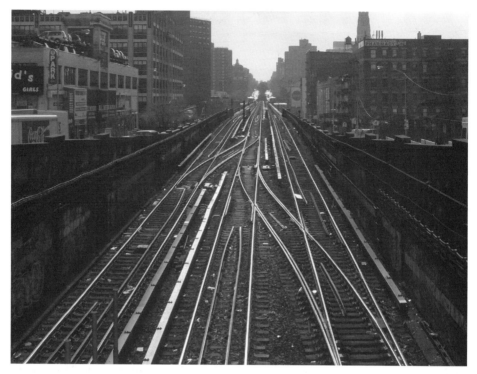

6.3.a

Movie 6.3: stasis and movement

Movie 6.3 investigates a spatial condition in New York City in which railroad tracks emerge from an underground tunnel and occupy a viaduct that cuts through the fabric of the city. Like the entrance into the Mellon Center, the transition is dramatic and awkward. The opening shot depicts the tracks in quiet morning light. Ambient sounds of the city are heard, but there is neither an audible nor a visual sign of any activity on the tracks. The entire movie consists of crosscutting between this serene (and frontal) scene and a series of dramatic and abstract shots that depict either the emergence of the train from the tunnel or its descent into the tunnel, always from a lateral position that reflects the lateral perception of passengers. The alternation between frontal and lateral shots reflects the tension between stasis and movement, and the crosscutting implies that the railroad creates two distinct environments in the city: one that celebrates movement and energy, and one that is eerily quiet and indifferent to the violence of the transition from the tunnel to the viaduct.

At first, the soundtrack of the movie is diegetic, as it seems to match the image tracks. Shots of the tracks are quiet and peaceful, and shots of the movement are loud and intense. In fact, all of the sounds in the movie have been composed from multiple shots of trains and urban environments that do not appear in the movie.

6.3.b 01:30:00 6.3.e

6.3.c 6.3.f

6.3.d 6.3.g

As the movie progresses, the abstraction of the sound slowly becomes more apparent, and hints of a non-diegetic soundtrack emerge. The final shot of the empty tracks is accompanied by the most violent sound of the entire movie, so that even casual viewers finally understand that the soundtrack had been manipulated the entire time.

Movie 6.4: scale and proportion

Movie 6.4 is a design provocation that is inspired by Hans Richter's *Rhythmus 21* and Kasimir Malevich's unrealized film for a new space-time conception (see Chapter 4). Throughout the duration of the movie, shots alternate between abstract depictions of architectonic features and unconventional depictions of human figures. The former shots are somewhat scaleless; each may be interpreted as a diagram of either a tectonic detail or an urban plan. The latter shots, despite their inclusion of human figures, curiously do not clarify the scale of the depicted environments; the depth of field in the shots and the overall compositions create distortions.

The objective of the movie, in fact, is to explore the relativity of scale and proportion. Whereas humanist architecture applies the proportional logic of the human body to the built environment, this movie suggests that the human body and the built environment engage in a process of negotiation. Both the making and the watching of the movie inspire a reconsideration of the role of scale and proportion in the design process. Depending on adjacencies, large becomes small (and vice versa), and several shots are repeated in order to disrupt any single reading of their scale and proportion relative to a "norm." While the movie may seem like a reproach to the notion of human scale, it in fact celebrates a potential correspondence between scales.

6.4.b

6.4.e

6.4.c

6.4.f

6.4.d

6.4.g

A particular focus of the shots that depict human figures is the way in which figures relate to the horizon. In some shots (such as 6.4.d), a clear horizon line positions the figures in space. In other shots (such as 6.4.b and 6.4.f), figures appear against horizontal surfaces, and the horizon is not apparent at all

6.5.a

Movie 6.5: threshold

Movie 6.5 investigates the notion of transition in architecture and urbanism. How does one thing end and another begin? How are boundaries defined and/or subverted? The movie is organized into six parts: horizontal thresholds; vertical thresholds; impenetrable thresholds; visual thresholds; implied thresholds; and indefinite thresholds. Camera positions and shot compositions are more causal (less rigorous) than those in the previous movies, and the shots are mostly handheld as opposed to tripod shots. The objective of these methods is to maintain a sense of fluidity, as thresholds are often fleeting. Panning and tracking, however, are avoided in order to dispel any sense that the camera is attached to an embodied observer. Instead of bodily movement, the motion of the camera appears indifferent to its subject, not unlike an unanchored boat drifting in a slow current. Each shot ends when the initial focus of the shot drifts out of frame. The lengths of the shots vary accordingly.

In order to further refute the potential interpretation of handheld shots as the point-of-view of an inhabitant in a specific environment, most of the movie is silent. The absence of sound renders the imagery more analytical/generic and less pictorial/specific. Silence also focuses viewers more intently on the spatial conditions depicted within the shots. Viewers, in a sense, become archaeologists who study the scene.

6.5.b 01:30:00 6.5.e

6.5.c 6.5.f

6.5.d 6.5.g

A final segment, "indefinite thresholds," includes sound but no imagery. The screen is black for the entire duration of this segment, and multiple sound sources are superimposed over each other and manipulated in terms of volume. The implication is that sound creates and subverts boundaries as powerfully as built form.

6.6.a

Movie 6.6: light

Movie 6.6 is an inquiry into light, both natural and artificial. More specifically, it investigates different aspects of how light interacts with or emanates from the built environment. Like Movie 6.5, this movie studies six distinct categories of a phenomenon; however, in this case, the movie is more loosely organized, and the different categories of light interact with each other. Like Warren Sonbert's movies, this is a creative essay on light, not an academic thesis on it. The themes, which are introduced through the appearance of white titles on a black screen at the beginning of the movie, are: reflection, shadow, figure–ground, intensity, contrast, and linearity. The movie is entirely silent, so as to focus the viewers' attentions on the visual phenomena of light.

The movie questions, like the films of Gordon Matta-Clark, conventional notions of cinematic craft (see Chapter 4). Its structure is tediously informal, meaning that it is carefully structured in order to appear unstructured. The primary structuring element is the ephemerality and/or endurance of the lighting conditions under investigation. Certain shots linger as the light subtly changes, and other shots abruptly end in response to a dramatic lighting event or effect. The lengths of the shots vary from a few frames to several minutes.

6.6.b 01:30:00 6.6.e

6.6.c 6.6.f

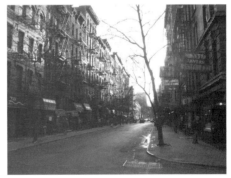

6.6.d 6.6.g

The movie does not have a specific beginning or ending, as it is meant to be shown as a loop. The cyclical and loose structure prevents viewers from identifying moments of closure or pause; however, the cyclical movie subtly references the regular cycles of natural light, despite the irregular rhythms of day and night depictions in the movie.

The Reflexivity of Architecture and Projection

The true architect is a man who in no way needs to know how to draw; that is, he does not need to express his inner state through pencil strokes. What he calls drawing is no more than the attempt to make himself understood by the craftsman carrying out his work.

Adolf Loos

The ultimate objective of this book is not to promote the adoption of any specific approach to linear perspective and cinema, but rather to call attention to the fact that the design professions rely on modes of projection (or, as Robin Evans would say, on "zones of instability"). The technological developments that are currently revolutionizing both the design and the construction of the built environment are in their infancy, and tools are evolving in ways that are unpredictable and perhaps even inconceivable. As Mario Carpo has suggested, it is possible that the design professions are evolving into collaborative models of social and physical construction that will overturn the Modern notion, which emerged in the Renaissance, that architecture results from a cohesive and clearly identifiable *design process*. Like medieval cathedrals, great works of architecture and planning in the future may not be attributable to a conventional understanding of a designer as an author.[1] At the moment, however, designers still author buildings and cities, and their design processes are still mediated by various modes of pictorial, graphic, and non-graphic (i.e., numerical and textual) projection. Vernacular structures and fabrics may evolve, as they always have, through relatively unmediated processes, but designers (or groups of designers) still initiate, develop, and ultimately realize architectural and urban proposals in a manner that has remained fundamentally unchanged for several centuries. Designers construct projections that allow for (or guide) the construction of buildings and cities, and, as long as they do so, it is essential that they understand their projections, in the spirit of Alberti, as non-literal modes of pictorialization. At some point in the future, the construction of architecture may not involve a design process, but, until that time, projection is the vehicle of architectural thought, and an analytical approach to the construction of architectural imagery, whatever its specific form, ensures that the experience of space is not reduced to pictures.

Some readers may consider my interest in linear perspective and cinema to be (either refreshingly or distressingly) nostalgic, but I am neither pining for a lost tradition nor afraid of an uncertain future. I am simply recognizing two modes of projection that, despite their apparent demise as paradigms of knowledge, continue to inform the ways in which built environments are depicted. The perspectival bias of digital imaging will likely persist into the foreseeable future, and time-based modes of digital imaging are likely to become more prominent as the technology that generates it becomes ubiquitous. Even when digital imagery does not adhere to conventional understandings of drawing and cinema, it is still indebted to the construction logics of the former paradigms. Whereas linear perspective and cinema are bookends of a Modern lineage of projection, digital imagery is the basis of a Post-Modern lineage of projection that has barely begun. Architects may continue to indulge in the belief in progress that has led to increasingly illusionistic modes of imagery, or they may revolt and embrace a notion of inquiry that is concerned more with analysis than with looking. Perhaps as the revolution

evolves further, the current enthusiasm for immediacy (or realism) will fade, and the great potential for digital abstraction will emerge. Perhaps it will not.

In conclusion, I urge readers to consider the relevance of analytical drawing and moviemaking to architectural research. The capacities of digital imaging may transform the practices of history and theory as much as those of design. As Peter Eisenman and Preston Scott Cohen have demonstrated, the use of drawing as a form of architectural research is an invaluable scholarly asset. Cinematic analyses of the same caliber are less common, as many of the movies that we discussed in Chapter 4 operate as vehicles of dissemination and/or inquiry, but not full-fledged research. The cinematic essays of Chris Marker, which are canonical works of analytical cinema, are perhaps a more fitting model. Although their subjects are not explicitly related to architecture and urban design, they address issues of time and space in a manner that resembles academic scholarship more than any of the movies discussed in this book. *Sans Soleil* (1983), for example, is an abstract mediation on distance, time, and local identities of place within a shifting global community. Most of Marker's images were shot with a silent movie camera, and almost the entire soundtrack is non-diegetic. The use of a female voice for the enigmatic narrator of the movie blurs the authorship of the movie (Marker is male) and helps to transform a personal narrative into a universal one. While historical and theoretical inquiries may not aspire to the profundity of *Sans Soleil*, Marker's method of weaving images and sounds into a tapestry of ideas is an inspiring use of cinema. Digital technology enables essayists of all types to engage cinema as a mode of discourse, and scholars of architecture who have graphic (or cinematic) literacy may read history differently than traditional scholars— not necessarily better but undoubtedly in a unique way. As such, analytical drawing and moviemaking are vital territories where scholarship and design innovation may cross-pollinate.

Notes and Credits

Notes

Chapter Heading Quotations

Preface (p. v): Albert Camus, "The Myth of Sisyphus," in *The Myth of Sisyphus and other Essays*, trans. Justin O'Brien (New York, Alfred A. Knopf, 1957), 117 (original publication in French 1942).

Introduction (p. 1): Leon Battista Alberti, *On the Art of Building in Ten Books*, trans. Joseph Rykwert, Neil Leach, Robert Tavernor (Cambridge, MA: MIT Press, 1988), 33 (original publication in 1455).

Chapter 1 (p. 21): Michael Baxandal, *Painting and Experience in Fifteenth-Century Italy: A Primer in the Social History of Pictorial Style* (Oxford, UK: Oxford University Press, 1972), 29.

Chapter 2 (p. 81): Roland Barthes, *Camera Lucida: Reflections on Photography*, trans. Richard Howard (New York: Hill and Wang, 1981), 115.

Chapter 3 (p.121): William Ware, *Modern perspective: a treatise upon the principles and practice of plane and cylindrical perspective* (New York, The Macmillan Co., 1900), iii–iv (original publication in 1882).

Chapter 4 (p. 167): Geoffrey O'Brien, *The Phantom Empire: Movies in the Mind of the 20th Century* (New York: W.W. Norton & Company, 1993), 24–25, 52–53.

Chapter 5 (p. 205): Robin Evans, *The Projective Cast: Architecture and Its Three Geometries* (Cambridge, MA: MIT Press, 1995), xxxvi–xxxvii.

Chapter 6 (p. 223): Germaine Dulac, "Avant-garde Cinema," quoted in Malte Hagener, *Moving Forward, Looking Back: The European Avant-garde and the Invention of Film Culture, 1919–1939* (Amsterdam: Amsterdam University press, 2007), 119 (original publication in 1932).

Epilogue (p. 247): Adolf Loos, quoted in Beatriz Colomina, *Privacy and Publicity: Modern Architecture as Mass Media* (Cambridge, MA: MIT Press, 1996), 65 (original publication in 1924).

Notes from Introduction

1. Leon Battista Alberti, *On the Art of Building in Ten Books*, trans. Joseph Rykwert, Neil Leach, Robert Tavernor (Cambridge, MA: MIT Press, 1988), 33–35.

2. Ibid., 35.

3. See Leon Battista Alberti, *On Painting*, trans. John R. Spencer (New Haven: Yale University Press, 1966). Alberti does not use the phrase *costruzione legittima*, but it was a popular nickname for his method during the Renaissance.

4. Colin Rowe and Leon Satkowski, *Italian Architecture of the 16th Century* (New York: Princeton Architectural Press, 2002), 31–32.

5. Rowe and Satkowski, *Italian Architecture*, 32, 57.

6. Martin Kemp, *The Science of Art: Optical Themes in Western Art from Brunelleschi to Seurat* (New Haven: Yale University Press, 1990), 47–49.

7. The phrase "willing suspension of disbelief" was first posited by the poet Samuel Taylor Coleridge in the nineteenth century as a condition of literature that allows readers to accept implausible scenarios, and it is widely applied to theater as well as cinema.

8. Robin Evans, *The Projective Cast: Architecture and Its Three Geometries* (Cambridge, MA: MIT Press, 1995), xxxi.

9. Robin Evans, "Architectural Projection," in *Architecture and Its Image: Four Centuries of Architectural Representation*, eds. Eve Blau and Edward Kaufman, (Cambridge, MA: MIT Press, 1989), 21.

Notes from Chapter 1

1. Kirsti Andersen, *The Geometry of an Art: The History of the Mathematical Theory of Perspective from Alberti to Monge* (New York: Springer, 2007), 476.

2. The notion of seeing something from an infinitely far away position did not occur to all Renaissance thinkers because the notion of infinity was not widely understood; however Kirsti Andersen notes that "Aguilon dealt with both parallel and central projections. He remarked [in 1613] that a parallel projection can be considered as a central projection having the eye located at an infinite distance." Andersen, *The Geometry of Art*, 403.

Notes from Chapter 2

1. Walter Benjamin, "The Work of Art in the Age of Mechanical Reproduction," in *Illuminations: Essays and Reflections*, ed. Hanna Arendt, trans. Harry Zohn (New York: Schocken, 1969), 240–241.

2. ibid., 238–240.

3. For a comprehensive account of the elusiveness of terms like "experimental" and "avant-garde," see Malte Hagener, *Moving Forward, Looking Back: The European Avant-garde and the Invention of Film Culture, 1919–1939* (Amsterdam: Amsterdam University press, 2007), 11–39.

4. These sorts of exposure and focus "errors" are coming in Dogme 95 movies. Dogme 95 is a Danish movie collective, founded in 1995 by Lars von Trier and Thomas Vinterberg, that bans the use of artificial lighting, enhanced sound, tripods and camera dollies, filters and special effects, elaborate narrative structures, sets, and even props.

5. Digital cameras have smaller apertures than analog cameras, so it is more difficult to achieve a shallow of depth of field in digital cinema (which means it is that more difficult to have either the background or foreground of the image out of focus). Many digital moviemakers like a shallow depth of field because it is reminiscent of analog (or film-based) cinema. In recent years, digital full frame single-lens reflex cameras have become more common, and these cameras allow for a shallower depth of field than typical digital cameras.

6. Frame resolutions typically have a suffix of either *p*, which stands for progressive-scan, or *i*, which stands for interlaced. Progressive-scan images are higher quality, but most televisions are capable of viewing only interlaced images. These details are somewhat beyond the scope of this book, and technology is changing fast. Most readers will not need to worry about the differences, and more advanced readers will easily find resources on the latest developments.

7. Academy of Motion Picture Arts and Sciences developed a standard ratio in 1932 that was used until the 1950s, and it was not precisely 1.33:1, but rather 1.375:1. The slight difference resulted from a series of changes introduced when soundtracks were added to the standard 1.33 ratio used in the silent era.

8. Jonas Mekas, founder of Anthology Film Archives, has argued that only federal funding will save celluloid film from extinction and that digital archiving, which is the current preservation strategy of the United States government, undermines the integrity of movies made on celluloid. Mekas made these comments at the 40th Anniversary of Anthology Film Archives "Return to the Pleasure Dome" at Hiro Ballroom in New York City on May 19, 2010.

9. Emigholz spoke about his work at Anthology Film Archives in New York City, September 21–25, 2011.

10. Professor Richard Peña introduced me to this film and its use of sound in his "Introduction to Film Studies" course at Columbia University, fall semester, 1991.

11. St. Augustine, *Confessions*, trans. E.B. Pusey, passage 11.14.17. Accessed January 22, 2012, http://www9.georgetown.edu/faculty/jod/Englishconfessions.html.

Notes from Chapter 3

1. Morris Kline, "Projective Geometry," *Scientific American*, Volume 192, Number 1 (1955), 86.

2. Andersen, *The Geometry of Art*, 159–160.

3. I first encountered the term "rebatment" in Kirti Andersen's writings, and I have since researched its meaning in the Oxford English Dictionary. My use of it fits the O.E.D. definition as well as Andersen's general use of it, but others may the same term in slightly different ways.

4. Samuel Y. Edgerton, *The Mirror, the Window, and the Telescope: How Renaissance Linear Perspective Changed Our Vision of the Universe* (Ithica: Cornell University Press, 2009), 69–74. Edgerton argues that the view of the Palazzo dei Signori may have been a frontal view with a viewing point that allowed for a view of the side of the building. The literature on the panel states that two sides of the buildings were visible, but that does not, according to Edgerton, mean that it was an oblique view.

5. ibid., 69.

6. Samuel Y. Edgerton, *The Renaissance Rediscovery of Linear Perspective* (New York: Basic Books, 1975), 6.

7. Samuel Y. Edgerton, *The Mirror, the Window, and the Telescope*, 40–41.

8. Harry Francis Mallgrave, *Modern Architectural Theory: A Historical Survey, 1673–1968*, (Cambridge, UK: Cambridge University press, 2009), xvi.

9. Alberti, *On Painting*, 58–59.

10. ibid., 56. The quasi-proof of the vanishing point location method in Chapter 1 (Figures 1.36–1.39) addresses the relationship between a point on the surface of the measuring plane and a point at infinity. As mentioned in Note 2 from Chapter 1, the notion of infinity was not available to Alberti.

11. Andersen, *The Geometry of Art*, 33.

12. Alberti, *On Painting*, 57.

13. Andersen, *The Geometry of Art*, 159–160.

14. ibid., 214.

15. ibid., 132–135.

16. ibid., 164.

17. Evans, *The Projective Cast*, 140.

18. Andersen, *The Geometry of Art*, 241.

19. ibid., 160.

20. ibid., 244.

21. ibid., 137–138.

22. Ibid., 250.

23. William Ware, *Modern perspective: a treatise upon the principles and practice of plane and cylindrical perspective* (New York, The Macmillan Co., 1900), 106.

24. Alberti, *On Painting*, 68–70.

25. Kirsti Andersen, "The Problem of Scaling and of Choosing Parameters in Perspective Construction, Particularly in the One by Alberti," in *Analecta Romana Instituti Danici*, Volume 16 (1987), 107-128.

26. ibid., 107.

27. ibid., 117–118.

28. ibid., 126.

29. Andersen, *The Geometry of Art*, 442.

30. ibid., 442.

31. Alberto Pérez-Gómez and Louise Pelletier, "Architectural Representation beyond Perspectivism," *Perspecta*, Vol. 27 (1992), 32. The industrialization of Western culture in the nineteenth and twentieth centuries would have been inconceivable without its ability to describe objects for purposes of fabrication.

32. Arnold Emch, *An Introduction To Projective Geometry and Its Applications: An Analytic and Synthetic Treatment* (New York: John Wiley & Sons, 1905), 45 (Note I).

33. Kline, "Projective Geometry," 83.

34. ibid., 84.

35. ibid., 84–85.

36. Pérez-Gómez and Louise Pelletier, "Architectural Representation beyond Perspectivism," 22.

37. Much of the literature on *The Flagellation of Christ* focuses on the figures within the paintings, but there is also significant writing on the architecture, including Warman Welliner, "The Symbolic Architecture of Domenico Veneziano and Piero della Francesca," *Art Quarterly 36* (1973), 1–30.

38. Rowe and Satkowski, *Italian Architecture*, 28.

39. ibid., 45.

40. Wolfgang Lotz, *Studies in Italian Renaissance Architecture* (Cambridge, MA: MIT Press, 1981), 14–15.

41. ibid., 14.

42. The simulated choir is best viewed from a purely frontal position, as it is a purely frontal construction in the Albertian tradition of the "prince of rays." From the sides, the simulation is highly distorted, as Leonardo's diagram in Figure 0.1 illustrates. *The Holy Trinity* (1425) by Masaccio is a perspectival mural in Santa Maria Novella in Florence that is also best viewed from a frontal position. Martin Kemp in fact has demonstrated that Masaccio calibrated an ideal viewing position within the church that corresponds to the viewing point of the painting. (Kemp, *The Science of Art*, 17–19). Unlike perspectival paintings in frames, which promote a separation between the space viewed and the space of viewing, these murals are illusionary expansions of an inhabitable space. The Masaccio painting, however, depicts a divine space that is conceptually distinct from the earthly realm of the church patron, whereas the Bramante painting depicts a corporeal space that simply expands the volume of an actual building.

43. Arnaldo Bruschi, *Bramante* (London: Thames & Hudson, 1977); James Ackerman, *The Cortile del Belvedere* (London: Thames & Hudson, 1964).

44. Bruschi, *Bramante*, 100.

45. ibid., 99–105.

46. ibid., 100.

47. Evans, "Architectural Projection," 24.

48. Lotz, *Studies in Italian Renaissance Architecture*, 21–22.

49. Sebastiano Serlio, *On Architecture, Volume One: Books I-V of 'Tutte l'opere d'architettura et prospetiva'*, trans. Vaughan Hart and Peter Hicks (New Haven: Yale University Press, 1996), 37.

50. ibid., 37.

51. ibid., 37.

52 This perspective was constructed as a backdrop for a three-dimensional diorama in the pavilion. It was installed on a curved wall and engaged a complex notion of visuality. See Richard Difford, "Infinite horizons: Le Corbusier, the Pavillon de l'Esprit Nouveau dioramas and the science of visual distance," *The Journal of Architecture*, Volume 14, No. 3 (2009) 295–323. The image was therefore not a pure example of Albertian linear perspective, but it nonetheless still engages the issues of the ideal city panels.

53. Nick Leahy, Principal, Perkins Eastman, New York, interviewed on August 10, 2011.

54. See Paul Lewis, Marc Tsurumaki, and David J. Lewis, *Opportunistic Architecture* (New York: Princeton Architectural Press, 2008).

55. See Cohen's use of digital modeling in, Preston Scott Cohen, *Contested Symmetries and Other Predicaments in Architecture* (New York: Princeton Architectural Press, 2001), 54–69.

56. See Rafael Moneo's discussion of Cohen's arbitrariness in, Ibid., 11.

Notes from Chapter 4

1. Benjamin, "The Work of Art in the Age of Mechanical Reproduction," 239.

2. Walter Benjamin, quoted in Detlef Mertins, *The Presence of Mies* (New York: Princeton Architectural Press, 1996), 152 (original publication in 1931 in "A Small History of Photography").

3. Sergei Eisenstein, "Montage and Architecture," trans. Michael Glenny, *Assemblage*, No. 10 (Dec., 1989), 116.

4. ibid., 117.

5. Le Corbusier, *Toward an Architecture*, trans. John Goodman (Los Angeles: Getty Research Institute, 2007), 221–224.

6. Anthony Vidler, "The Explosion of Space: Architecture and the Filmic Imaginary," *Assemblage*, No. 21 (Aug., 1993), 56.

7. Andre Bazin, *What is Cinema?: Volume I*, trans. Hugh Gray (Berkeley: University of California Press, 1967), 109.

8. ibid., 21.

9. Andre Bazin, "De La Politique des Auteurs," *Cahiers du Cinema*, No. 70 (April 1957), 2–11. In this article, Bazin gives several warning regarding the limits of the theory and the carelessness with which others may adopt it without a full understanding of its nuances.

10. Thomas W. Benson and Carolyn Andersen, *Reality Fictions: The Films of Frederick Wiseman* (Carbondale: Southern Illinois University Press, 2002), 1–2.

11. Bernard Tschumi, *Architecture and Disjunction* (Cambridge, MA: MIT Press, 1996), 196–197.

12. Bernard Tschumi and Peter Macapia, "On the Ontology of Events: A Conversation with Bernard Tschumi," interview transcribed online, accessed January 24, 2012, http://www.petermacapia.com/blog/conversationbernardtschumi.

13. Tschumi, *Architecture and Disjunction*, 185 & 196–197.

14. Given Tschumi's interest in Soviet montage, I find it curious that all of the follies in La Villette recall the imagery of Russian Constructivist architecture. His procedures, as opposed to his taste, are supposed to have determined the forms of the park, but the references to Constructivism seem too obvious and stylized to be a coincidence.

15. For a thorough critique of the cinematic promenade, see Nicole Pertuiset, "The Floating Eye" in *Journal of Architectural Education*, Volume 43, No. 2, p. 7–13.

16. In *The Hunchback of Notre Dame*, Victor Hugo proclaims that the invention of the printing press killed the traditional communicative role of architecture. I reference the phrase in order to imply that may consider cinema as a threat to architecture because it is allegedly more dynamic and engaging than the built environment, a premise with which I do not agree.

17. See Marc Boumeester, "Reconsidering cinematic mapping: Halfway between collected subjectivity and projective mapping," in *Urban Cinematics: Understanding Urban Phenomena through the Moving Image*, eds. François Penz and Andong Lu (Bristol, UK: Intellect Books, 2011), 239-256.

18. The Teatro Olimpico by Palladio is one of many examples of theater sets that have address depth, which is to say that not all theater sets are flat and non-spatial. Palladio's design is especially interesting in our discussion because of its perspectival tricks, but it is somewhat peripheral to our immediate concerns.

19. James Steffan, "The Passion of Joan of Arc," accessed on January 24, 2012, http://www.tcm.com/this-month/article/81387%7C0/The-Passion-of-Joan-of-Arc.html.

20. David Bordwell, *The Films of Carl-Theodor Dreyer* (Berkeley: University of California Press, 1981), 67–69.

21. Ibid., 77–79.

22. Michael J. Dear and Steven Flusty, *The Spaces of Postmodernity: Readings in Human Geography* (Oxford, UK: Wiley-Blackwell, 2002), 292.

23. Thomas de Monchaux, "L'Inhumaine," in *Film Architecture: Set Designs from Metropolis to Blade Runner*, ed. Dietrich Neumann (Munich: Prestel, 1996), 80.

24. Vertov states this in an inter-title before the beginning of the movie.

25. See Anthony Vidler, "The Explosion of Space: Architecture and the Filmic Imaginary," 58, for note on Abel Gance's theory of cinematic space.

26. It is also important to note that moviemakers and architects belonged to the same artistic communities as each other, and to the same social circles as their clients, so collaborations were not surprising.

27. Sigfried Giedion, *Building in France/Building in Iron/Building in Ferro-Concrete*, trans. J. Duncan Berry (Los Angeles, 1995), 176.

28. Andres Janser, "Only Film Can Make The New Architecture Intelligible: Hans Richter's Die neue Wohnung and the Early Documentary Film on Modern Architecture," in *Cinema & Architecture : Melies, Mallet-Stevens, Multimedia*, eds. François Penz and Maureen Thomas (London: British Film Institute, 1997), 38.

29. ibid., 43.

30. Letters in the archive at the Fondation Le Corbusier chronicle several exchanges between Le Corbusier and moviemakers who sought to work with him, but they never amounted to any cinema commissions. Le Corbusier typically failed to respond to persistent requests.

31. Janser, "Only Film Can Make The New Architecture Intelligible," 44.

32. ibid., 37; Janser identifies a construction genre as one of many documentary genres that appeared in the 1920s (see Chapter 6).

33. Guerín spoke about his work at Anthology Film Archives in New York City, December 13, 2011.

34. ibid.

35. ibid.

Notes from Chapter 6

1. See pages 84–85 for Benjamin's argument.

2. Janser, "Only Film Can Make The New Architecture Intelligible," 36.

3. ibid., 37.

4. ibid., 37.

5. Andres Janser and Arthur Rüegg, *Hans Richter, New Living: Architecture. Film. Space.* (Baden: Lars Müller Publishers, 2001).

6. ibid., 18–19.

7. For a discussion of intersections between commercial film and avant-garde film, see Malte Hagener, *Moving Forward, Looking Back: The European Avant-garde and the Invention of Film Culture, 1919–1939* (Amsterdam: Amsterdam University press, 2007), 44–61.

8. Janser, "Only Film Can Make The New Architecture Intelligible," 42.

9. ibid., 42.

10. Alexandra Shatskikh, "Malevich and Film," *The Burlington Magazine*, Vol. 135, No. 1084 (Jul., 1993), 471.

11. Ibid., 476.

12. Ibid., 478.

13. Hans Richter quoted in Malcolm Turvey, *The Filming of Modern Life: European Avant-Garde Film of the 1920s* (Cambridge, MA: MIT Press, 2011), 30.

14. Janser, "Only Film Can Make The New Architecture Intelligible," 44–45.

15. Ernie Gehr, accessed on January 24, 2012, http://www.hi-beam.net/mkr/eg/eg-bio.html.

Notes from Epilogue

1. Mario Carpo spoke on this matter at University of North Carolina at Charlotte School of Architecture on February 16, 2011.

Illustrations

All drawings, diagrams, photographs, and stills were created by the author. Student assistants: Brandon Benzing (lead), Sam Buell, Steven Danilowicz, Taylor Milner, Allen Pratt, Carson Russell, and Kerry Weldon.

The following Figures from historical treatises on linear perspective were based on the publication of the drawings in Martin Kemp, *The Science of Art*: 0.1, 3.11, 3.13.

The following Figures from historical treatises on linear perspective were based on the publication of the drawings in Kirsti Andersen, *The Geometry of Art*: 3.01, 3.02, 3.03, 3.04, 3.05, 3.06, 3.14.

Index